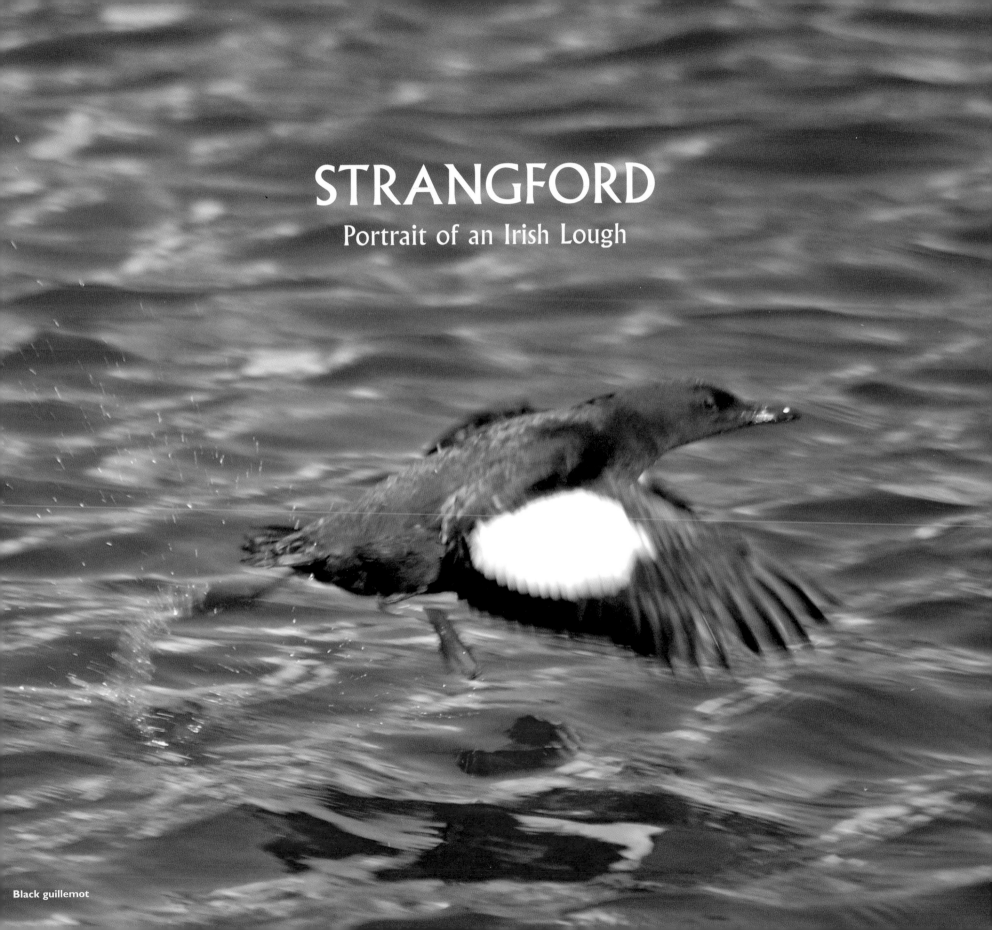

STRANGFORD

Portrait of an Irish Lough

Black guillemot

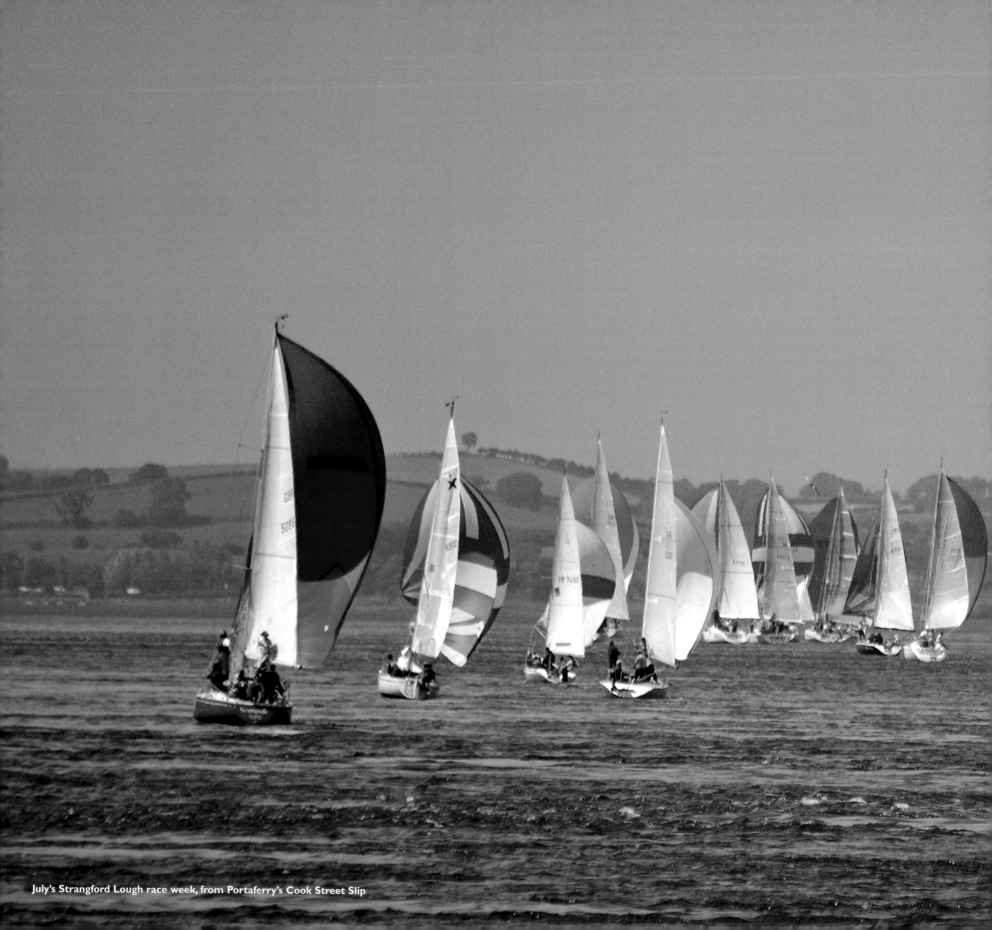

July's Strangford Lough race week, from Portaferry's Cook Street Slip

STRANGFORD

Portrait of an Irish Lough

PHOTOGRAPHS
ALAIN LE GARSMEUR

WORDS
IAN HILL

BLACKSTAFF
PRESS
BELFAST

For my grandson, Arthur Stokes Le Garsmeur

ALAIN LE GARSMEUR

For Raymond Piper,
who first showed me Killard's Irish wild orchids

IAN HILL

Mooring, off Kircubbin

Contents

Foreword

Arlene Foster, MLA
MINISTER OF THE ENVIRONMENT

Strangford Lough is an exceptional place, renowned for its natural beauty, its wildlife and its rich heritage. The lough's importance for marine life is recognised internationally; its scenery is greatly valued by the many who visit for recreation and enjoyment; and around its shores are many features and monuments which record the long history of human settlement in the area.

Protecting and managing Strangford Lough is one of my top priorities as Environment Minister. The protection that is given to the area is designed to ensure that we look after it properly. This is why the lough is an Area of Outstanding Natural Beauty, with several Areas of Special Scientific Interest and seven statutory Nature Reserves around its shores. The lough is also a Special Area of Conservation, a Special Protection Area, the largest Marine Nature Reserve in the United Kingdom and a wetland of internationally recognised importance.

The lough's shores are also home to a wealth of archaeological features, historic monuments, listed buildings, conservation areas, and historic parks, gardens and demesnes, some dating from pre-Christian times.

The best way to protect this area is by ensuring that everyone who uses the lough and its environment is aware of its value and respects it. This magnificent book, which celebrates the landscape, wildlife and built heritage of Strangford Lough, will go a long way, I am sure, towards raising public awareness, both locally and overseas, of the beauty and importance of the area.

I am therefore delighted that this publication has been funded in part by my department's Environment and Heritage Service and I am sure that it will delight and excite all who open its covers, now and for generations to come.

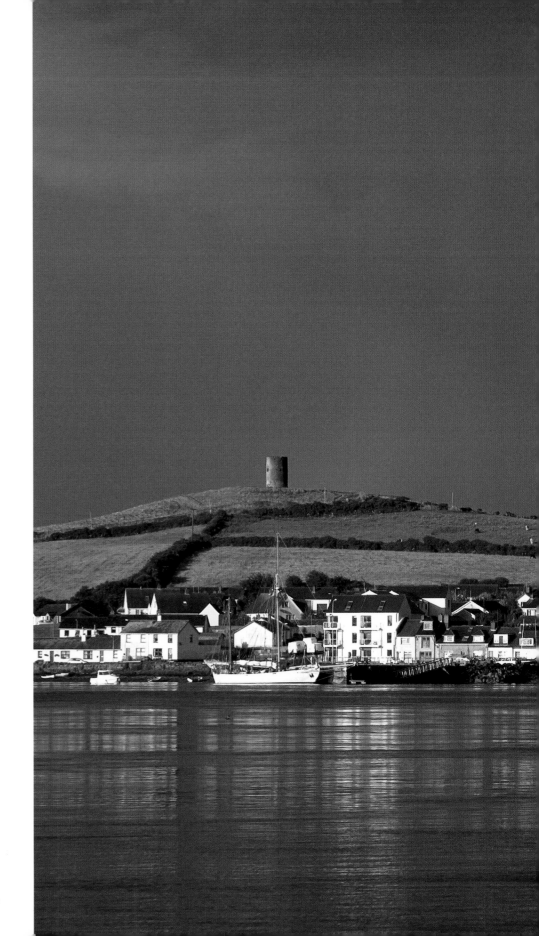

The lough's windmills – even when reduced to stumps, such as this just south of Portaferry – remain vital navigational aids, even in an electronic age.

Introduction

Yours won't be the first footfall on Strangford Lough's shores, though you might be tempted to think it so on an empty beach or down a smuggler's ancient track to the rocky shore. Others have been docking here for over eight thousand years, the first settlers drawn by favourable tides and equipped with the knowledge that where wildfowl flock, and where sweet freshwater meets the sea, the good sailing waters will be rich in fish, the shallows abundant with shellfish, the shores of the estuary heavy with berries.

So began, and so continue, this lough's attractions, and these were the matters which, in a less academic fashion, Alain and I discussed when we began this book, over what Michael Longley refers to – in his poem 'The Lifeboat' – as the kind of 'pluperfect' pint poured in the island of Ireland's quiet, tiny and ancient maritime pubs.

We talked too of how, on different days, light off the lough can show the ferry-boats as if they were on a Norwegian fjord, an English lake, off an Italian coast, or in the Straits of Malacca. We spoke also of the area's micro-climate; of the sensuous curve of the drumlin hills; of the particular blue of that tiny flower, the vernal squill; of the red-footed guillemot's sooty black plumage. In short, we planned for a book which would, in pictures and words, convey what the French might call the lough's *terroir*. Thus begins our – and we hope your – anti-clockwise odyssey, from Ballyquintin to Killard, around the shoreline.

History, in the form of the built heritage, from prehistoric time right up to today, is woven through the book. And no note on heritage is complete without a record of the civilisations – each interpreted in different ways by archaeologists who root around their graves, their household middens and their castles – which sent their invaders, one after another, to this lough over the centuries.

But this being Ireland, mythology also has to have a voice on these pages, for often its roots are mulched in at least a leavening of truth. Those in thrall to these myths will be entranced by the suggestion that the first sophisticated invaders were led by Noah's Anatolian granddaughter Cessaria, who vanquished the Mesolithic hunter-gatherers, only to be supplanted herself by Sicilians, who in turn were despatched by pirates from shores of the Caspian Sea. These rascals lost out to hirsute Belgians who fell to the elegant Tuatha dé Dannan – a race so beautiful that they hid underground rather than engage in fisticuffs with rough adventurers from Spain's province of Galicia.

So far, so mythic. But there is some evidence – much disputed – that Roman-educated Christians, their champion St Patrick, arrived in the fifth century AD. Vikings certainly harried the coast in the tenth century, the Anglo-Normans conquered all in the twelfth, as did the Scots in the early seventeenth, and William III, the archipelago's last invader, in 1690.

Strangford village's Conservation Area

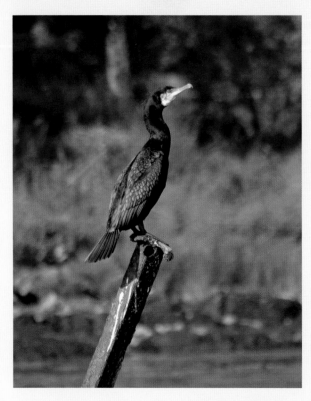

The cormorant, *Phalacrocorax carbo* (Ir. *broigheal*), bears a white flash on cheek and thigh; a distinctive marking that its smaller cousin the shag, *Phalacrocorax aristotelis* (Ir. *seaga*), does not share.

A taster of this book's scope can be gained by our treatment of a single civil parish, that of Ballyculter and Kilclief – or, in English, Coulterstown and the Wattle Church. The parish runs from Audleystown, along the shore past Castleward, Strangford village, and the seals on Cloghy Rocks, to Killard Point's wild orchids before meandering nor' west then nor' east past townlands with names as curious as Lagnagoppoge and Ballynagarrick, translated as Horses' Hollow and Rock Farm.

The beaches at Castleward yield six-thousand-year-old flints used by Mesolithic hunter-gatherers. The Neolithic herders who followed built their 'giants' graves' – the stone structures which archaeologists call megaliths, dolmens and cairns – around the rides, or borders of the parish, from Audleystown to the Stone Circle at Castlemahon, from where they could see Loughmoney's dolmen, leading some authorities to theories suggesting a reason, found in the alignments of the sun, the moon and the planets, for the geographical relationships between one historical site and another. Audleystown has also revealed its Bronze Age pottery, Kilclief its monastic fish traps, Black Causeway its Georgian tide mill, Tullyratty its Victorian lead mine, and Strangford the history of its cargo, passenger and pleasure quays.

The drumlin-top defences at Loughkeelan and Raholp were the farmsteads of the first millennium, safe from the Norse raiders. St Patrick, legend goes, left a blessing of his holy wells and churches from Saul to Chapel Island. The stone tower-houses in this parish – Audley's, Castle Ward's, Strangford's and Kilclief's – are a legacy of the much earlier twelfth-century Anglo-Norman colonisation led by John de Courcy, an adventurer who, disturbed at prayer, slew fourteen with a Christian cross. He also embroidered the legends of St Patrick and restructured half a dozen monasteries. A Viking fleet anchored off Audley's Castle in the waters dubbed, confusingly for landlubbers, Audley's Roads, and the Spanish Armada and the French invasion force would have done so too, given a fair wind and secure diplomacy. Bishops Court, having misplaced its Norman castle, gained an airfield guarded by Second World War observation bunkers, and Cold War radar posts on Killard from where, in summer, watchers scan the seas for basking sharks, bottlenose dolphins and pods of harbour porpoise.

Churches add the architectural grace notes: the Church of Ireland's Christ Church in handsome Planters' style at Ballyculter itself; the privacy of Old Court's 1629 chapel; Mary Star of the Sea in Roman Catholic Gothic; the modest Methodist chapel at Black Causeway returned to cottage status; and the Presbyterian Trinitarian spare meeting house, closed for lack of Dissenters.

Presently Strangford village, with its encircling muffler of mature deciduous trees has all the advantages a visitor or resident could wish for, from bars and a baron, bistros and butcher to castle, heronry, medical hall, newsagent, woodland walks and a yacht club in a designated Conservation Area rich in Georgian houses – listed and pastiche – whose residents, just like all the lough's homeowners and visitors, face this century's challenge: to match true conservation with sensitive centripetal, rather than centrifugal, growth and regeneration.

The Wards of Castle Ward didn't have time for such fine debates when they deported Audleystown's tenants or commissioned Castle Ward House, whose elegance, along with its seductive acres, is meticulously preserved by the National Trust, owners and managers of much of the lough's foreshore, sea bed and islands, along with private landowners and other statutory and voluntary agencies. Valentine Paine's seventeenth-century Horseferry Slip and Old Quay survive little altered in Strangford itself, but a parliament of rooks quibbles in the stark ruin of the Isle O'Valla Charter School, and Old Court is gone, burnt by the 'old' IRA in the Troubles of 1922.

But the past has also, as we discovered when working on this book, a lighter side with many curious and instructive diversions to be had from the more intimate history of the parish's major landowners. We find Bernard Ward, for instance, pressuring his vestry to dismiss Ballyculter's rector, the Reverend Edward Smyth who'd found a maidservant 'partaking of his [Lordship's] bedchamber' and who'd then preached a sermon on adultery. We came to applaud Mary Ward, an artist-scientist of great note, and the actress Sarah 'Lalla' Ward, who married the evolutionary scientist Richard Dawkins while starring in *Dr Who*. Or take Henry, nineteenth Baron de Ros, whose father, when married, had had an affair with Caroline Princess of Wales, who became wife to George IV. Henry, a friend of the Duke of Wellington, was also caught in his club, cheating at cards, not once, but twice. But then whom amongst us, without an archivist to write it down for us, has an ancestry less diverting? If only we knew.

IAN HILL, STRANGFORD AND
ALAIN LE GARSMEUR, PORTAFERRY

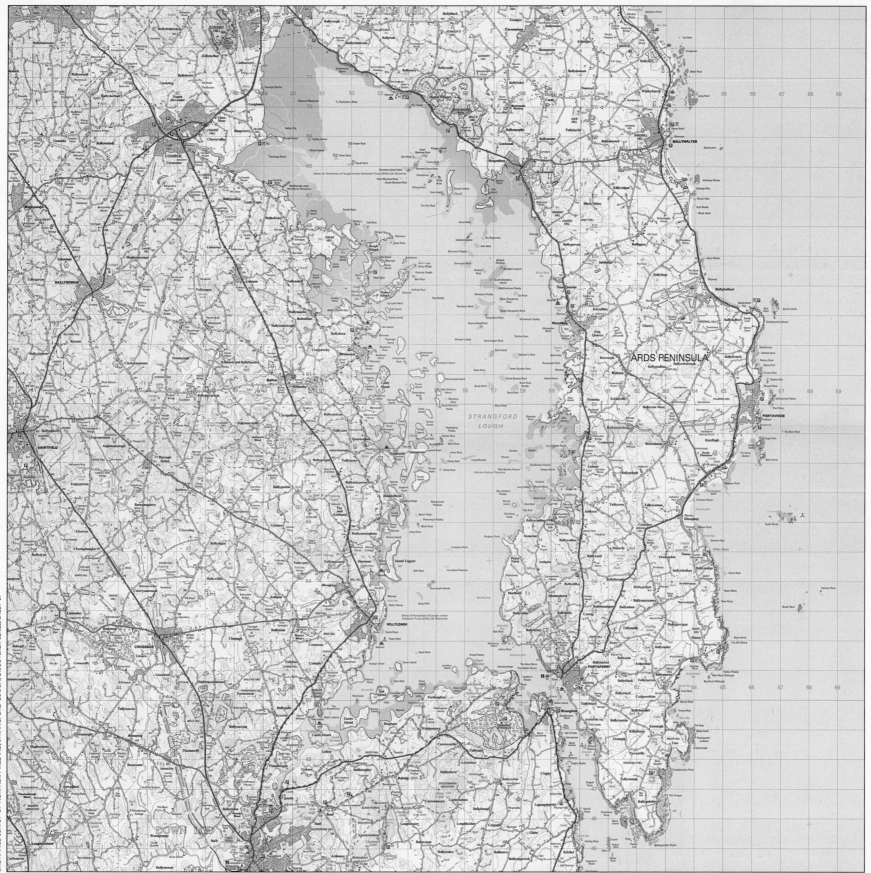

ORDNANCE SURVEY OF NORTHERN IRELAND, STRANGFORD LOUGH, DISCOVERER SERIES, SHEET 21

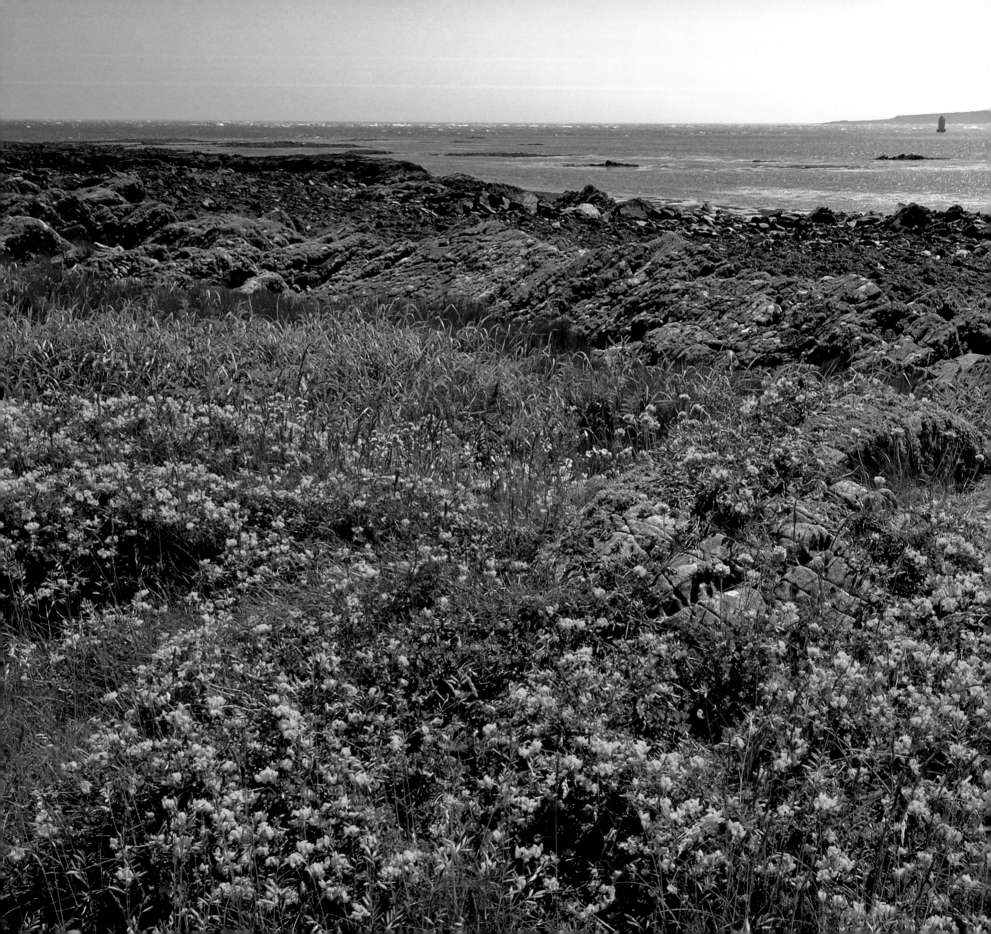

Ballyquintin Point to Bishops Mill

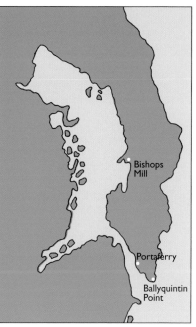

The lough's salty and shingled shores – at the points of Ballyquintin on the tip of the Ards Peninsula to the east and of Killard to the west – are fringed with wild flowers and washed, twice each day, by the encroaching, then retreating, tides of the Irish sea.

Here the lough forms a passage, narrowing at the Narrows, opening up beyond Portaferry and flowing between the drumlins which tempted the ice age's hunter-gatherers. Now Sunday go-for-a-spin picnickers come to photograph ringed plovers' nests, and scan for shearwaters and bats at dusk.

Here the sun rises over a basket of egg-shaped hills called Ballyquintin, Ballytrustan, Ballyfounder and even Ballywierd. Then it catches the white-horse waves rearing up at the bar, where the lough's currents clash with the seas rolling in from the east and the Isle of Man. That's an island which will be lost from view in the cold incoming winter, only to be found again in summer when the early morning mists are banished by the days' emerging warmth.

Kilclief's church and castle, on the other side of the lough, would have been, and still are, essential markers for the seafarer seeking safe passage, as were, and are, the natural anchorage and slipway in Bar Hall Bay, the folly on Bankmore Hill, the windmill above Portaferry. A sailor will have to hand charts marking these shore-bound navigational aids, plus those erected over the centuries on the Angus and Garter Rocks, the Pladdy Lug and other such potential wreckers – cartographers have been persuaded by the litany of barques, brigantines, cutters, drifters, Drontheims, ketches, nickeys, nobbies, schooners, skiffs, smacks, steamships, wherries, yachts and yawls that have foundered in the lough, only for their timbers to sustain the roofs, newel posts, banisters and winter fires of Ballyquintin and beyond.

Ballyquintin Point looking towards Killard

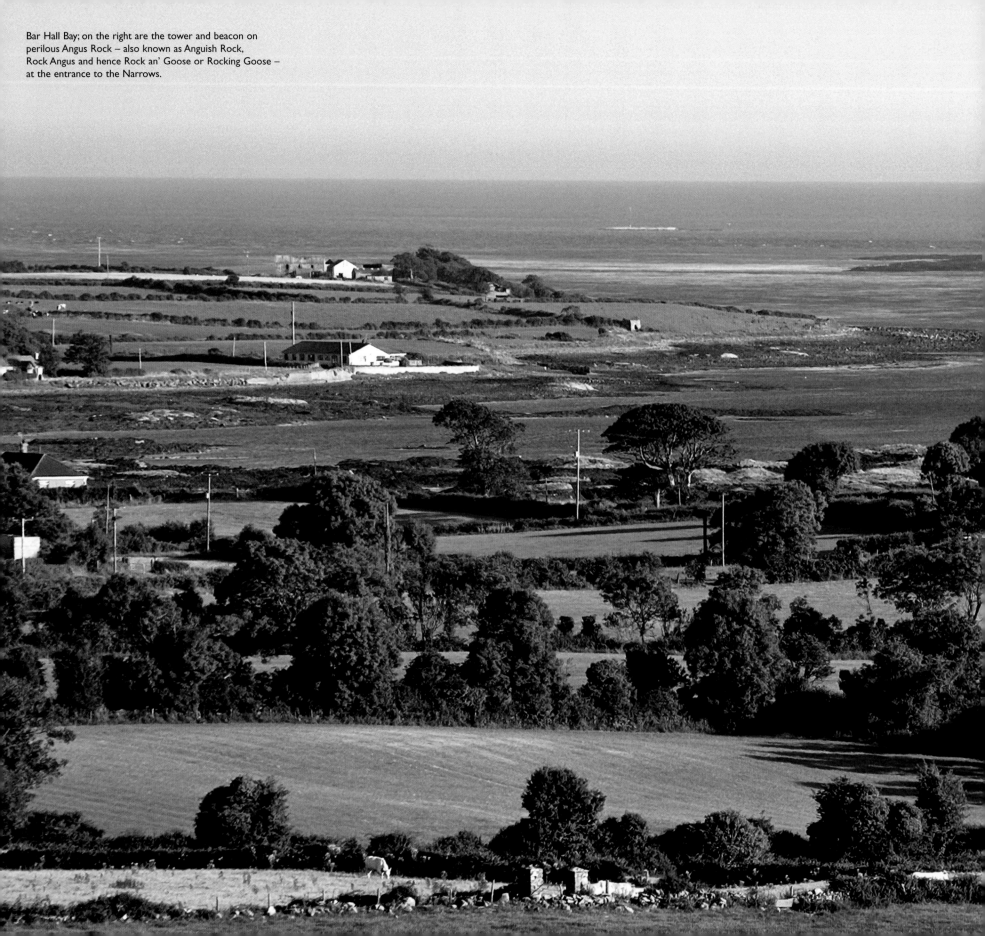

Bar Hall Bay; on the right are the tower and beacon on perilous Angus Rock – also known as Anguish Rock, Rock Angus and hence Rock an' Goose or Rocking Goose – at the entrance to the Narrows.

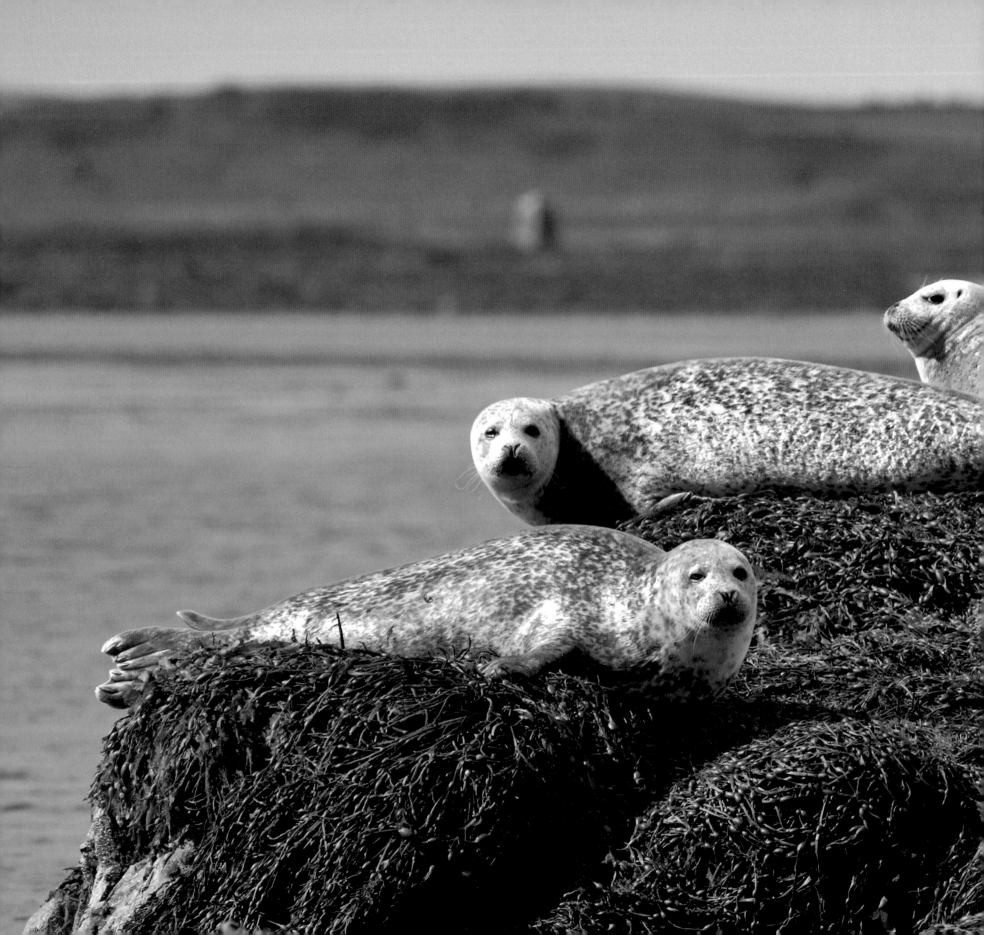

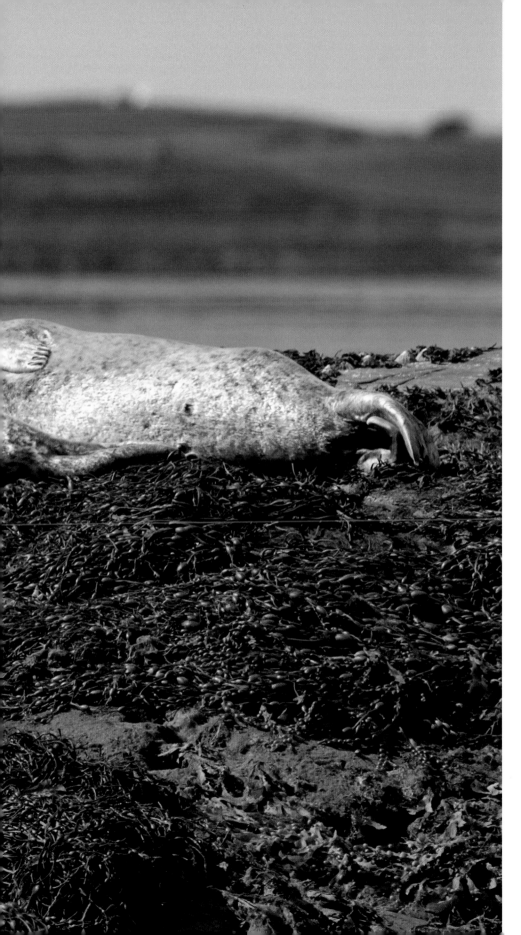

Exploring the Marine Nature Reserve

The common and grey seals, hauling themselves out onto rocks around the lough shore, are a world away from cubs endangered on windswept Arctic foreshores. Once under threat from the fishermen who used to claim that fish stocks were diminishing due to the predations of the seals – rather than because of pollution or drift-netting and reef-wrecking trawling – the seals are now protected animals.

Folk tales, heard of an All Souls' Night around a turf fire, tell of the seal as a selkie, a sleek seductress who diverts fishermen to watery graves. However, the truth is that there was many a sailor who manipulated this legend to excuse the fulfilment of his dream of a girl in every port.

While the whole lough is a Marine Nature Reserve, and Ballyquintin a National Nature Reserve, it is Cloghy Rocks – one of four nature reserves in the Narrows – that is the best place to see seals.

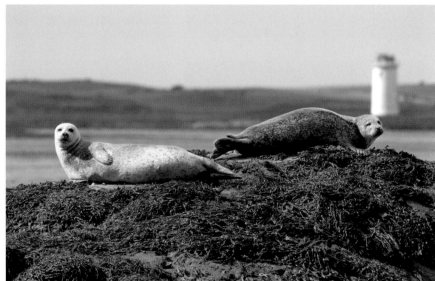

Bar Hall Bay, Angus Rock and Killard beyond

Left: Common seals, *Phoca vitulina* (Ir. *rón beag*), at Bar Hall Bay

The lough's shores offer wide-open skies at every turn, best viewed by dawn's early light or at the going down of the sun. For at these times nature's elements combine to produce the greatest shows on earth.

That's if you don't count the brilliance of the stars, best seen far from the lights of the city. And to the south, and seen from almost everywhere around the lough, lies that family of bears, songwriter Percy French's Mountains of Mourne, sweeping down to the sea.

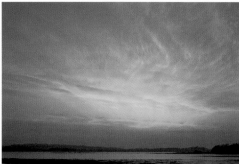
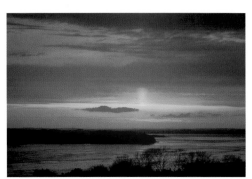
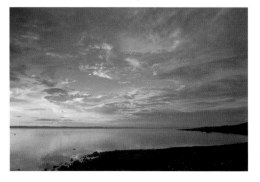
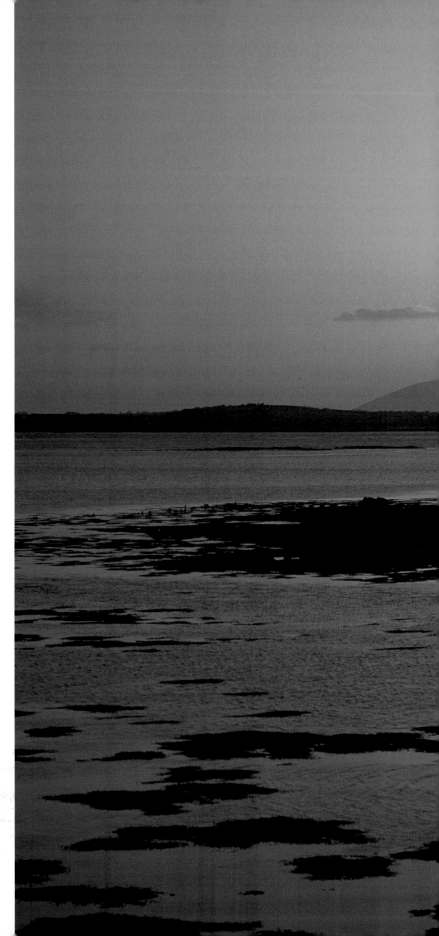

The Mountains of Mourne from Bar Hall Bay

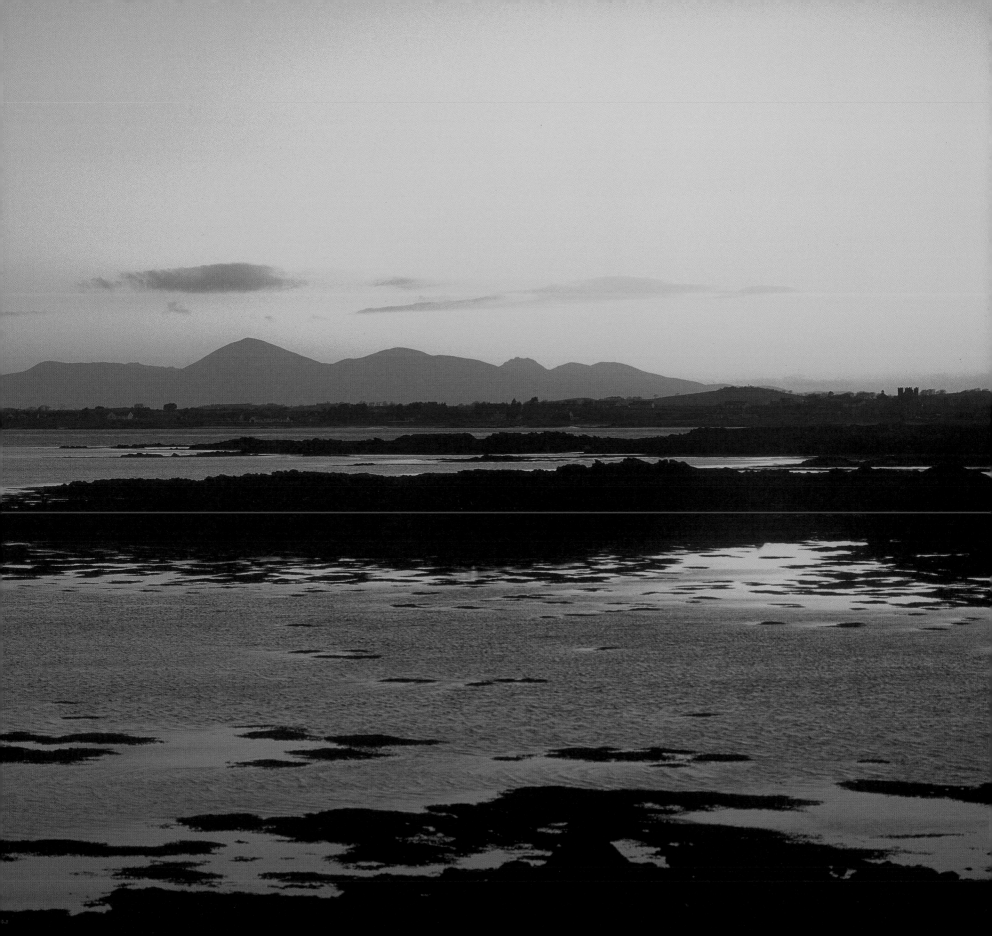

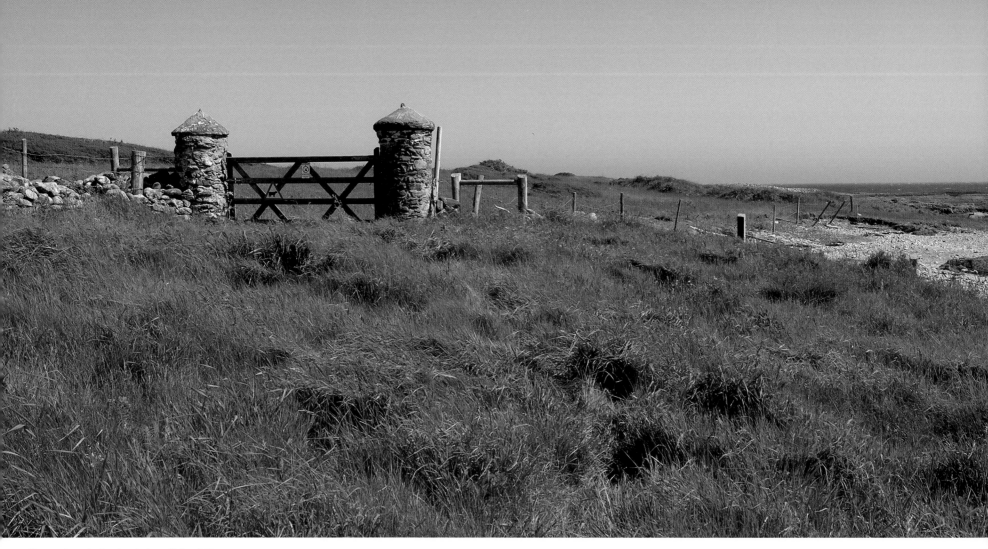

Stone gateposts, timeless totems, Ballyquintin

Stone gateposts are as much totems of the Ards and Lecale landscapes as the man-made split-rubble castles and tower-houses of the sixteenth century, the 'Giant's Grave' dolmens of the megalithic period, or the stone-lined cairns of similar antiquity that were once regarded as fairy gateways to an underworld. Legend has it that the gateposts were given cone-shaped caps so that ill-tempered 'wee folk' (fairies) would slip from their perches before they had time to curse the cattle or sour their milk.

The gateposts also offered the perfect elbow-height rest from which a pipe-smoker could compare his well-wrought acres with his neighbour's shingly foreshore, good for growing little but burnet rose and sea pink.

Right: Sea pink, *Armeria maritima* (Ir. *rabhán*)
Far right: Burnet rose, *Rosa pimpinellifolia* (Ir. *briúlán*)

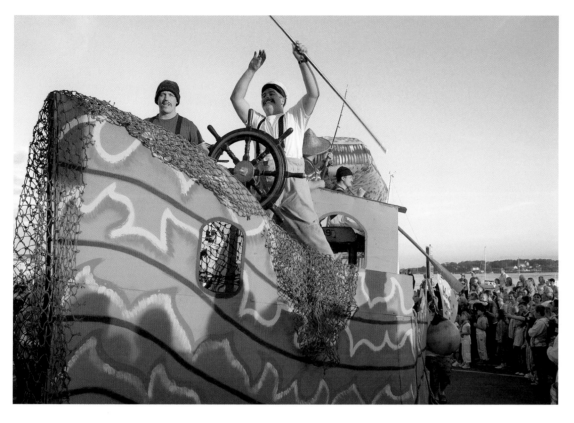

Every Irish lough should have a monster as old as time forgot. And Portaferry's marine researchers have no doubt reviewed ancient reports of vast creatures – probably nothing more than stray whales, basking sharks, or pods of once common dolphins and porpoises. They've looked over the particulars of the now protected massive ninety-kilogram common skate which as recently as forty years ago burrowed into the deepest of the lough's troughs. They've examined the details of the also protected – and almost absent – tope, an elegant species of pale grey shark weighing in at up to thirty-four kilograms, nicknamed 'Sweet William' for its ammonical smell.

But their only confirmed sightings of sea monsters occur when they look out from their windows on to the Strand on the night of the village's less than Saturnalian, but still highly diverting, gala summer carnival, which takes place in July. Its floats, sponsored by the village pubs, poke fun at politicians, satirise the Hollywood blockbuster, and set the legends of St Patrick's landing across the lough against tales of the heathen Vikings who razed his churches to the ground.

Left: Portaferry Gala
Below left: Garden of delight
Below right: Lead *Kindly-Light*

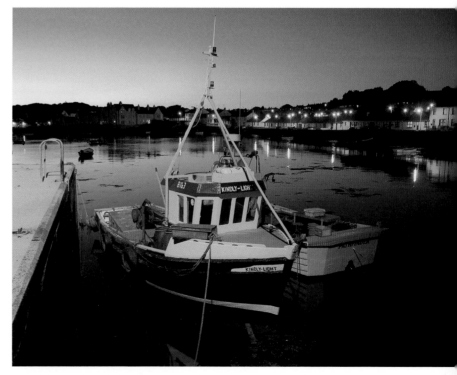

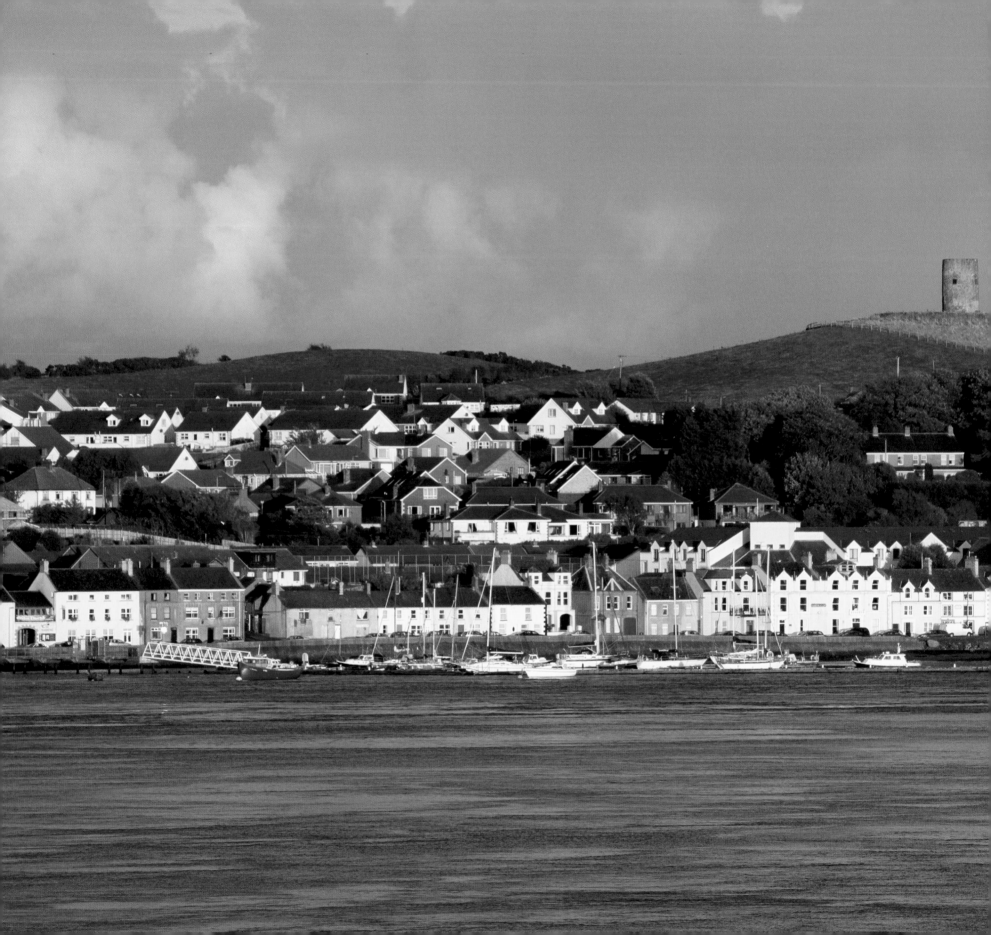

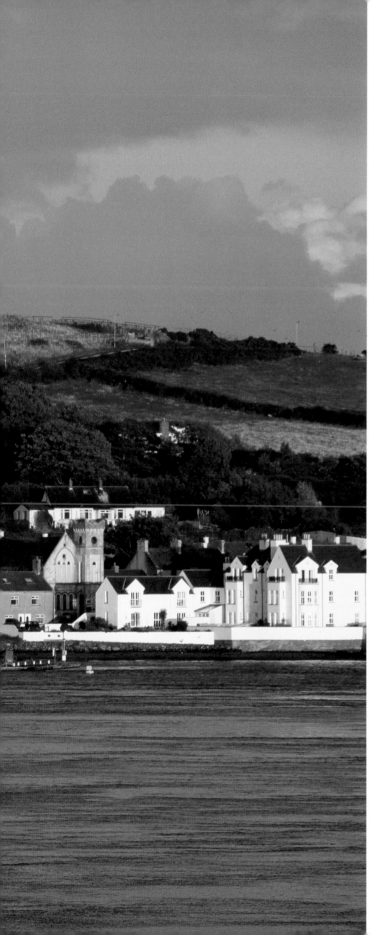

Patrick Savage, an English settler, fiercely lampooned by the Irish as 'hang-dog-faced hangabone hangman MacSavage', made a poor stab at founding the village of Portaferry until he was assisted in 1636 by his new brother-in-law, a hard-headed Scots colonist called James Montgomery, whose family came near to owning all the land around Strangford Lough.

Though hard-hit by the great famines – and subsequent emigrations – of 1740–41 and 1845–49, and the inevitable decline of a port too small to cater for increasingly large vessels, Portaferry's charm survives. It's found in plentiful public houses, a welcoming sailing club, churches, a sixteenth-century tower-house, a Georgian market house and similarly ancient private homes, modest and merchant, all set amongst narrow winding streets – with local soubriquets such as Purgatory, Shambles and Virgin's Lane – listing like sailors home from the sea.

Any navigator will confirm the worth of windmill stumps, such as Tullyboard's (left), which punctuate the skyline, and of the Big Houses – such as Portaferry House – so beloved by the Anglo-Irish literati, nestling in woody demesnes patrolled now only by buzzards.

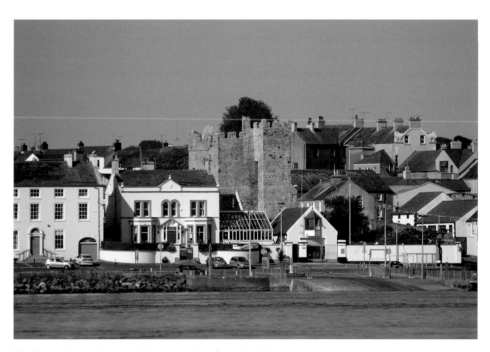

The Savages' tower-house, predecessor to their Portaferry House, braced between the Marine Research Station, a guesthouse, the Tourist Information Centre, the boathouse of the Royal National Lifeboat Institute (RNLI), and the Portaferry Hotel.

Portaferry's marina and strand under Windmill Hill look much their best in the setting sun.

From Ballywhite Bay, north of the National Trust's Ballyhenry Island

For nigh on a thousand years, since the time of the Anglo-Norman conqueror John de Courcy, ferries have braved the waters between the baronies of Ards and Lecale, from Portaferry to Strangford.

A Royal Charter of 1611 granted ferryman's rights – to employ four able boatmen to transport men, horses and oxen – to Peirce Tumalton of Portaferry, a name surviving through the actress daughters of the late actor and playwright Joseph Tomelty and spelt more often as Tumelty. For centuries, dipping lug and foresail was the rig on passenger ferries while a single mast and square sail sufficed for mere animals. Then the Portaferry and Strangford Steamboat Company took the wheel, briefly, in the mid-nineteenth century, its forty-ton paddle steamer *Lady of the Lake* departing every fifteen minutes, thus leaving each port in sequence at half-hourly intervals, much as her diesel-powered car-ferrying sucessors do today, navigating the fierce currents via crab-like routes inexplicable to the landlubber, as four hundred million tons of water rush past, four times in every twenty-four hours, as the tide goes in and the tide goes out.

Blue Peter V, an Atlantic 75, the RNLI's 30-knot Portaferry lifeboat

Right: The Mersey-built MV *Portaferry II*, in service since 2002

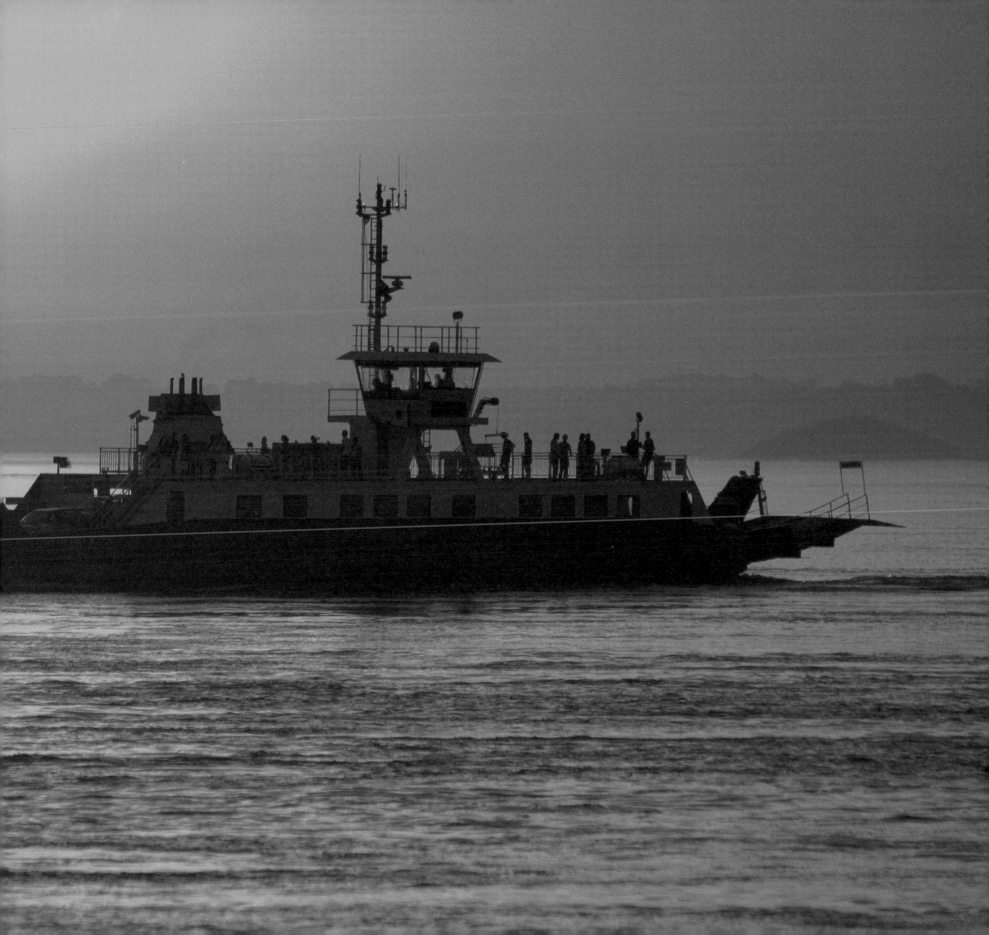

Portaferry marina

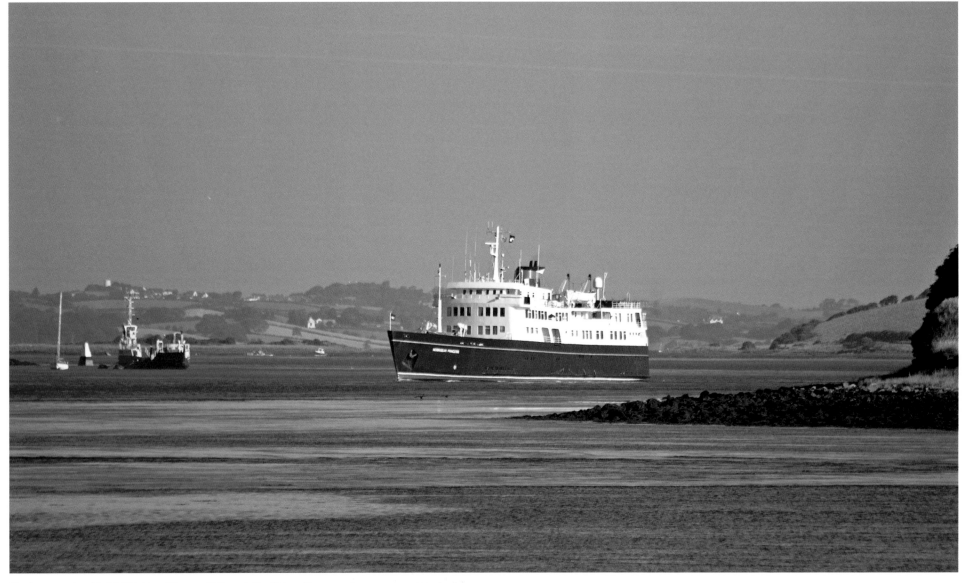

The luxury cruise ship MV *Hebridean Princess*, off Granagh Bay Nature Reserve

Where there are fish, people will catch them. But by the late-eighteenth century the fishing industry, traditionally serviced by clinker-built rowing boats, was in difficulty as the unpredictability of herring shoals drove Portaferry's fishermen outside the Narrows in ill-equipped half-deckers.

By the nineteenth century fishermen were reduced to catching fry and smelt for bait, hand-lining for fish for the table, dredging for oysters, raking for cockles and salting to catch razor-shells. Farming oysters is a mainstay of current practice, alongside potting for common crabs, Norway and native lobsters, and velvet crabs – which are exported as the *étrille* essential for a French *plateau de fruits de mer*, and for a Spaniard's *ración de nécoras*. And when summer mackerel are in, a boy and his rod are rarely parted.

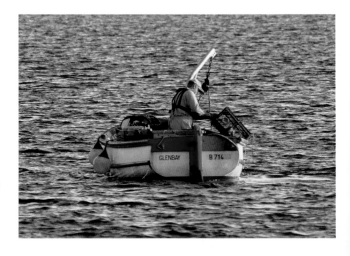

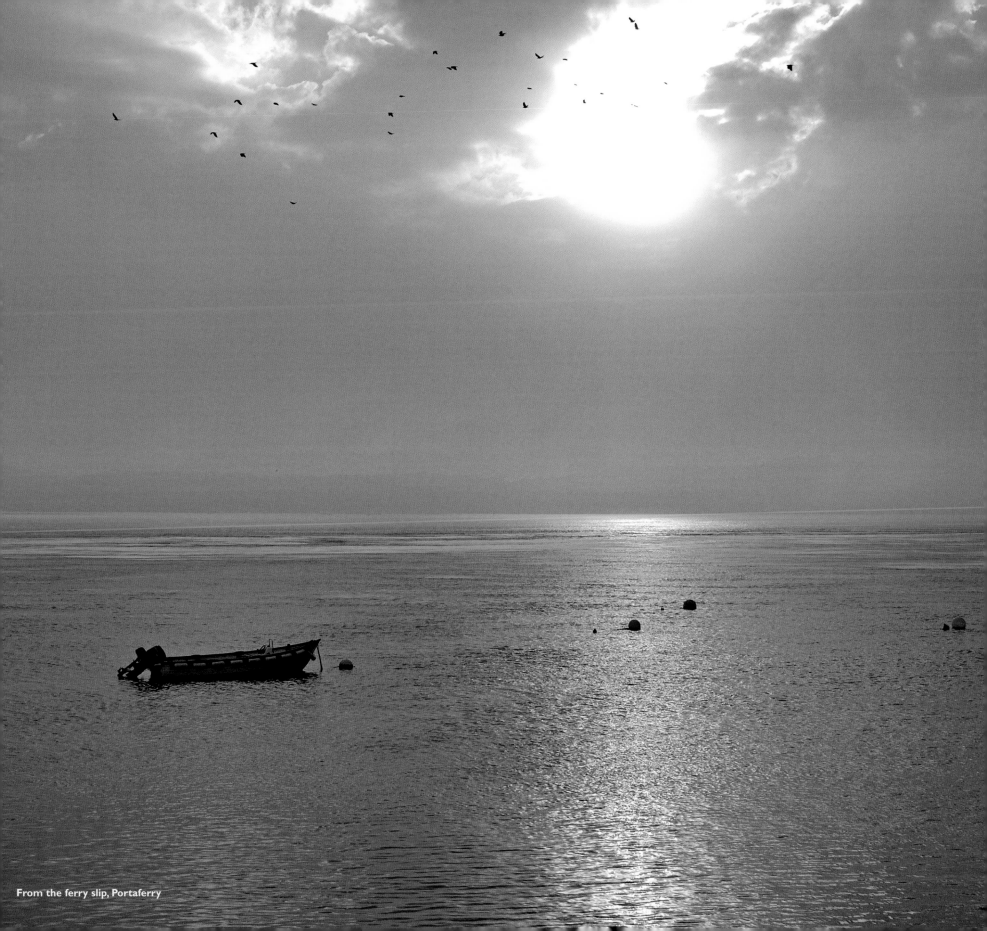

From the ferry slip, Portaferry

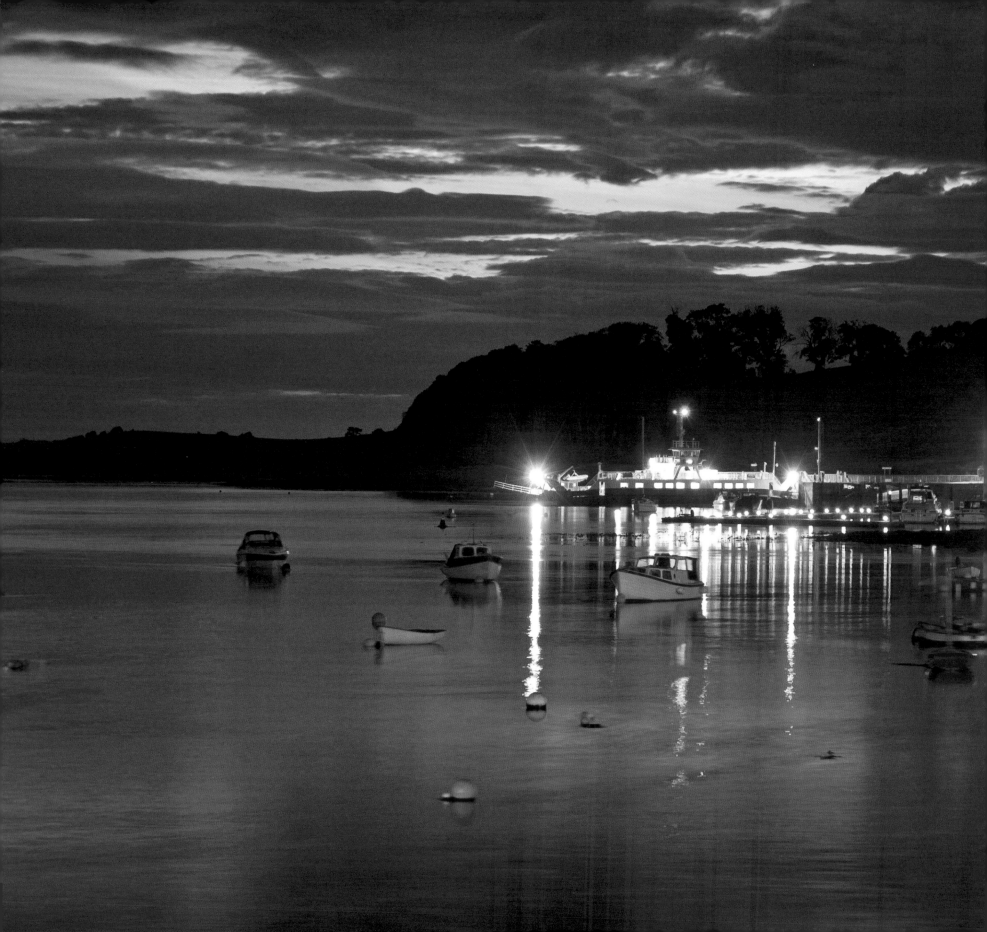

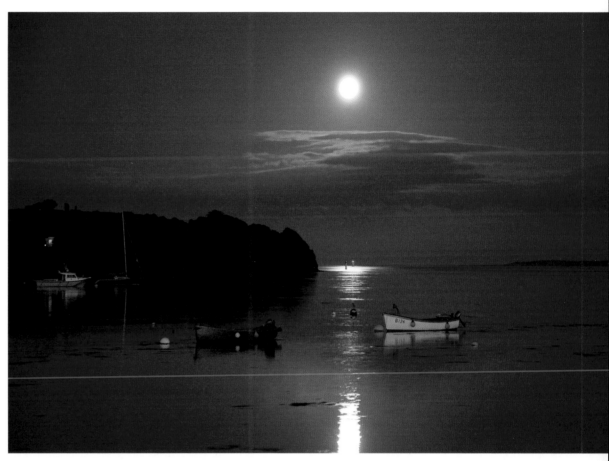

Moonlight over the Narrows, south of Portaferry

South of Portaferry lie the open seas. But travel north, by the narrow coast road, and follow the ship's anchor curve of Ballyhenry Bay, with Selk Rock to port, and Ballywhite's slipway, whalebone arch and Italianate House – complete with ballroom, conservatory, stable and wooden nectarine house – to starboard. North, at the end of a lane, stands one-and-a-half storey Marlfield House, which dates from the 1830s. Next ahead lie Priest Town, Ringburr Point, Old Mans Head and the Dorn. Then in the townland of Ballywallon, facing Strife Rock, Sleetch Rock and Codlock to the north and Deer Park to the east, lies Bishops Mill.

The old mill – a casualty when forces of the Crown suppressed the summer soldiers of the United Irishmen in 1798 – survives, complete with undershot wheel and many working timbers intact.

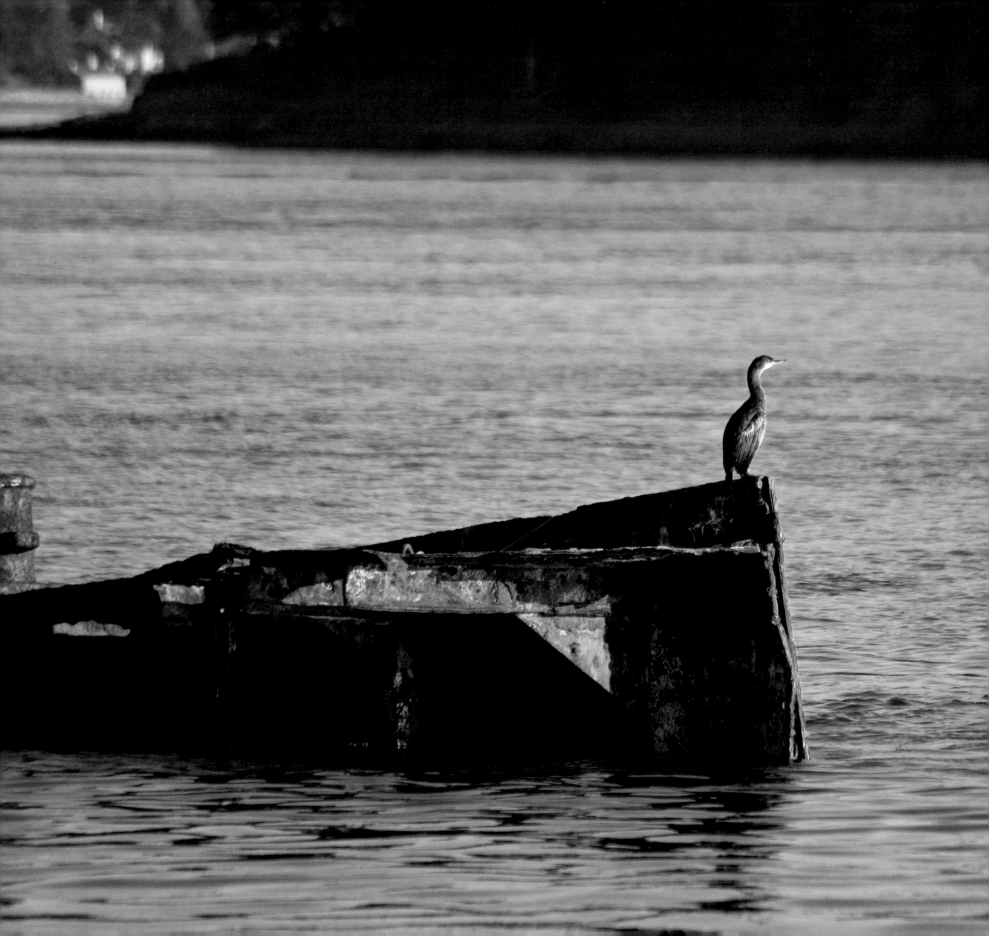

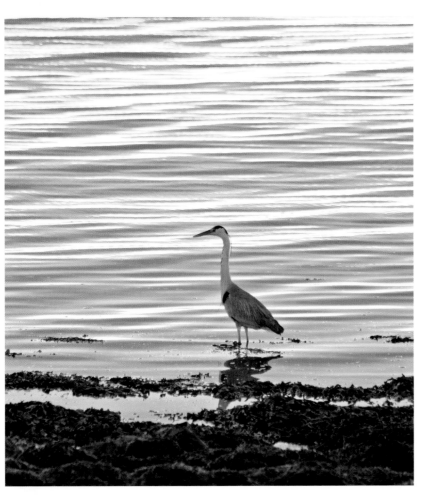

The shag and the heron are two of the lough's icons. The former balances effortlessly on boats' gunnels, wrecks' rusting plates, or sailors' rocking and bobbing buoys before scooting across the water to settle and dive. The latter cries its rasping call as it rises from hillside heronries, flapping, ungainly as a novice even in its maturity, to settle at its favourite fishing station.

When the shag, or its larger cousin the cormorant, dives, it disappears for an alarming length of time only to resurface many metres away, juggling with its prey – a small mackerel, mullet, saithe or pollock – until it can be swallowed, head first, whole and often alive.

The heron, by contrast, is one of nature's sentinels. It stands in inches of water, still as a statue at late dawn or early dusk, often perfectly reflected in calm water, poised to stab – as schoolboys used to do with a billiard cue tipped with a straightened fish-hook – the little dab, flounder, plaice, migrating elver or the slight silvery sand eel. Even a blenny or a butterfish would do.

For the sea angler, surfeited with undiscriminating mackerel, fatigued by the dead weight of coalfish, frustrated by the fickleness of grey mullet, too impatient for the wary seatrout, even a male cuckoo wrasse would suffice. After all, this wrasse (*Labrus mixtus*) – which grazes the rusted hulks of half-drowned wrecks such as the *Empire Tana* (far left), towed here for scrap from Normandy's Second World War beaches – has a colouring of orange and blue which echoes that of holy statues of Mary, the origin of its Irish name *ballach Muire*.

Grey heron, *Ardea cinerea* (Ir. *corr ghlas*)

Left: The unmistakable shelduck, *Tadorna tadorna* (Ir. *seil-lacha*), which breeds in estuaries, and nests in rabbit burrows

Far left: Juvenile shag, *Phalacrocorax aristotelis* (Ir. *seaga*), on the wreck of the *Empire Tana*

33

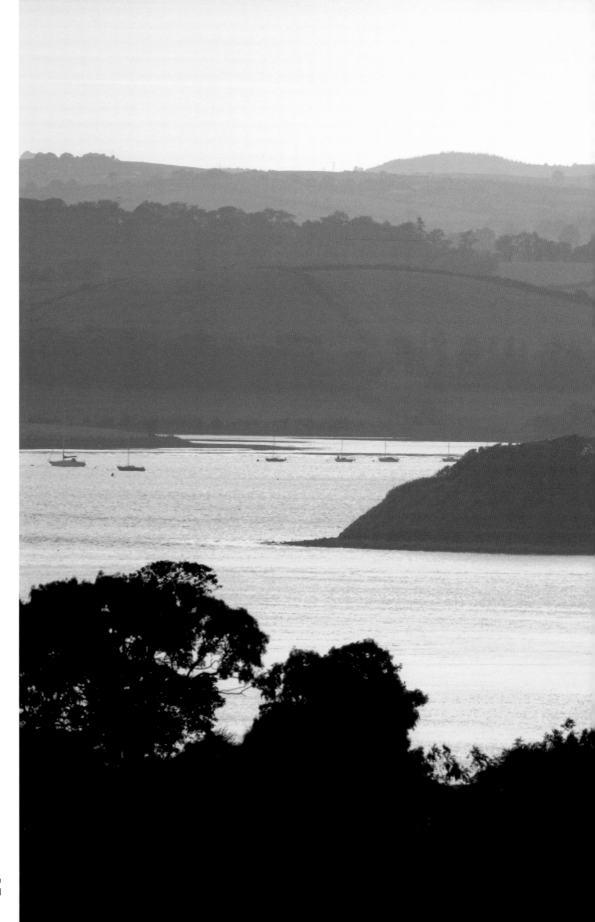

From Marlfield, looking west to Dunnyneill Island, with
Island Taggart and the East Down Yacht Club beyond

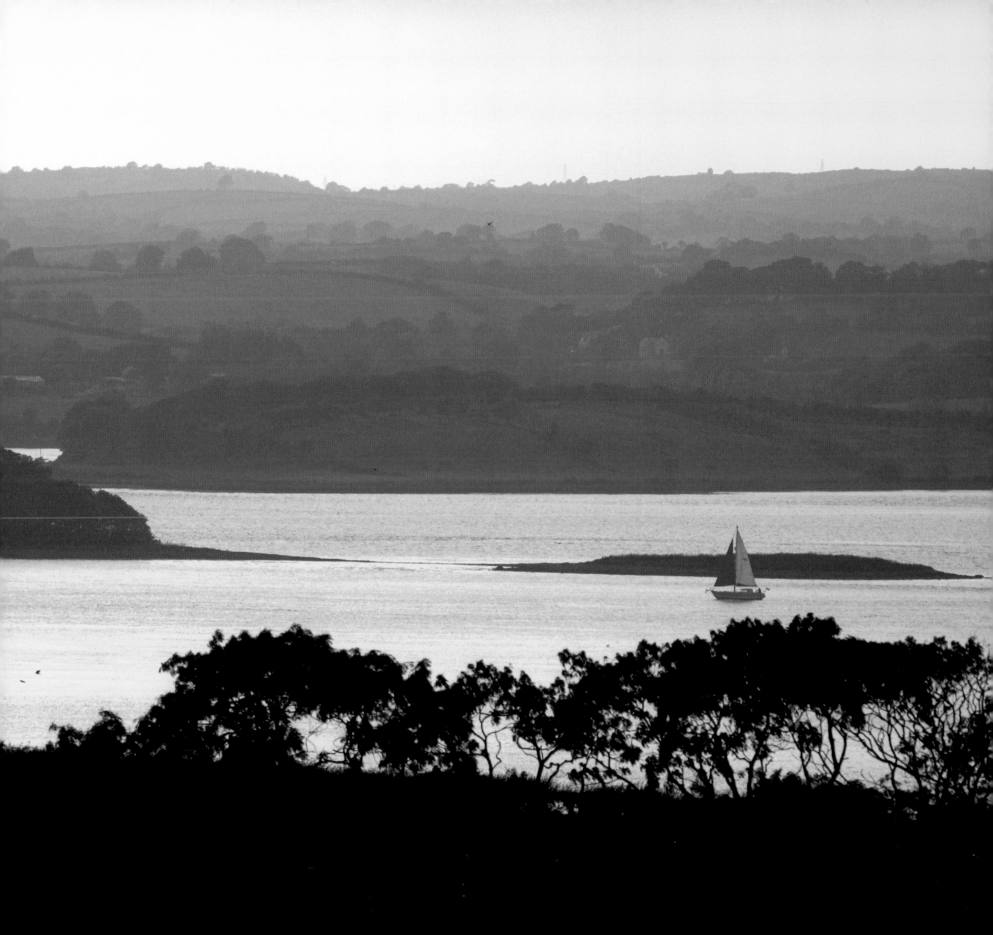

Bishops Mill to Greyabbey

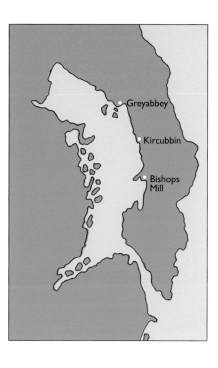

Salt, one of life's essentials, is a hard taskmaster: not just for the desert Tuareg and camels of north Africa's Maghreb, but also for plants inhabiting the permanently damp and muddy marshes of Strangford Lough's shores. Some which do so share characteristics with the plants of the tropical desert, for they have all developed mechanisms which permit them to retain freshwater inside their cells.

There is a fascinating number of saltmarsh plants, as likely as not to be covered twice a day by the incoming tide, which have juicy, sap-retaining leaves, while, in some, dedicated glands expel excess salt. In sheltered bays and inlets, where the rise and fall of the tide is gentler than on rocky precipitous coasts, waterborne sediment has time to accumulate, creating land where there was none before. But even then, an invading plant faces a struggle as it strives to establish roots in the almost oxygen-free mud, whilst its leaves spend one half of the day under turbid water which lets in little sunlight, and the other half exposed to wind and sun.

Glassworts are amongst the heroes in this struggle. Their succulent leaves cloak inconspicuous flowers and their seeds establish further roots even when the plant dies. Inshore of the glassworts, succulent blue-green seablites bind the sediment and sea asters flaunt their purple heads.

Beyond the sea lavender and glasswort around Ballywallon Island, near Bishops Mill, are the vast and precious beds of eel-grass that provide nourishing and essential food for the overwintering pale-bellied geese – the ornithological stars of Strangford Lough – from their arrival in autumn until their return journey to the Arctic in the spring. Wintering too are many of the resident species of duck, diving for fish, crustaceans, molluscs and other invertebrates amongst the aquatic vegetation.

Glasswort or marsh samphire, *Salicornia europea* (Ir. *lus n gloine*), is a plant that colonises soft mud, leading to the foundation of salt marsh.

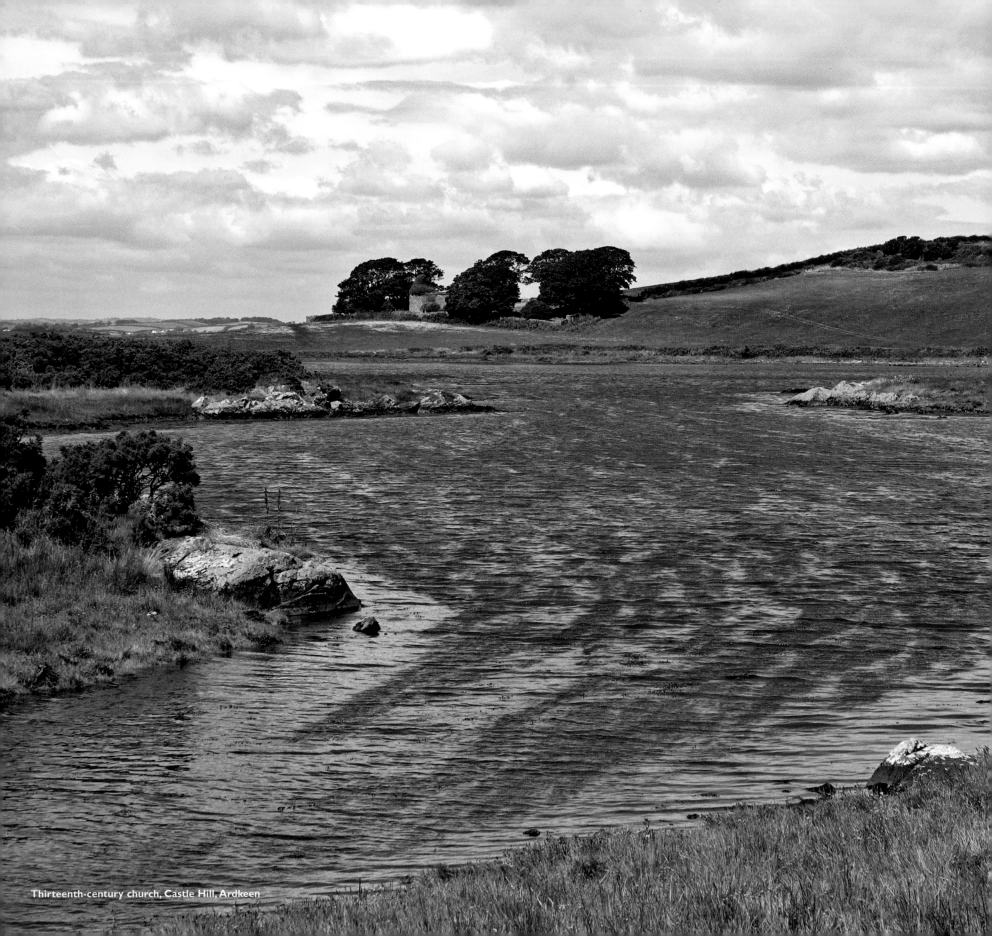

Thirteenth-century church, Castle Hill, Ardkeen

Rain, incoming, in sheets

Common cockle, *Cardium edule* (Ir. *ruacan*)

Lax-flowered sea lavender, *Limonium humile* (Ir. *lus liath na mara*)

Right: Common sea-urchin, *Echinus esulentus* (Ir. *cuán mara*)

Below: Common mussel, *Mytilus edulis* (Ir. *diúilicín musla*) with sea anemone, *Actina equina* (Ir. *budun leice*)

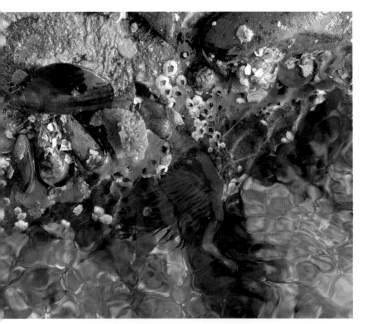

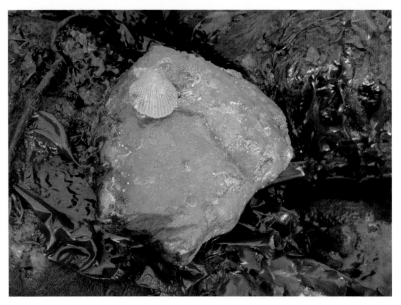

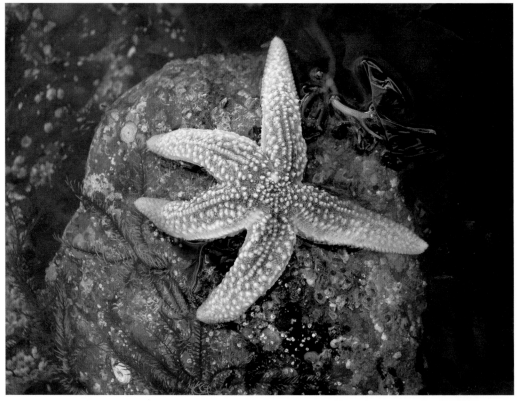

Above: Variegated scallop, *Chlamys varia* (Ir. *cluaisín garbhh*), on a sponge-encrusted stone

Right: Common starfish, *Asteria rubens* (Ir. *crosóg mhara*)

Rosy feather-star, *Antedon bifida* (Ir. *cleiteach mhara*)

Gourmets, who don't visit a seashore without their *coupe-oursin*, a French device fashioned for the purpose, will slice the top off the common sea-urchin, scooping out its orange gonads to eat raw, or in an omelette. There are braver souls who would slice and fry the sea anemone in olive oil with a few shallots.

The red seaweed, dulse, when dried can be a hard chaw but enhances a seafood salad, if finely chopped. The common inshore prawn (the *camarón* or *gamba* of your Spanish holiday), turns a tasty red when boiled but briefly while, treated similarly, the tinier grey shrimp, the French chef's *crevette grise,* turns a scrumptious brown. You can buy delicious common lobsters and Dublin Bay prawns – the ones restaurants serve as *langoustines*, purists call Norway lobsters, scientists know as *Nephrops norvegicus*, and romantics describe as *les demoiselles de Cherbourg* – from the lough's boatmen. You can also buy scallops, which need to be prised open and shucked before you eat the muscle and roe, raw or fried in butter with smoked bacon. Cockles and mussels are steamed in white wine with onion, celery and peppercorn, an alchemy which will also suit the fearsome spoot or razor-shell, humble whelk, modest periwinkle, tiny tellin, wedge-shells of the *Donax* tribe and even the chewy limpet – these last three also well suited to a milk, chive and potato soup.

The most celebrated alchemy of all is reserved for braves who having extracted the hole-boring piddock, boil and chew it of an evening, then expel their truly luminous breath into the night sky.

Bladder-wrack, *Fucus vesiculosus*
(Ir. *feamainn bhoilgíneach*)

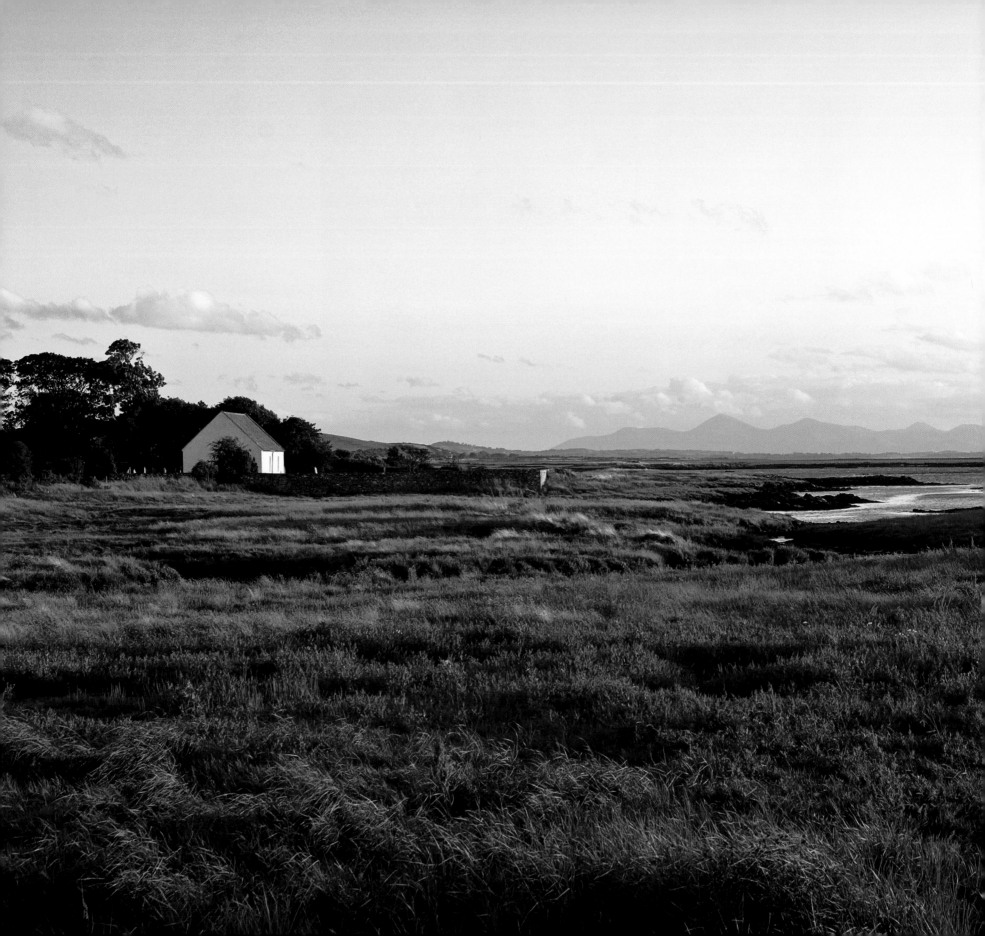

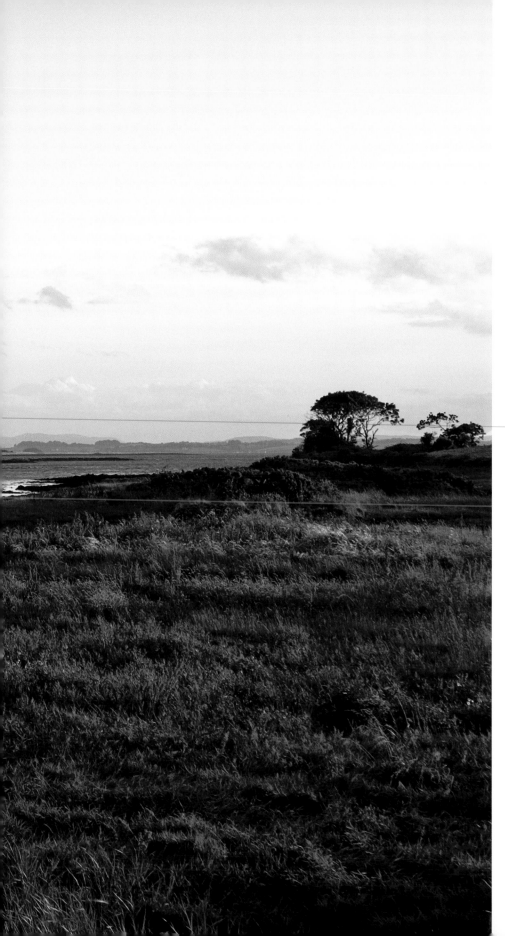

December Bride, Sam Hanna Bell's stark novel of life on the Ards coast, in which the two brothers of the Echlin family share their beds with the same independent-minded woman, was published in 1951. In 1990 it was made into a film directed by Thaddeus O'Sullivan, and the shooting took place as close as could be to where the book was set. St John's Chapel stood for Ravara Meeting House where the elder brother Hamilton, played by Donal McCann, marries Sarah Gomartin, played by Saskia Reeves, while her son, paternity unresolved, looks on.

St John's Chapel was built in 1777 by parish priest Daniel O'Doran with a roof of Tullycavey slates, is sited on a penal mass rock near a more ancient chapel called Moyndele and was paid for by general subscription. Described in 1836, somewhat improbably, as capable of catering for a congregation of 400 souls, it measures roughly 62 by 24 feet. When a new church was erected at nearby Ballycranbeg forty years later, the chapel's status was reduced to that of a mortuary house. A nearby country pub, the Saltwater Brig, an imaginative corruption of Saltwater Bridge, is now almost as famous as the chapel.

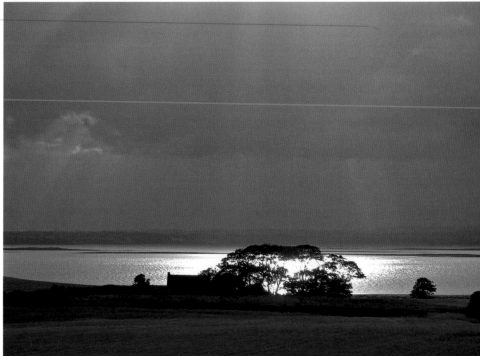

Bloody Burn Bay, Nuns Quarter, north of Kircubbin

St John's Chapel, Saltwater Bridge

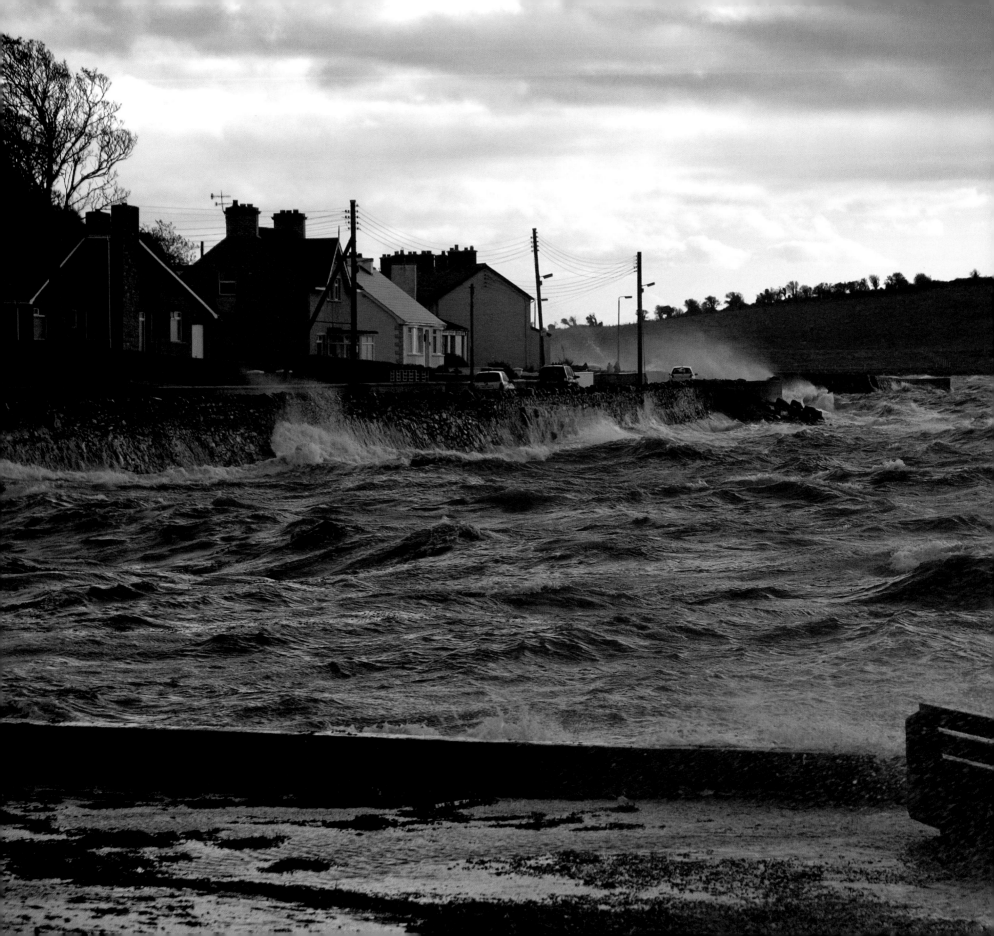

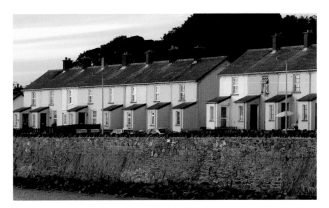

Above and left: Kircubbin

North of Doctors Bay, once a smugglers' haven approached by sea with Slave and Dullisk Rocks to port and Black Neb to starboard, Kircubbin's thousand souls find themselves cast up between Fish and Nuns Quarters, a fitting situation since the settlement is named for a fourteenth-century kirk possibly mistakenly attributed to Saint Ghobáin.

At the quay in the eighteenth and nineteenth centuries, craft discharged whiskey which had been distilled legally at Downpatrick's Steam Street and at Saul, before being shipped from Quoile Quay. There was also a trade in grain, kelp and potatoes to Liverpool, while imports of coal and limestone came back. Flax mills, a market house, monthly fairs and an enterprise in embroidering straw bonnets spoke of mercantile prosperity well into the twentieth century. Berthing with Kircubbin Sailing Club, or breaking their drive down the Ards Peninsula, visitors may note the listed Presbyterian manse and the Church of Ireland's Church of the Holy Trinity with its fine Doric columns on Main Street. Others will seek out Tubber-na-Carraig or Rock Well House, a nineteenth-century hunting lodge which housed Royal Air Force Command during the Second World War. Fishing, which boasted fifteen luggers in the 1880s, is now confined to digging lugworm, raking cockles and picking mussels.

North of Kircubbin, Herring Bay presents, at low tide, an at first mysterious plaything of the lough's pagan gods, a chessboard grid of rocks – the relic of a once grand kelp industry which brought income to the shoreline's tenant farmers in the seventeenth, eighteenth and nineteenth centuries.

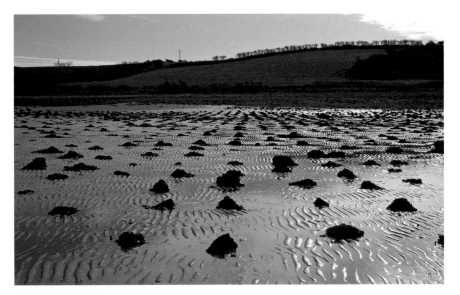

Kelp grid, Herring Bay

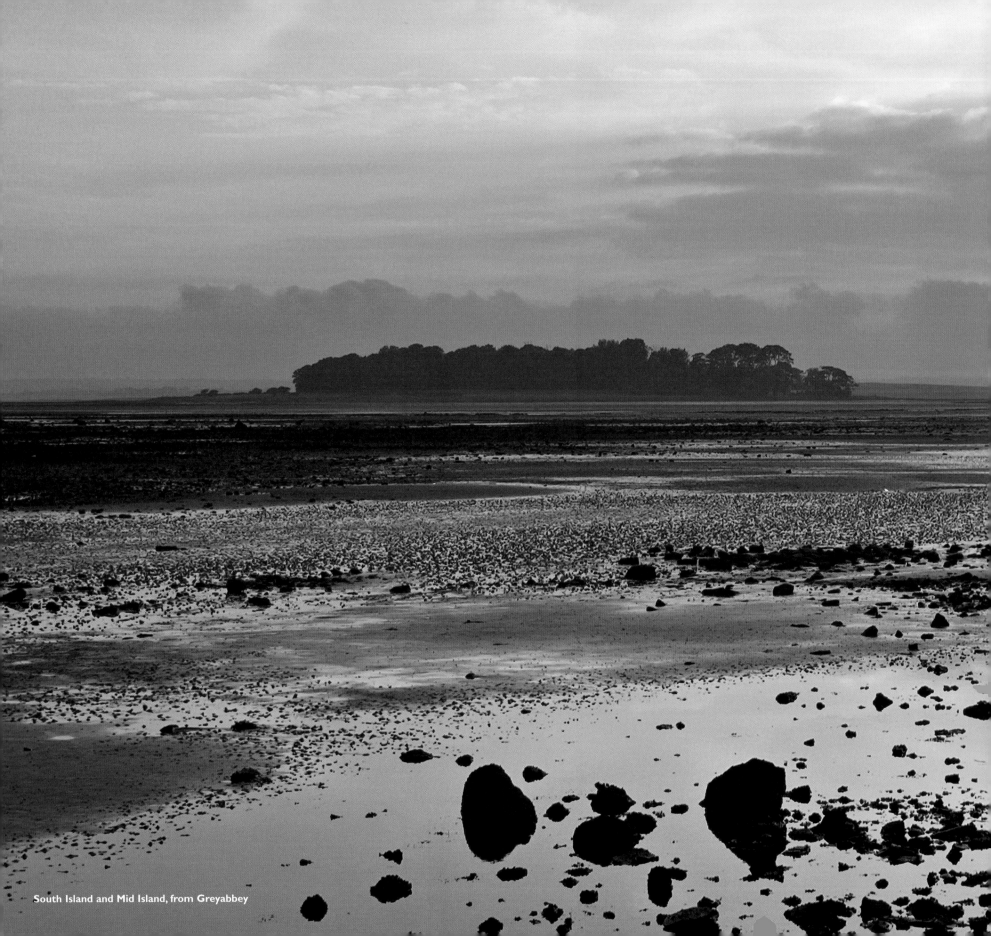

South Island and Mid Island, from Greyabbey

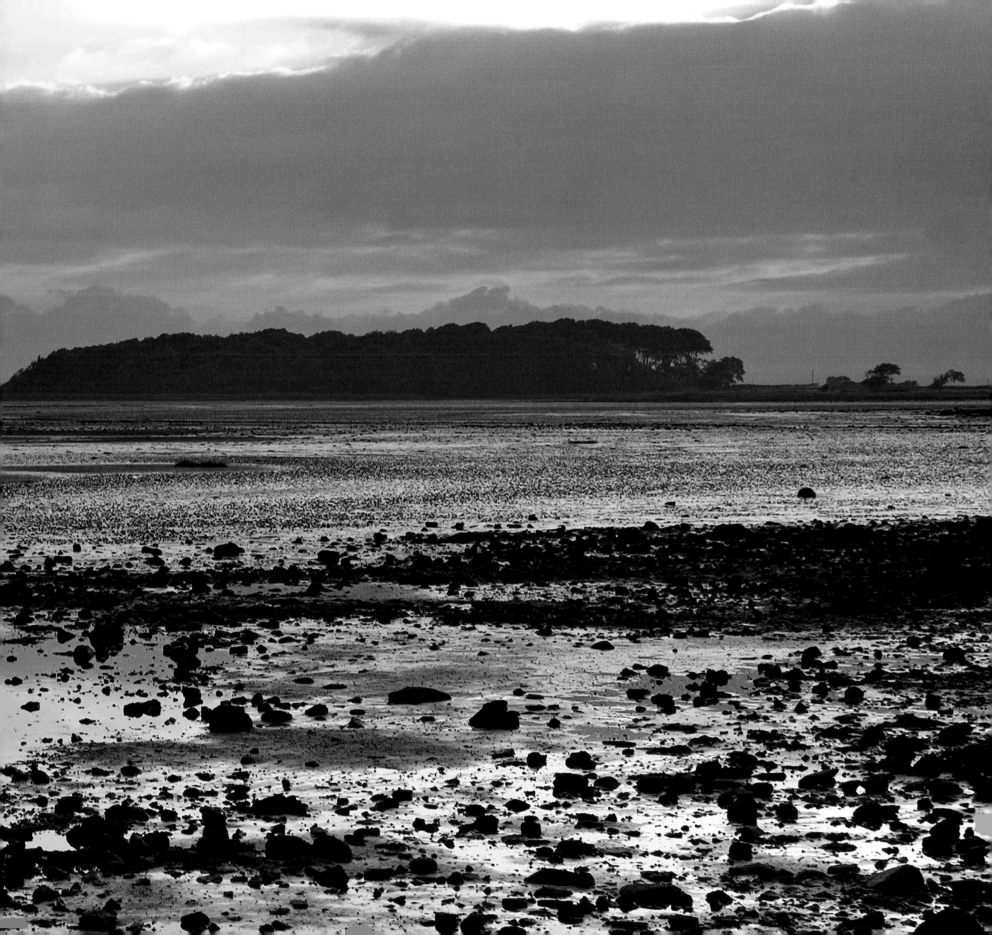

The tides wash in. And with them come fish. So, by the sixth century, the inhabitants of the lough shore had worked out how to trap the fish using the receding tide. They built metre-wide, metre-high walls set in V-, tick- or crescent-formation, fashioned from wood, boulder and pebble, positioned in the channels of bays fed by freshwater streams, whose nutrients attract the catch. The sea would top the walls after four hours of flood, and any gap at the apex was closed when the tide turned on the ebb. So there were two hours for fish to swim in and two more in which to cut off their escape with a portable barrier of woven wattle. Some didn't even use a barrier, just counting on retaining fish behind the wall, to be caught at low tide, whilst others made good the trap.

Though many fish traps had fallen into disuse in the sixteenth century, with their larger stones put to reuse in establishing kelp grids, the outlines of almost two dozen traps survive. Place names such as Fish Quarter at Kircubbin lend a clue, whilst other traps, such as the one at Kilclief, are not hard to spot. But the greatest concentration is around Greyabbey, where the monastery had the hierarchy and manpower to manage the process; plus a duty to a Christian dietary edict forbidding the eating of red meat on the numerous days of fasting.

No scroll survives telling which saint the monks evoked, *sotto voce*, when the lough's summer shoals of grey mullet, the fish the French rightly call *sauters* (jumpers), soared easily over any enveloping restriction.

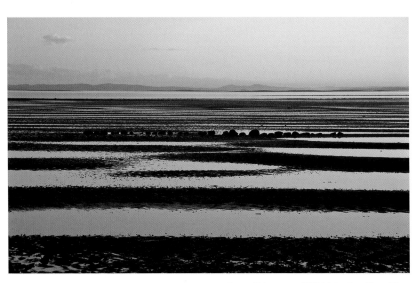

Stone fish traps off Mid Island at Greyabbey

The isthmus between Skillins Point and Mid Island

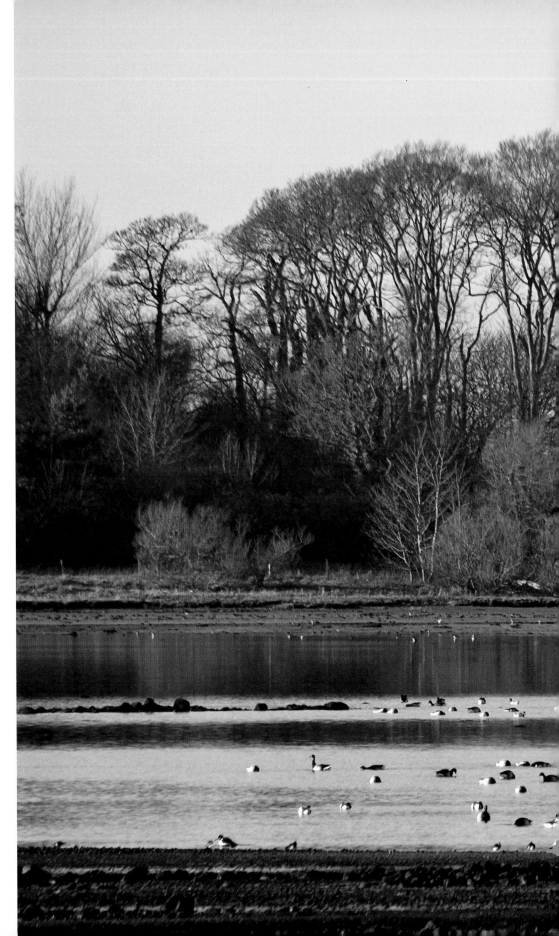

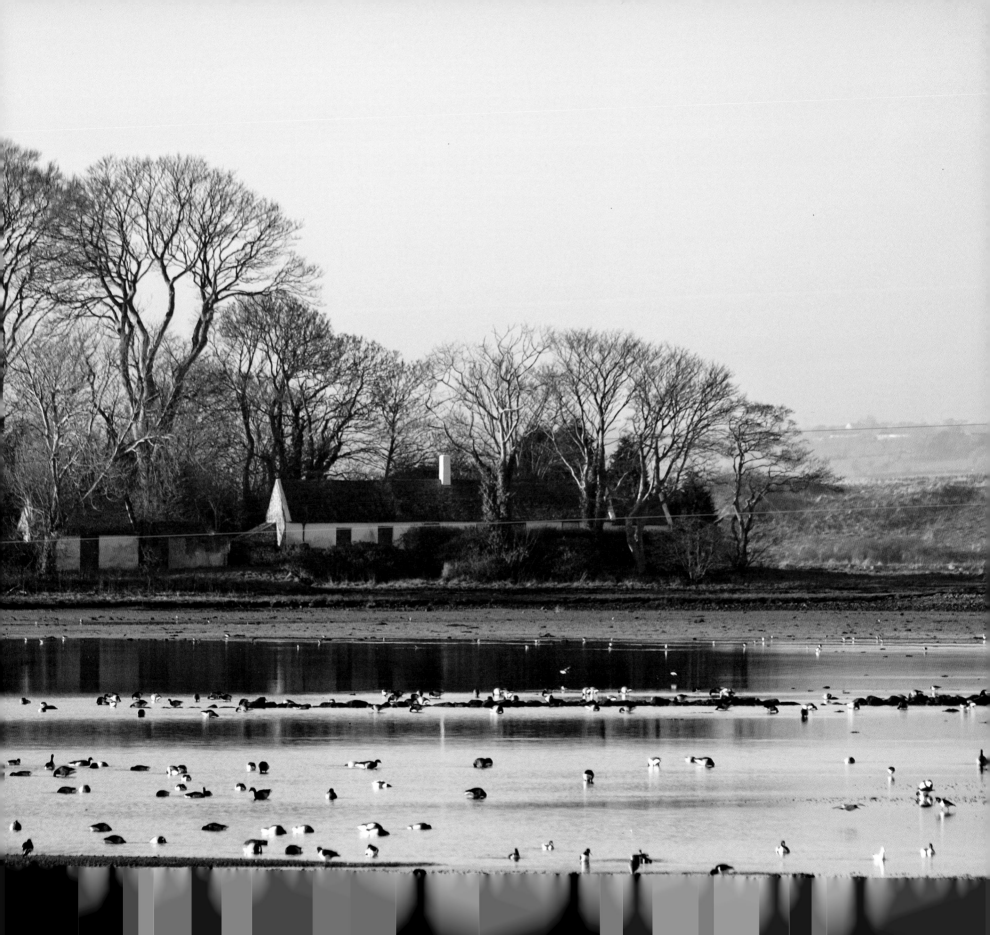

There were kelp grids – chessboards of boulders arranged in sandy bays to encourage seaweed to root on them – all around the lough's shores in the eighteenth and nineteenth centuries. The best records exist for those of the big estates such as Ardkeen, Ardmillan, Ardquin, Castle Ward, Delamont and Ringdufferin, where the traditional rights of tenants were overridden by the landlords' determination to enhance the manner in which they lived by leasing the cutting of kelp for fertiliser.

It was a major industry, the kelp – the word used both for a particular group of seaweeds (*Fucus seratus*, *F. vesiculosus*, *Ascophyllum nodosum*) and also for the slag produced when the kelp had been dried and burnt in loughside stone-lined kilns. This slag was rich in sodium carbonate, an alkali essential as a bleach in the expanding Ulster linen industry and also for the manufacture of glass and soap. Kelp houses, evidence of whose walls survive offshore on islands such as South Island, preserved the soluble soda from the elements.

Kelp has a more basic and ancient history as a fertiliser, spread on the land in what were once – ironically, considering the weight of the wet seaweed – called lazy beds.

At first, intertidal walls alone divided the jealously guarded foreshore, apportioning rights to cut the kelp. But soon, realising that seaweed does not root and grow on bare rock, or on sandy or muddy foreshore, men took to drawing small boulders from their fields and distributing them in grid-like patterns, many of which extended across several hectares in parallel rows roughly a metre apart.

But, as with many technical advances, there were ecological drawbacks. Cutting the seaweed removed the haven where the herring spawned. Burning it produced noxious fumes which added to the herring fry's discomfort. Whatever other factors were involved, by the middle of the eighteenth century, bays such as Ballygarvan's Herring Bay no longer deserved their titles.

The National Trust's Mid Island (far right), linked by an isthmus to Skillins Point, Greyabbey, and by a causeway to South Island (near right), is one of the 'Grey Abbey Islands' designated in the seventeenth century as a port 'with pilotage and other advantages and priveledges to ye same'.

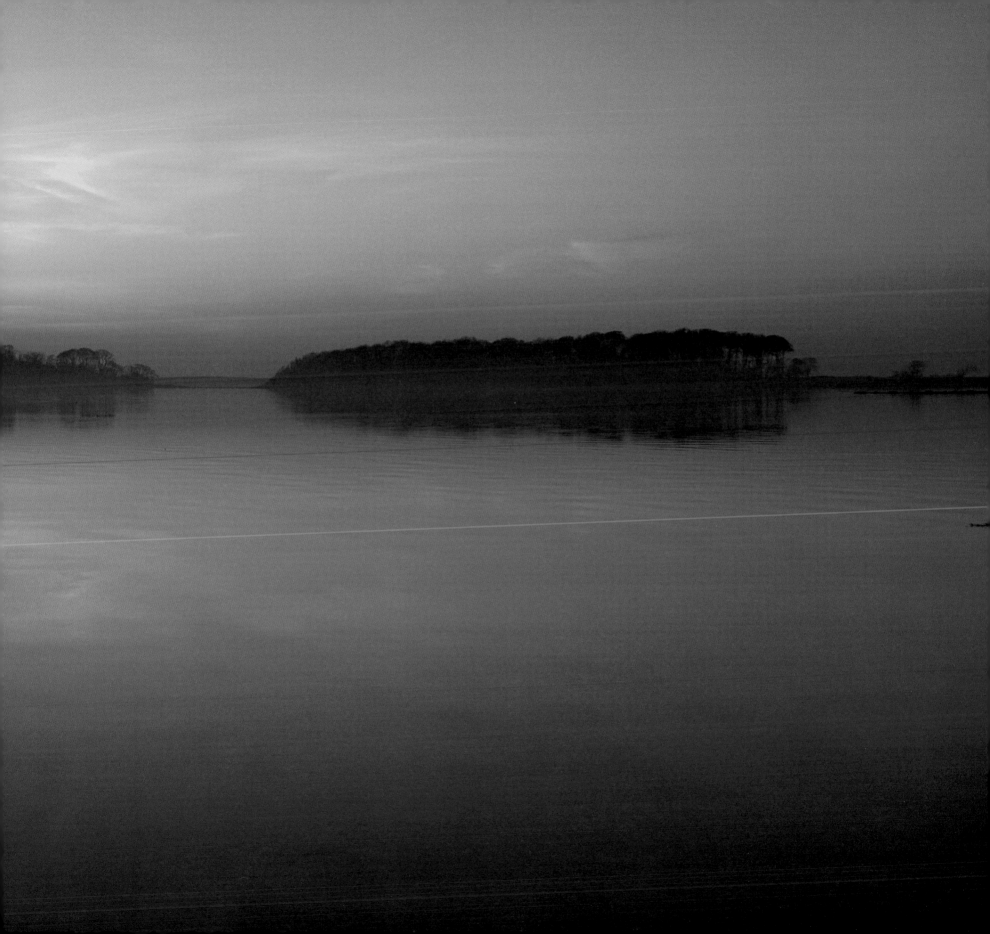

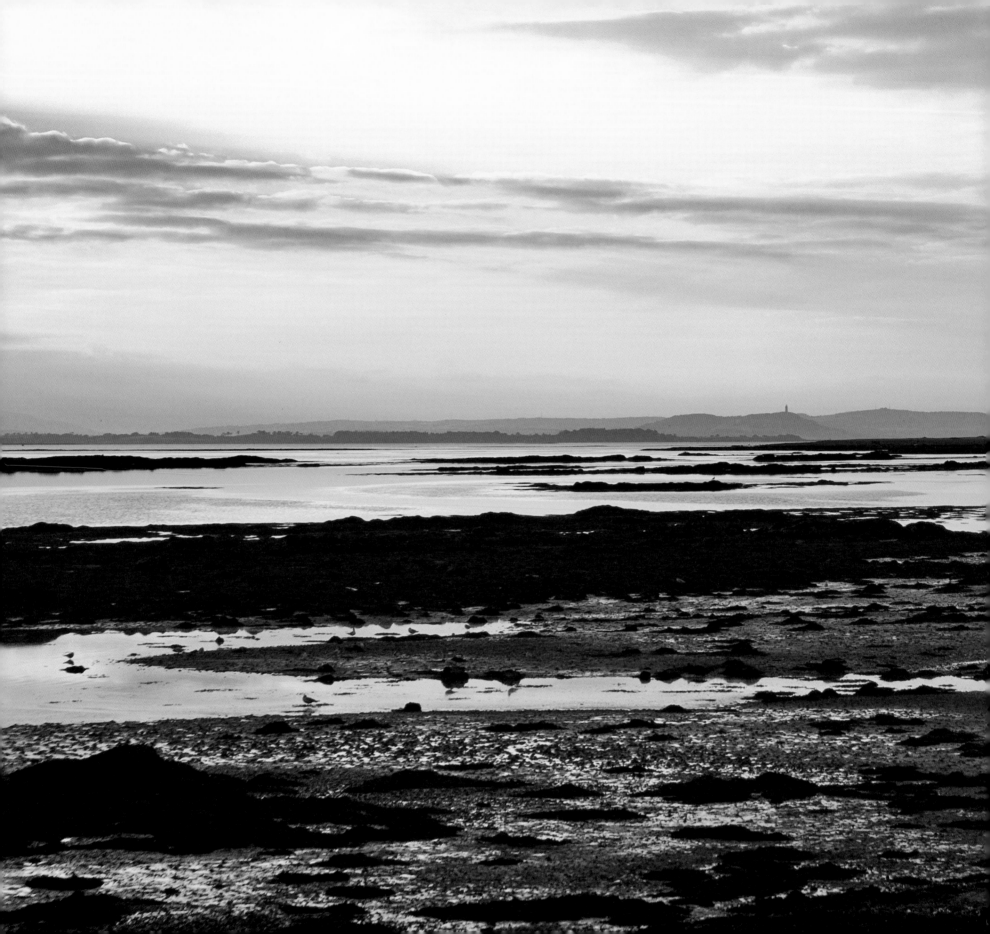

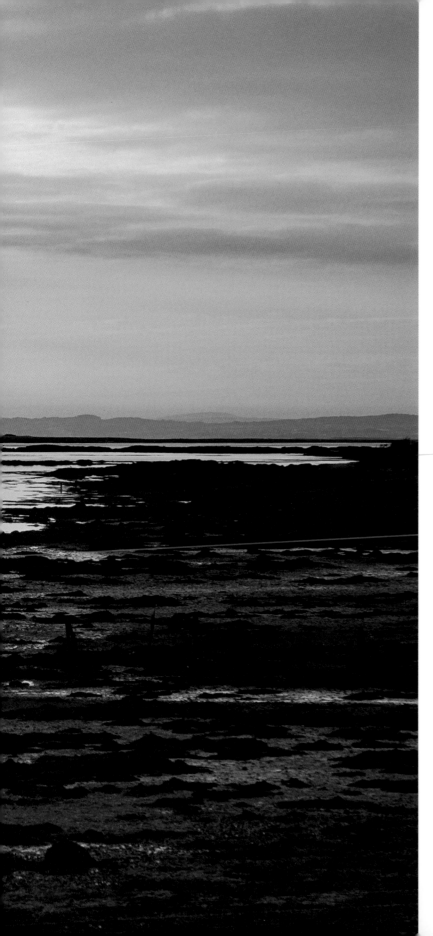

Greyabbey to Newtownards

Robert Lythe's 1568 map of the lough naming it Lough Coyn – an anglicization of the Irish name Loch Cuan, meaning 'Lough of the Harbours' – shows a Domincan friary in Newtownards, naming it 'Neuwe towne abbaye'; the cathedral at 'Donne' (Downpatrick); an 'old abb at Inche' (Inch); an 'Abbaye at Sawlde' (Saul); with parish churches at 'Kilcleffe' (Kilclief) and Ringhaddy. The cartographer Mercator's 1595 update, *Ultoniae Orientalis Pars*, adds churches at 'Bellarastaine' (Ballytrustan), 'Phillips towne' (Ballyphillip), 'Arrawgwhin' (Ardquin), 'Blackstaffe' (Blackstaff), and 'Graye Abbaye' placed where Black Abbey stood and Black Abbey misplaced.

The lough's concentration of shoreline Christian strongholds owes much to St Patrick's introduction of the faith after he landed at Saul, between Downpatrick and Strangford, in the fifth century, and to the struggles between a politically aware Church and those wily politicians – such as John de Courcy and his wife Affreca – who manipulated the religion's earthly strengths, which lay both in the income from its vast estates and in its ability to draw people together, giving the state the opportunity to surreptitiously monitor their political allegiances.

Sixth-century Movilla, of which naught survives, was reached from a now lost inlet running through Newtownards at the head of the lough. Nendrum, whose fascinating ruins survive on Mahee, can be traced to the early seventh century. Downpatrick monastery, then bordered by the River Quoile, received its first abbots in the eighth century, as did nearby Inch.

The reform of the Irish Church in the twelfth century, which saw a regeneration of the early monasteries and priories, lasted until they surrendered to Henry VIII's suppression, many in February 1514, some after a thousand years of power.

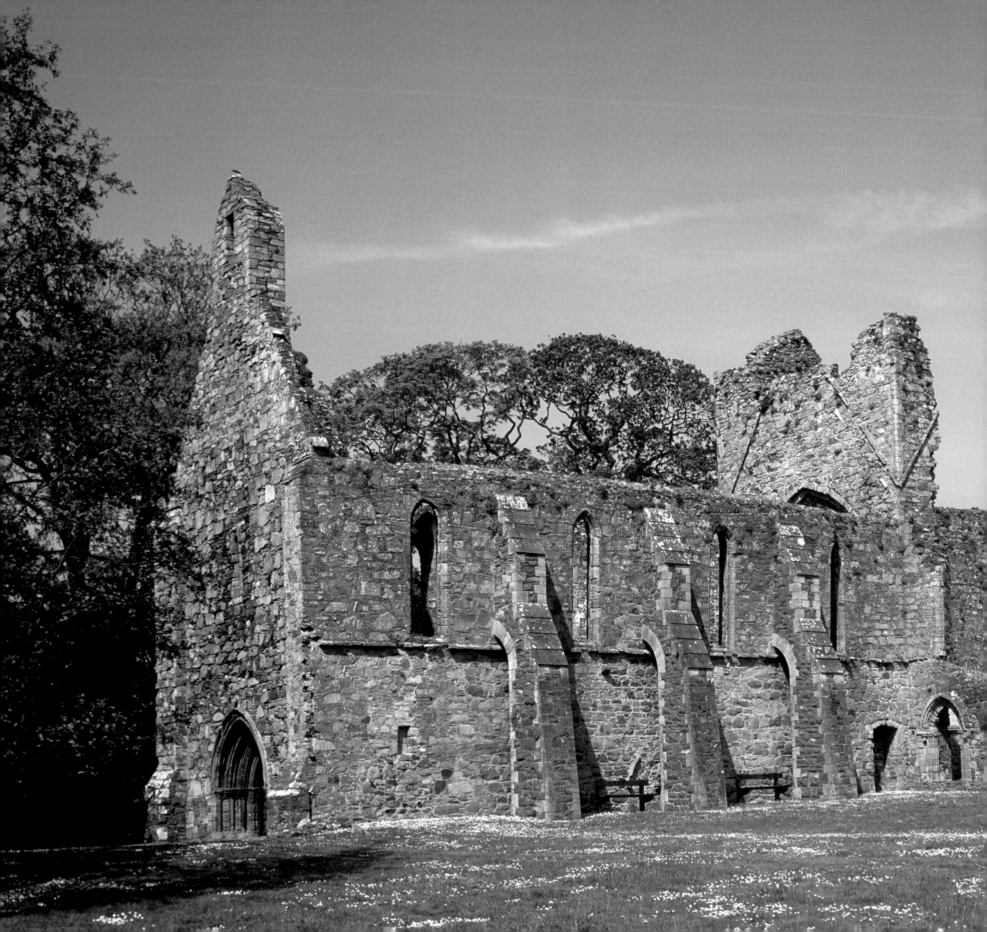

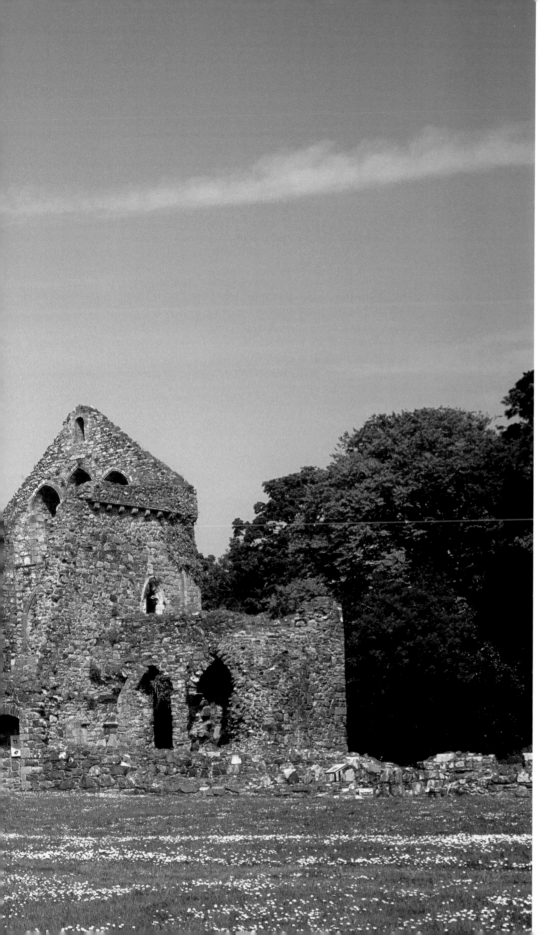

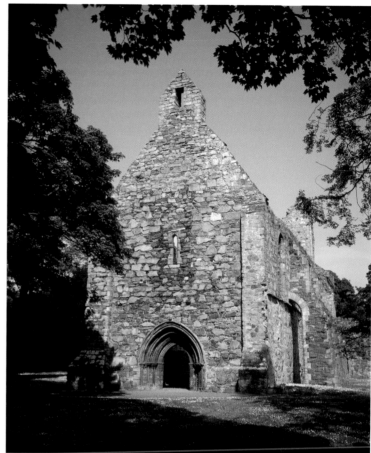

Grey Abbey, Greyabbey

Founded in 1193 by Affreca, daughter of the King of the Isle of Man and the politically astute spouse of the Anglo-Norman coloniser John de Courcy, on a site favoured for Bronze Age burials, Greyabbey's Cistercian Abbey of the Yoke of God was itself an invader, an outpost of the empire of an English religious foundation soon to become reliant on the import of Strangford's loaves and fishes.

Affreca's ghost can be evoked from a tomb effigy on the north wall of the choir, whilst a member of the Montgomery Planter family is recalled in the inscription: 'Sir James by pirates shot and therof dead 12 of March 165$^{1}/_{2}$ by them i' the sea solemnly buried'.

North of Greyabbey, in view even without binoculars, lies the National Trust's Chapel Island. It is 'a wee cuttie', but a slip of a thing, running north–south and approached at low tide by prescient walkers paddling cautiously along a causeway from near Patterson's Hill, secure in the information contained in the tide-table in their pockets. Its attractions include the ruin of an early medieval stone chapel to the south end of the central ridge, an enclosure to the north-west and a three-foot defensive earthwork on the approach.

From the chapel's vantage point, a challenging exercise – compass, map and binoculars to hand – is to distinguish the various Boretree Rocks and Boretree Islands from one another, and from the engagingly titled Whaup Rock, onomatopoeically named by the Ulster Scots Planters because of the sound of beating wings of the lough's most plaintive bird, the curlew. Budding ornithologists may scan this rock, checking if its flocks are indeed curlew or their smaller migrant cousin, the whimbrel whose cry is, if that were possible, even more plangent.

To the east and west of the island lie the boulders of stone fish traps and the more elusive rows of wooden stumps of a brace of other foreshore fish traps dating from around AD 700, plus, confusingly, the trunks of ash and willow trees which were submerged by rising sea levels around 7000 BP. The keen-eyed and persistent may also spot the loose form of a kelp grid between the island and Ballyurnanellen, as well as, on the island itself, the remains of seven kelp kilns at the southern end and a ruined kelp house near the north-eastern tip. Archaeologists located a Mesolithic oyster midden on the island; walkers will keep an eye on the returning tide.

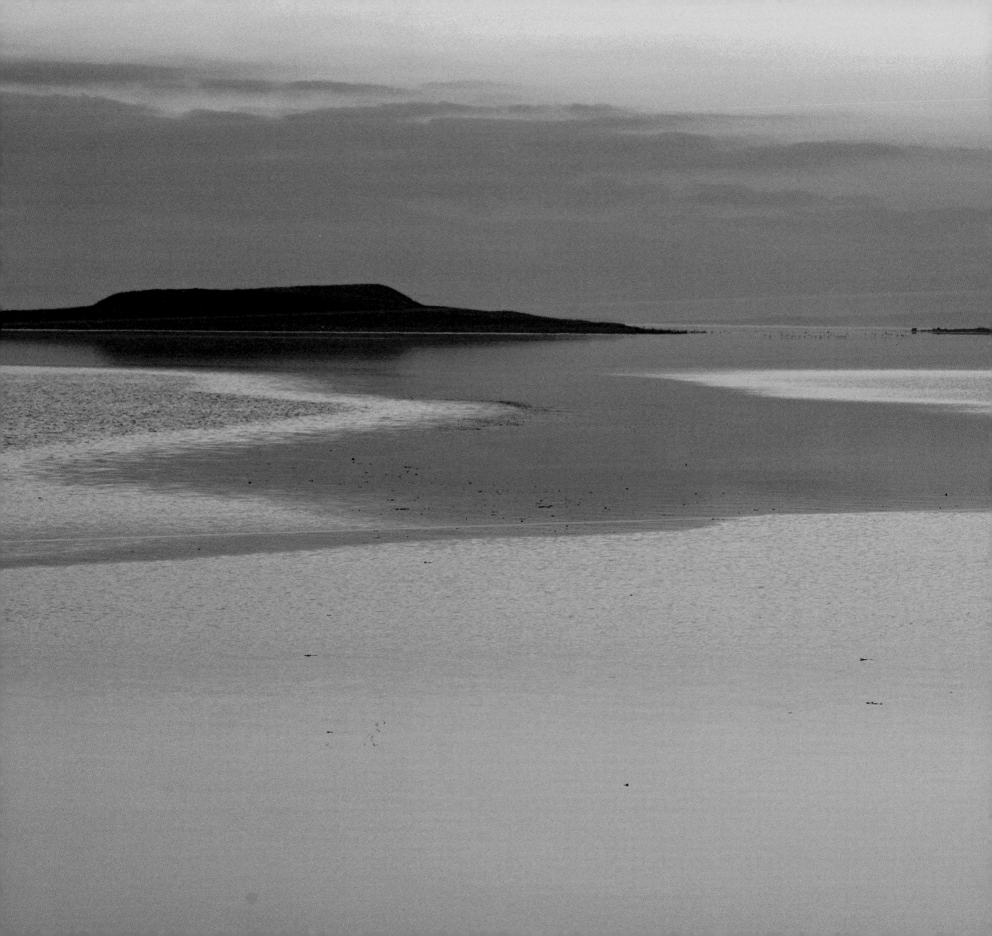

The shores of Strangford Lough are a patchwork of farms owned by the descendants of the staunch Calvinists who followed Hamilton and Montgomery from Scotland when they came near to colonising half the county. But amongst the faithful, the Stewarts of Mount Stewart stand out. Beginning with Alexander, born in 1700, who became the first Marquess of Londonderry – or 'Lond'n'dry', as the squirearchy still pronounce it – each generation married beauty, money and title, cultivating powerful friends, thus building and adding to an exquisite house.

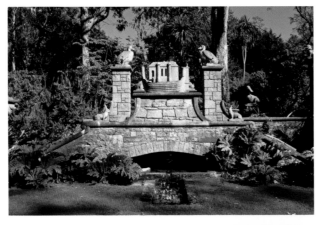

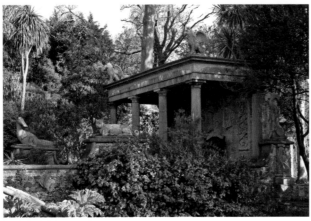

Views of the Dodo Terrace

The delights at Mount Stewart include Ireland's finest equestrian painting, George Stubbs's *Hambletonian*, plus a brace of nude marble seductresses. Yet many visitors are seduced instead by the famous gardens created by Edith, the wife of the seventh Marquess who was a duke's granddaughter, a suffragette, a confidante of Winston Churchill and – as England's premier society hostess – romantically linked to both the Irish revolutionary Michael Collins and Prime Minister Ramsay MacDonald. Charles, the seventh Marquess, cad and rake, fathered children out of wedlock, while biographers present Edith as a flirt who kept her admirers out of the bedchamber when Mount Stewart played host to British and Spanish royals, German ambassadors, W. B. Yeats, Sean O'Casey and his dazzling wife Eileen, plus the society painter Sir John Lavery, whose spouse Hazel was also amongst Collins's paramours.

Mount Stewart from the Italian Garden

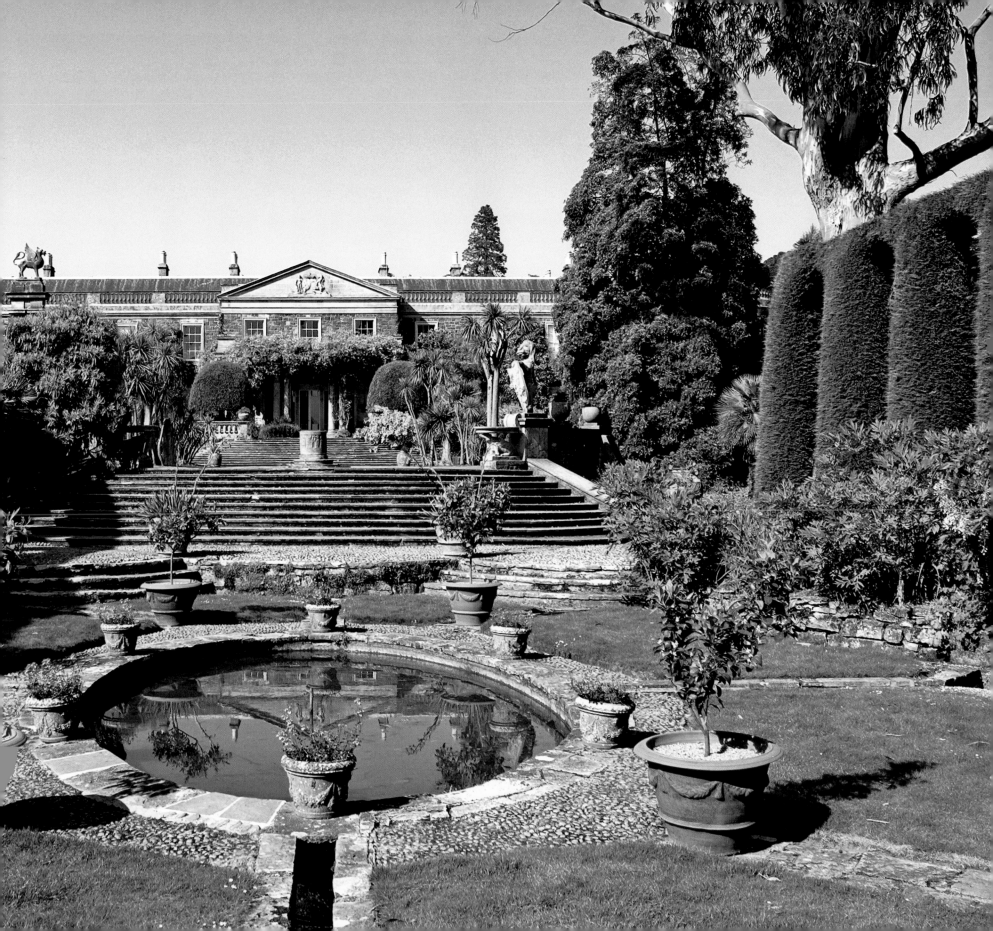

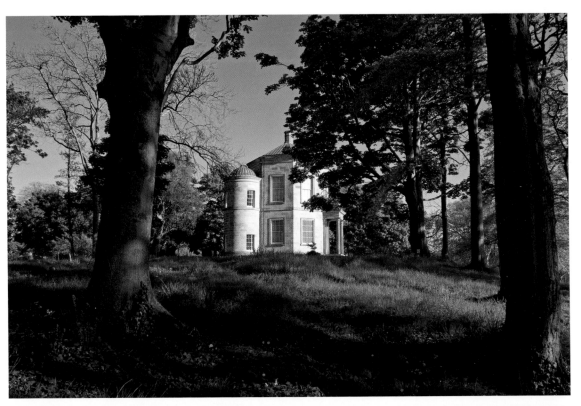

Clockwise from above: The gate into the family's burial ground; Japanese flowering cherry, *Prunus shirotae* (Ir. *crann silíní bláthanna Seapánach*); the Temple of the Winds; the lake walk.

Charles wrote to Edith with the riddle: 'What is the difference between a March hare and a beautiful woman?' The answer, he continued, was 'One is mad as a hatter of course, the other is had as a matter of course.' Edith, for all her biographers' protestations did have a sensuous side, revealing, as hemlines rose, a tattooed snake winding from her left ankle.

Even those unfazed by aristos know of Robert, Lord Castlereagh, the second Marquess who was British Foreign Secretary from 1812–22. At the Congress of Vienna, while the socially inept Robert and his inordinately fat wife Emily sought pan-European governance and the abolition of slavery, his half-brother General Sir Charles chased whores. An unhappy man who cut his own throat in 1822, Robert was identified with both the brutal suppression of the 1798 insurgency and the 1819 Peterloo Massacre, the latter earning him the poet Percy Shelley's lines: 'I met Murder on the way / He had a mask like Castlereagh'.

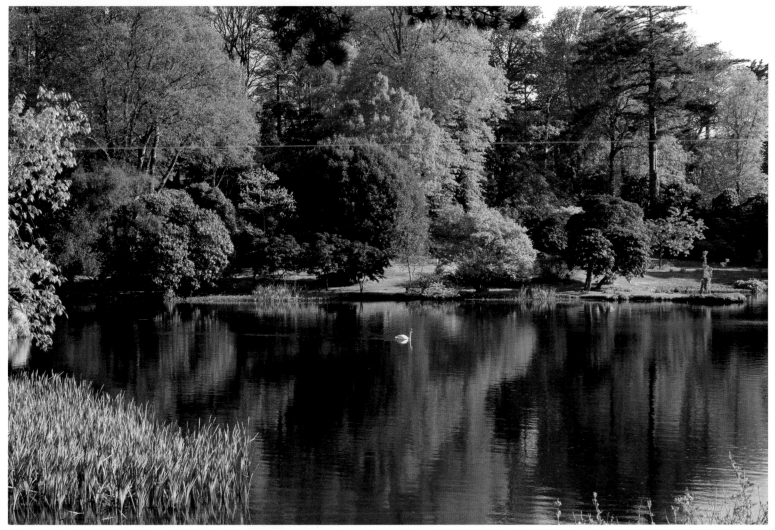

The sub-tropical micro-climate described by Edith, Lady Londonderry in 1956 is reflected in the variety of the ornamental lake's shrubs and trees.

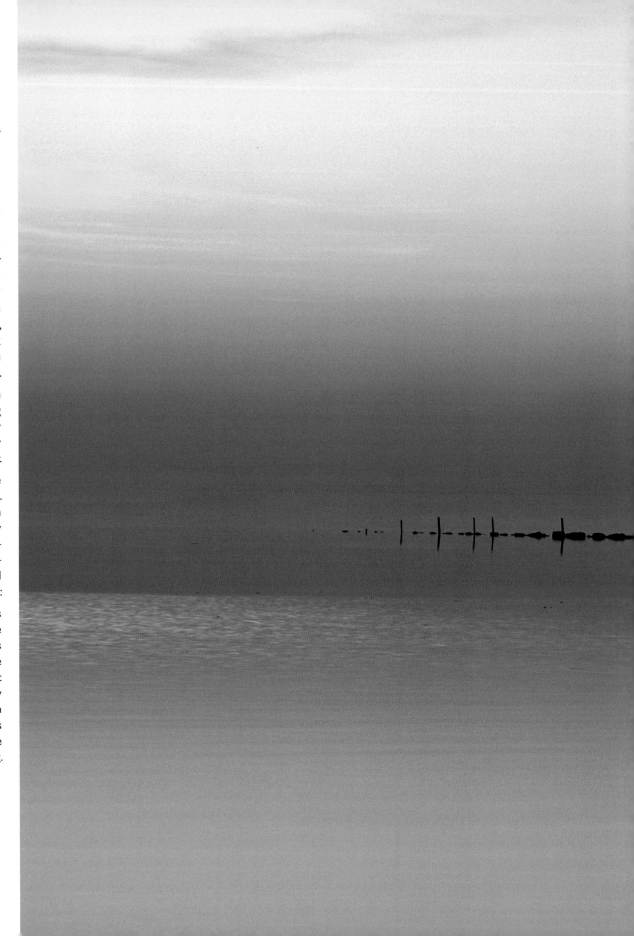

After the dissolution of Grey Abbey in 1537, Elizabeth I granted its lands to Sir Thomas Smith, an English adventurer. His son's arrival prompted the Irish – who reckoned they had better claim to it – to burn it down. Later those enterprising seventeenth-century Scots adventurers, the Hamiltons and the Montgomerys, whose descendants survive most comfortably in Killyleagh Castle and Greyabbey's Rosemount, respectively, repaired the roof, creating a parish church which remained in use until 1778. Its successor stands nearby.

Ballybrian House, on the edge of the Montgomerys' Rosemount estate in Greyabbey, looks south to a windmill stump and then, beyond, to bays, slipways and views west to Janes Rock, the Ragheries, Selk Rock, Downey's Pladdy and Downey's Rock and, on the far shore, to Mahee Island and Nendrum, one of the most magnificent monastic sites in Ireland.

Many a loughside farmer-fisherman had a natural landing place on shingle or sand. If not, a clearway was created by dragging stones and boulders away at low tide. The more energetic or more ambitious had his tenants create a rough stone or wood jetty, quay or pier.

East, over Hawks Hill, stood Black Abbey, founded by de Courcy in 1180 and colonised by Benedictines from Somerset. Constituted a cell of the Priory of St Mary of Lonely in Normandy by another Anglo-Norman, Hugh de Lacy, the priory was dissolved in the mid-sixteenth century, with the buildings – of which no trace survives bar a coffin lid in Grey Abbey – passing eventually to the Montgomerys. A plaque in the west wall of Inishargy's Church of Ireland at Balliggan reads:

This brass commemorates the Priory of Saint Andrew of the Ards (commonly called the Black Abbey) founded circa 1200 AD for the brethren of the Order of St Benedict to which this church was appropriate. The Priory was dissolved after the Order issued in the 33rd year of the reign of King Henry VIII and this church was rebuilt in the year 1704 AD. We laud and bless Thy Holy Name for all Thy faithful servants who through the centuries have served Thy Church in this place. We pray Thee help Thy servants whom Thou has redeemed with Thy Most Precious Blood make them to be numbered with Thy Saints in Glory Everlasting.

The Sea Plantation, Mount Stewart

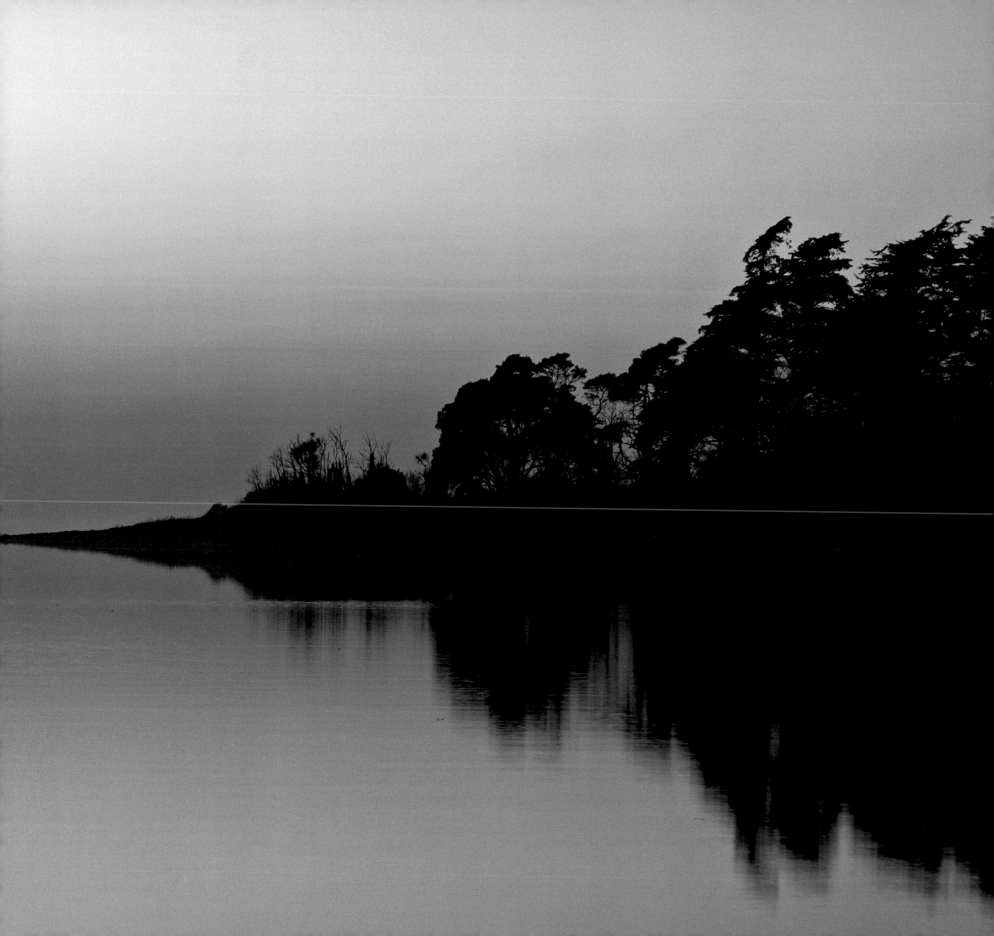

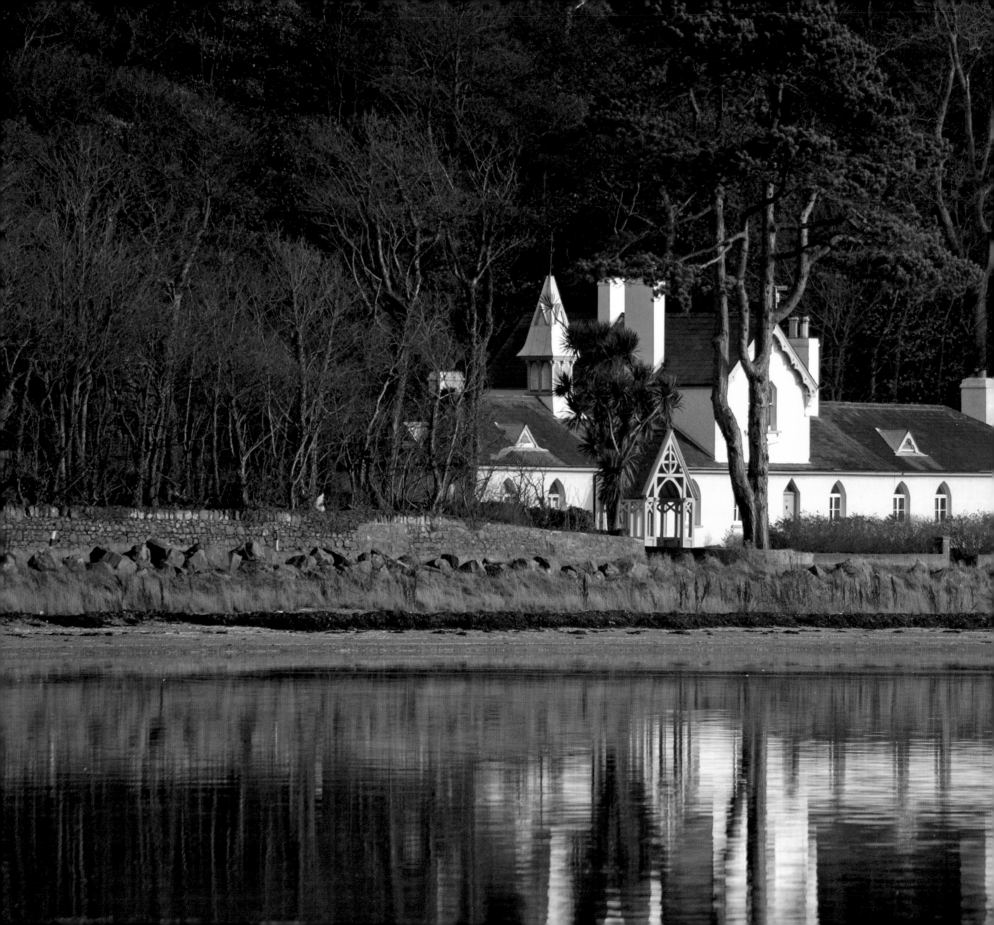

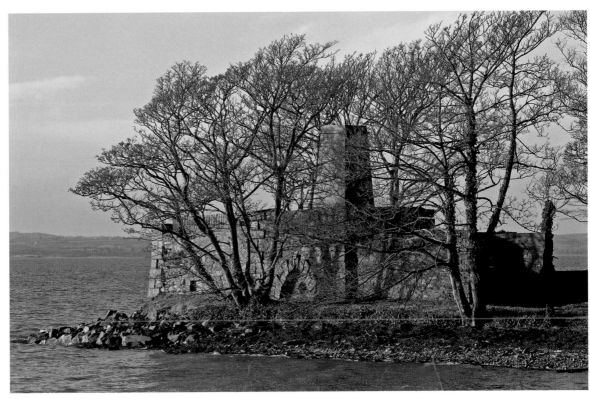

The Gasworks, Mount Stewart

Landowners, titled and otherwise, took deliveries of coal by boat to their own piers. The coal fuelled the kilns which transmuted kelp into soda, and helped to heat the draughty Big Houses by fuelling the coal-fired gasworks.

Just as Chairman Mao thought it too soon to judge the French Revolution, so contemporary historians weigh up the heritage, positive and negative, of the demesnes. Their almshouses, famine-relief walls and schools, which provided education regardless of religion, are placed on the 'good' pan of the scales, as is – in the eyes of the conservative commentator – a dowager's smile.

The Old Schoolhouse, Mount Stewart

A real wild goose chase is best pursued on the island of Ireland in and around the two and a half thousand acres of mudflats exposed twice every twenty-four hours by Strangford Lough's tides. For here you'll see, when you go down to the winter flats, a fair proportion of the world's population of thirty thousand pale-bellied brent geese. Its rarer brother in feathers, being darker, is the dark-bellied brent goose, or *gé dubh* (black goose) in Irish.

The pale-bellied goose's head is as black as its neck is short. Birders will tell you that it's little bigger than a mallard, measuring approximately 60cm (2ft) in length. Up to twenty-six thousand of them land on the lough in August to graze, having flown from the eastern Canadian high Arctic where pairs have bred the three or four chicks which followed them south. The much smaller pink and grey wigeon, a bird delightfully cited as *Anas penelope* by ornithologists, *lacha rua* in Irish, compete for the eel-grass around the lough.

Noisy and sociable, the brent geese go 'rroonk', while those prim black-and-white Victorian spinsters, the barnacle geese, chatter 'hugug hugug'. The heavyweight contender in the goose stakes is the greylag, once so much cosseted and favoured by the owners of large demesnes – who encouraged it both for its flavour and for its habit of honking noisily at poachers – that it has become feral, neglecting to return to Iceland to breed. Feeding on drumlin grasslands, it is easily recognised by its hefty orange bill, its sturdy pink legs and its characteristic cackling 'aahng-uung-ung'. The Canada goose, with its signature white bow tie, 'ah-honks', the second note higher, asking who knows what.

Windsurfer and kitesurfer

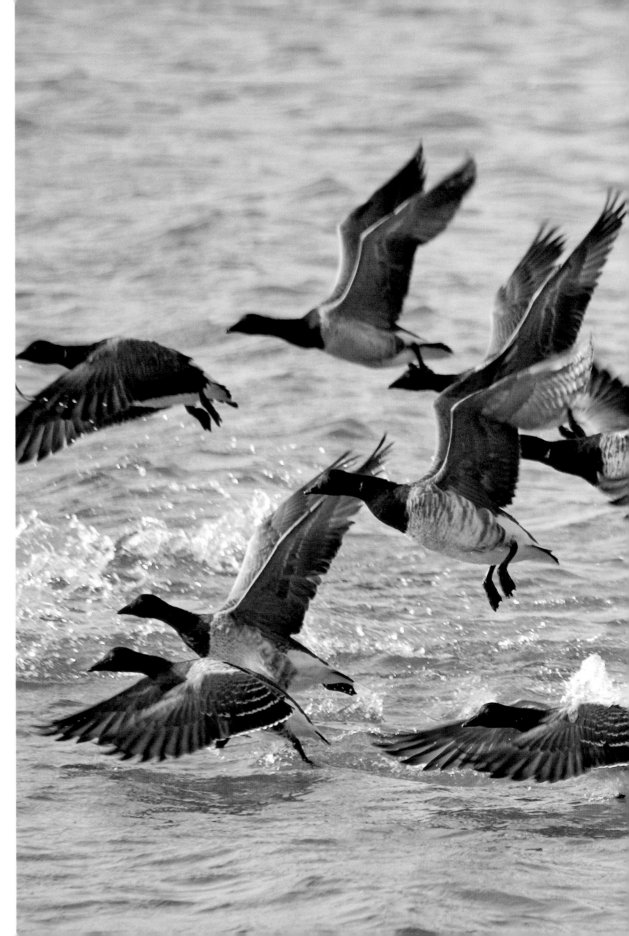

Pale-bellied brent geese, *Branta bernicla hrota* (Ir. *cadhan*)

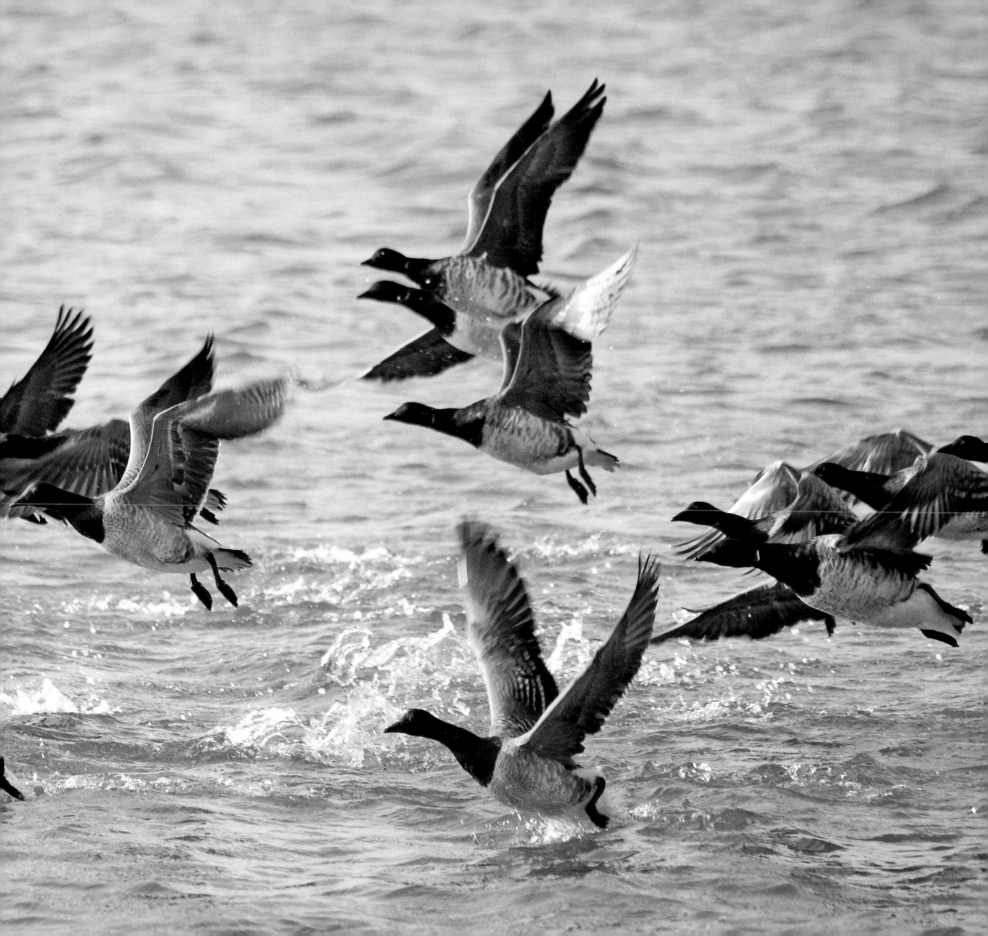

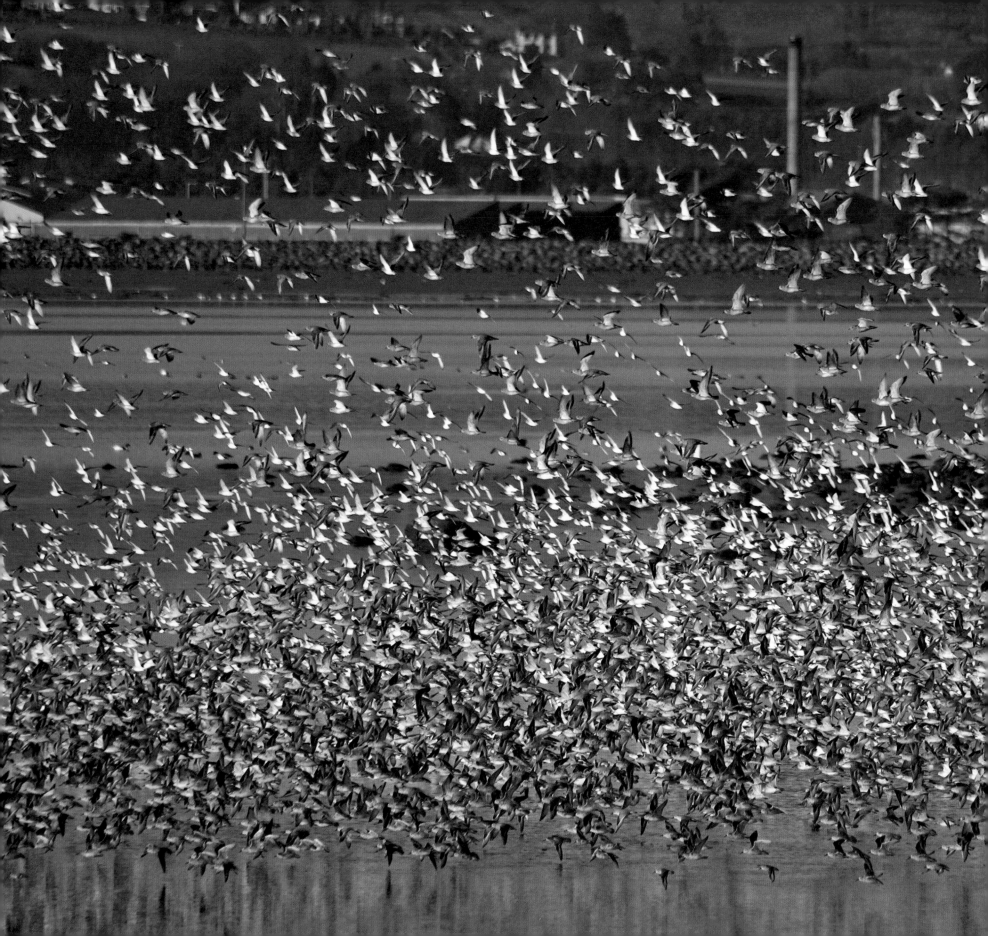

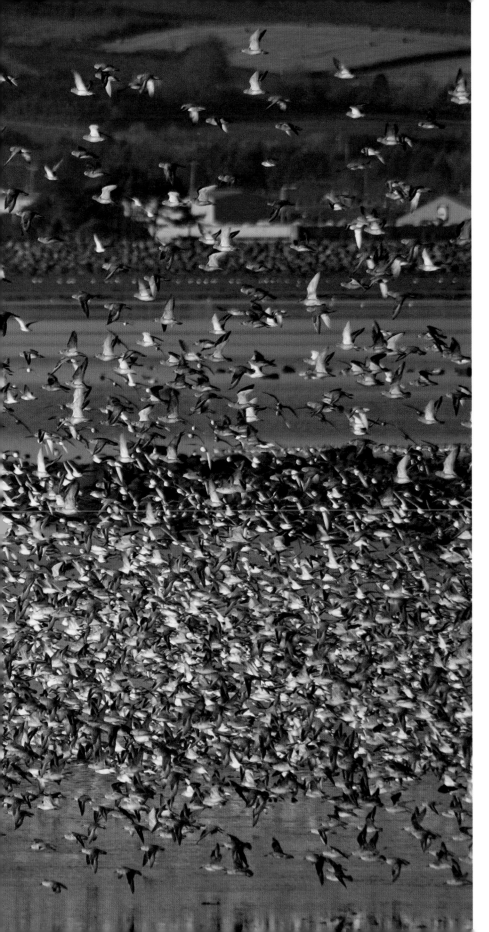

Horse-riders

With more than two thousand species of the lough's marine lifeforms flourishing underwater, it is no surprise that the shores and waters provide food for more than geese. The appropriately named and excitable foot-high redshank picks at the wave line, worrying for worms, calling 'teeuu'. Green-legged, grey-breasted knots probe for molluscs, before flying off in flocks, crying 'knut'. Grey plovers go 'tee-oo-ee', dropping pitch as they finish. Tiny dunlins or 'little brown jobs' (LBJs) to most, the fast-fooders of the shoreline, 'treep' when in flight. The orange-billed, chiaroscuro-bodied oystercatcher is unmistakable, but separating the bar-tailed from the black-tailed godwit is another matter.

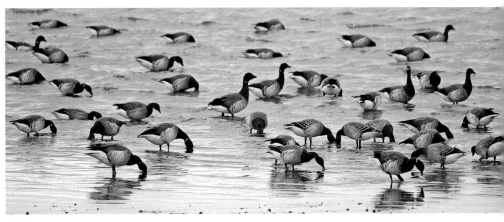

Above: Pale-bellied brent geese

Left: Golden plovers, *Chadarus apricarius* (Ir. *feadóg bhui*), and the smaller dunlins, *Calidris alpina* (Ir. *breacóg*)

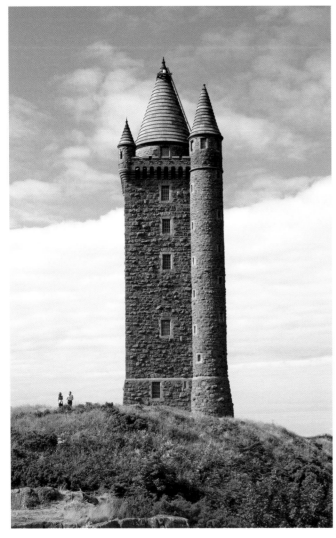

Scrabo Tower, near Newtownards

Her English coal mines, plus lands inherited from her mother the Countess of Antrim, were amongst bounties brought by Frances Anne Vane-Tempest to her marriage with a Londonderry. She protested but a chaste intimacy with Tsar Alexander of Russia and was a confidante of Prime Minister Disraeli. She funded schools and raised follies, including Scrabo Tower – built in 1858 over what was locally called the house of 'the king of the fairies', with its silver Viking hoard, and designed by Sir Charles Lanyon – to her spouse Frederick, the third Marquess. Their son, named 'Young Rapid' for his antics, went mad. Below, downhill from the ancient earthworks, in the sandstone which yielded the friable Scrabo building stone, were the footprints of reptiles from Triassic times, 200 million years ago, who walked the earth long before the Jurassic dinosaurs.

Scrabo, from Ballywatticock's sandstone outcrop

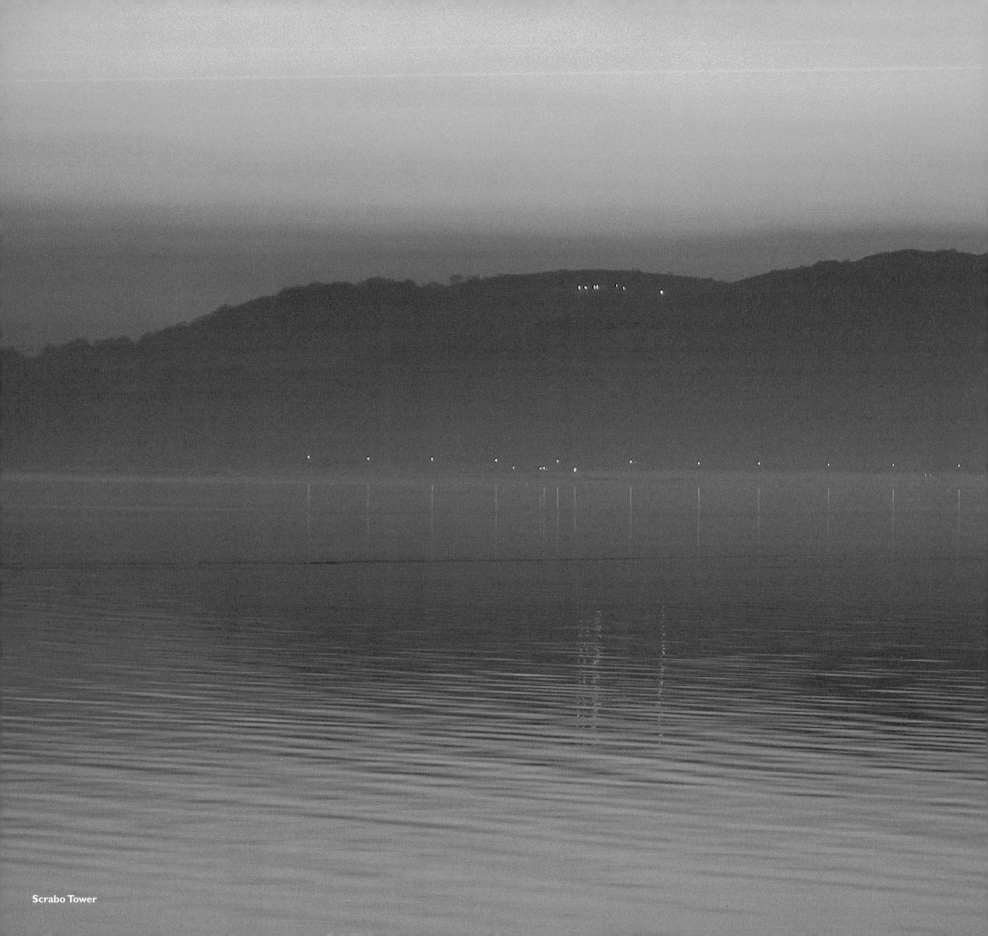

Scrabo Tower

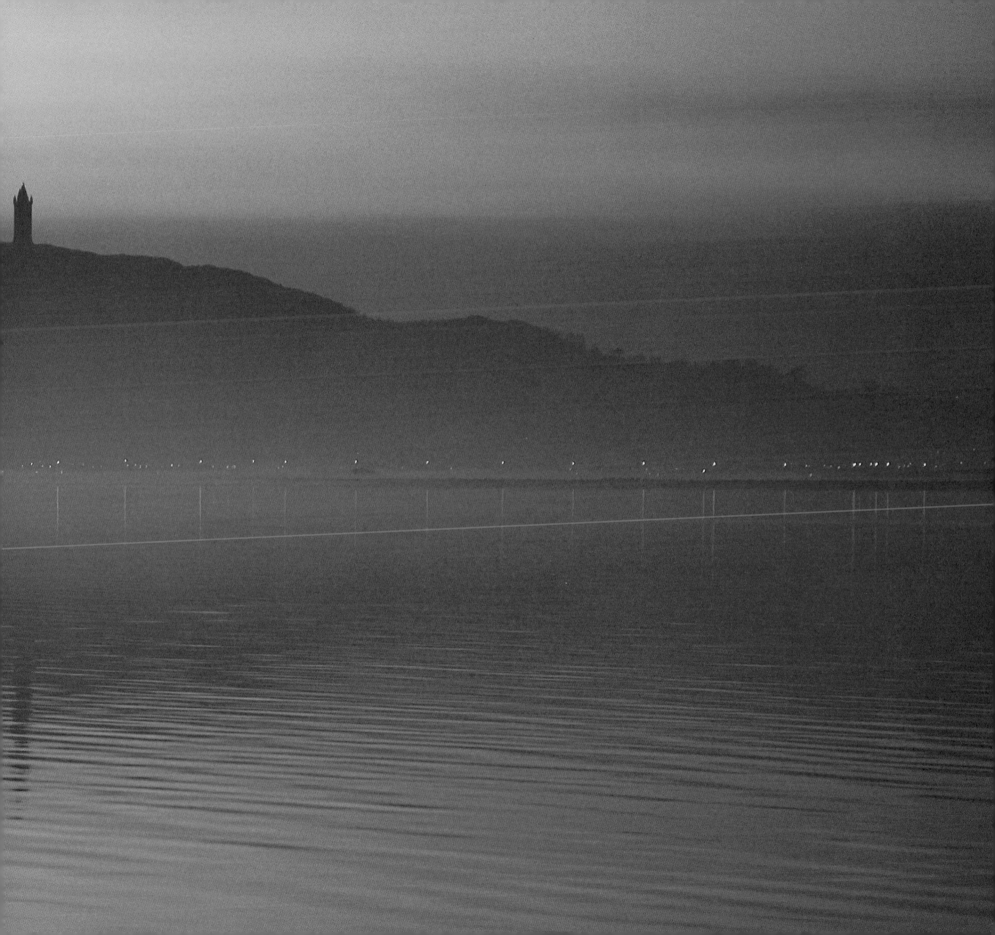

Newtownards to Mahee Island

In the seventeenth and eighteenth centuries, the more energetic the landowner the more likely it was that he would seek to increase his lands by reclaiming those acres which the sea, he argued, had stolen from him. Thus it is no surprise that in 1637 the Marquess of Hamilton sought, and received, permission from the Crown to reclaim, improve and make new manors of 'surrounded and dissected lands' between the high and low water lines in Lough 'Coyne'. He also, naturally, sought a grant for the works. Thomas, Lord Cromwell, Viscount Lecale, and his heirs and assigns were also granted, in the same year, the right to drain away the entire waters of Lough 'Coyne'.

Such ambitious schemes – luckily for posterity – came to naught, and it was not until William Montgomery erected sea defences and sluices to improve Greyabbey in the early eighteenth century that serious reclamation began. At the southern end of the lough, Edward Southwell, who owned Downpatrick, began building what was to turn out, over the centuries, to be the first of many barrages and floodgates across the River Quoile. In general, their principle was simple: the incoming tide closed the hinged base of the structure, while the outgoing tide opened it. Nature is not, however, that manageable. Beautiful species-rich marshes still extend north of Downpatrick and its Market Street still floods in severe weather.

The Chevalier de Latocnaye, an early tourist who was passionate about drainage, urged the reclamation of sand flat and salt marsh at Newtownards when he toured Ireland in 1796–97 – a project that the Marquess of Londonderry had begun in the 1790s. His first embankment's foundations were fashioned from whins along a line followed by today's sea defences, in a similar position to that of a natural ford shown on the earliest maps.

Founded in 1244, the Domincan priory at Newtownards was burnt by the O'Neill of Clandeboye in 1572 after the dissolution of the monasteries, to prevent it from being used as a fort by colonising forces sponsored by Elizabeth I.

Now almost implausibly close to the main road and managed by the Environment and Heritage Service, it was re-roofed in the early seventeenth century by Hugh, first Viscount Montgomery, who also added the tower. He turned much of the hundred-foot-long building into his own home, while rebuilding the town and running up huge debts. In time he sold the priory on to the Stewarts who used it as a courthouse and built the town's market house, one of the most elegant of its kind in Ulster.

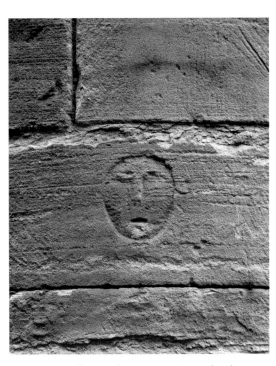

Face on the west nave pier, on the obverse to Russal's inscription (see opposite)

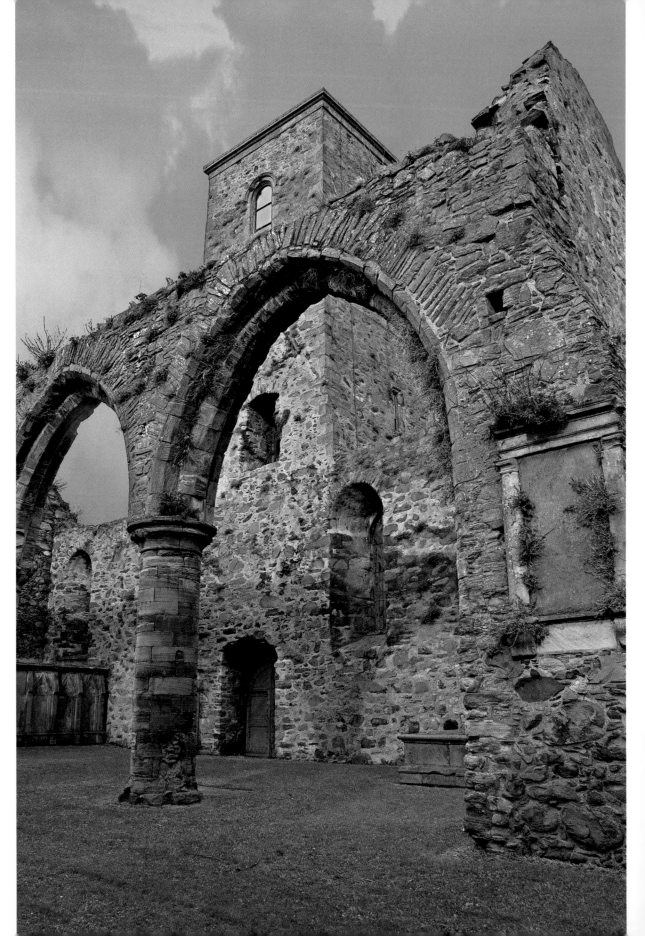

The Dominican Priory, Court Street, Newtownards, open to the public only on European Heritage Days

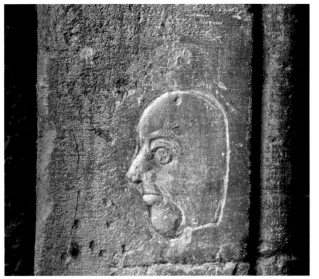

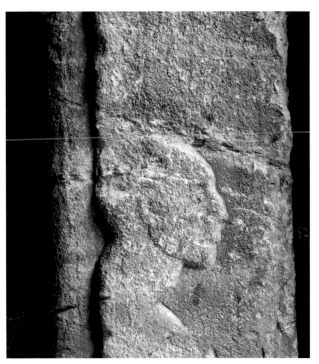

Eighteenth-century heads, carved on opposite jambs of the tower's inner door

'Here lye's the Body / of RRob^t Russal / Stone Cutter who died / Dec^mr 29 1771 Aged 27'

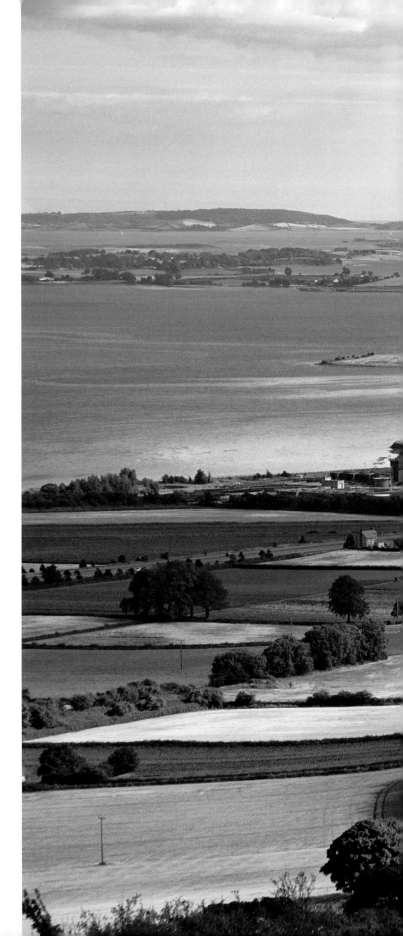

Comber's fame now rests on the humble spud – its early-crop potatoes grown on alluvial acres – which are as common on the country's dinner tables as Ardglass herrings once were. Comber whiskey – traditionally served in warmed glasses, melded with demerara sugar, cloves and lemon, and cut with boiling water – was much favoured, and there are some who still treasure a last bottle squirrelled to the back of the drinks cabinet.

St Patrick is credited with founding, in 432, a St Mary's church at the confluence – the *comar* in Irish – of the Comber River with Strangford Lough. This *comar* became over the centuries Combair, Comar, Comer, Cumber and finally Comber, with that first Patrician church being ravaged by warring tribes in 1031.

Stone fish traps rediscovered between Black Island and Ogilby Island in the distance belonged to the town's Cistercian abbey, whose monks would have known that the meeting of fresh and salt waters causes a build up of nutrients attractive to the grey mullet. This abbey, founded in 1200 and burnt to the ground in 1537, was replaced, eventually, by St Mary's Church of Ireland.

Local place names attest to a scattering of castles and forts, and after the abbey's dissolution its lands passed to Thomas Smith, whose son, for his colonial ambition, was murdered by his indigenous servants at 'Newcastle Comber' in the 1570s.

However the Ayrshire adventurer Hugh Montgomery, having acquired his fellow Scot James Hamilton's claim on the tiny ports of Comber and New Comber, benefited from its water-powered mills and re-roofed Comber's abbey just as he had repaired the priory at Newtownards. The town later passed through the hands of the Stewarts of Mount Stewart, and then to the Andrews, a flour-milling, flax-milling dynasty, one of whose scions, Thomas, designed the ill-fated *Titanic*.

Such respectable Calvinist commerce may be balanced against records from 504 which tell of lubricious dancing around a bonfire, akin to that celebrated in Brian Friel's play of the same name – although the festivities at Scrabo had the distinguishing feature of the burning of a wicker man at the top of the hill.

South-east from Scrabo, north of Rough Island and the Comber River Estuary

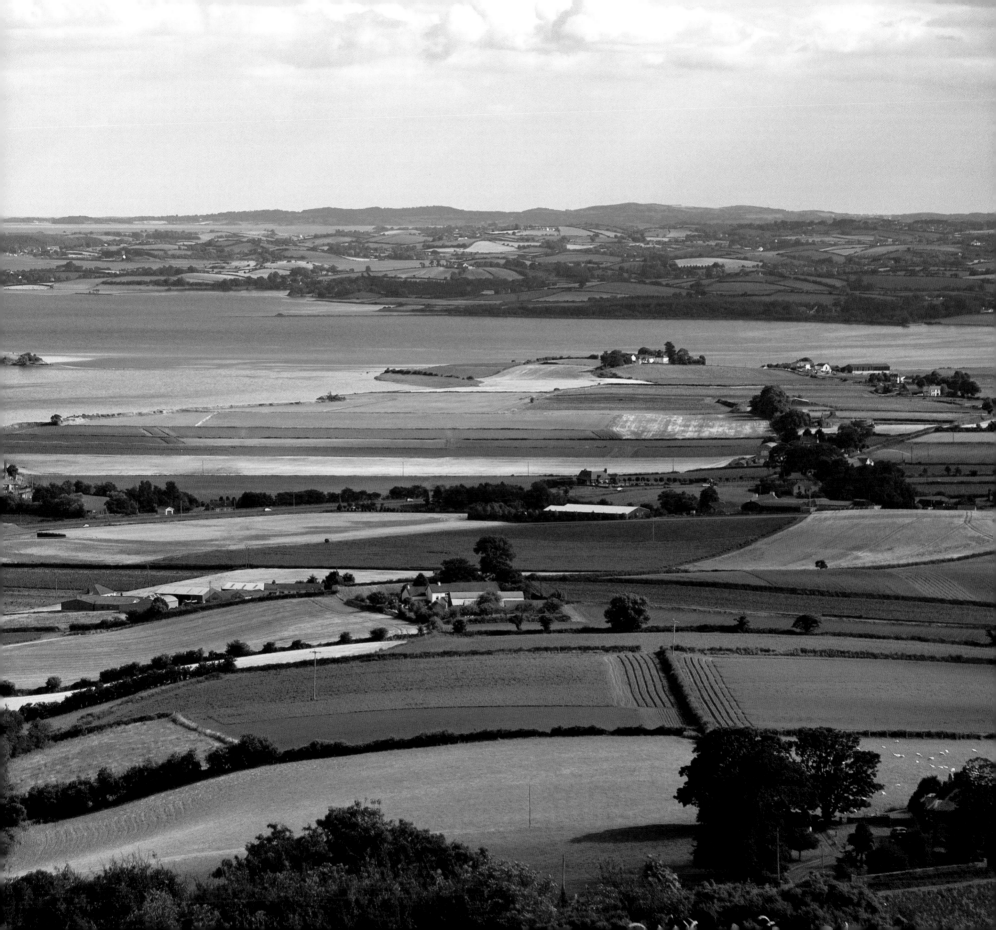

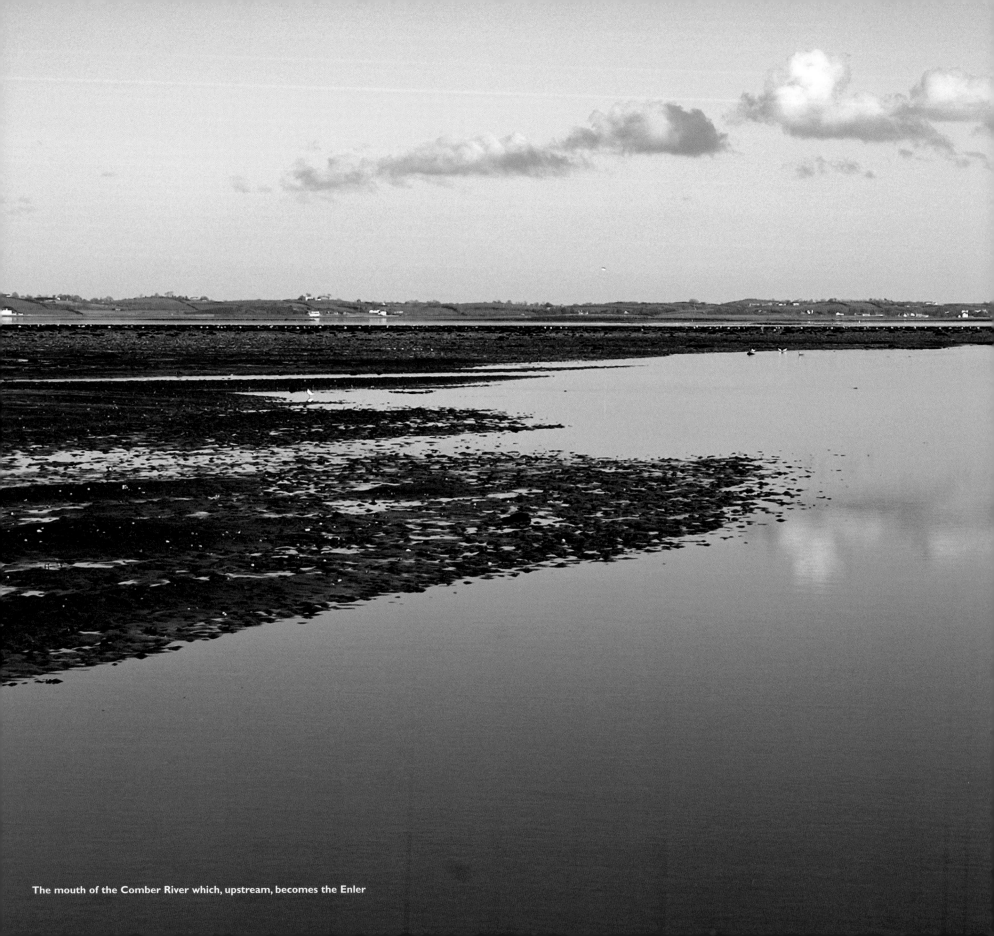

The mouth of the Comber River which, upstream, becomes the Enler

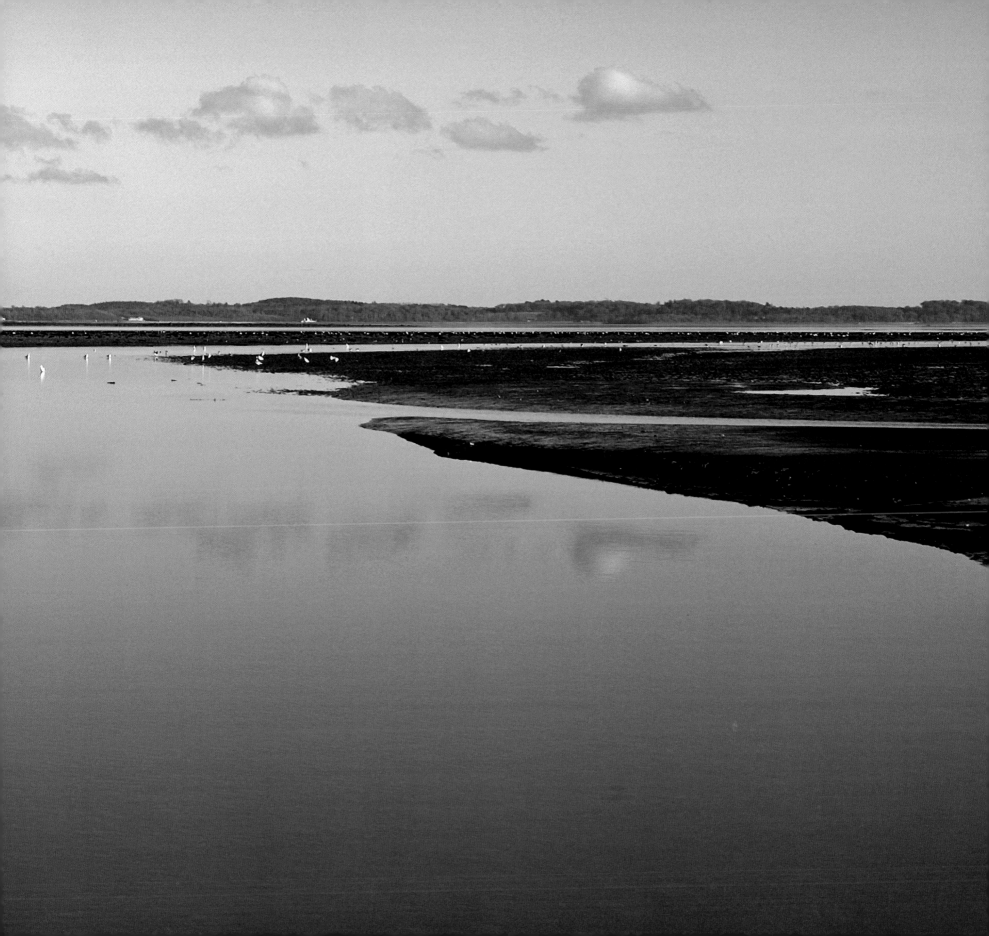

The road to Mahee Island

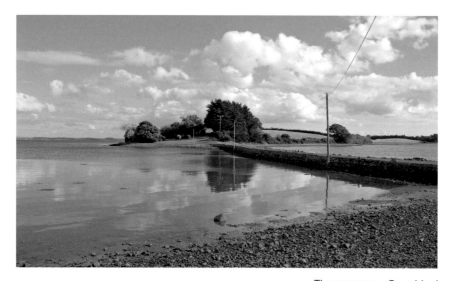

The causeway to Cross Island

The shoreline of Rough Island was the preferred point of disembarkation for coal boats too large to sail up the estuary as far as the Ghost Hole at the edge of Comber. At low tide, a roughly fashioned stone landing-stage and causeway afforded passage west to what is now Island Hill picnic site in the townland of Ringcreevy. A short sail south, by the once industrial pier which served Castle Espie's disused red limestone quarries, tile-works, and brick and lime kilns, is the Wetland Centre. South again lies Ringneill Bay, a suitably Riddle-of-the-Sands type enclave with its enclosing chain of islands – Rolly, Reagh, Cross, Bird, Mahee, Calf, Rainey, Watson's, Wood and Long – accessible by boat or causeway.

The causeway from Rough Island

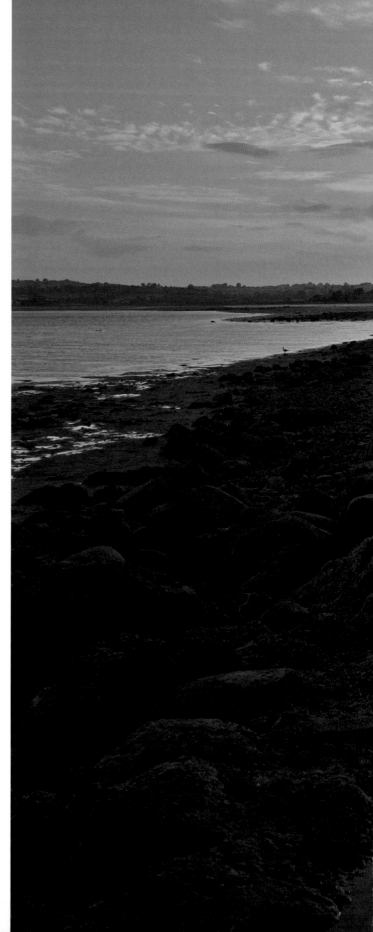

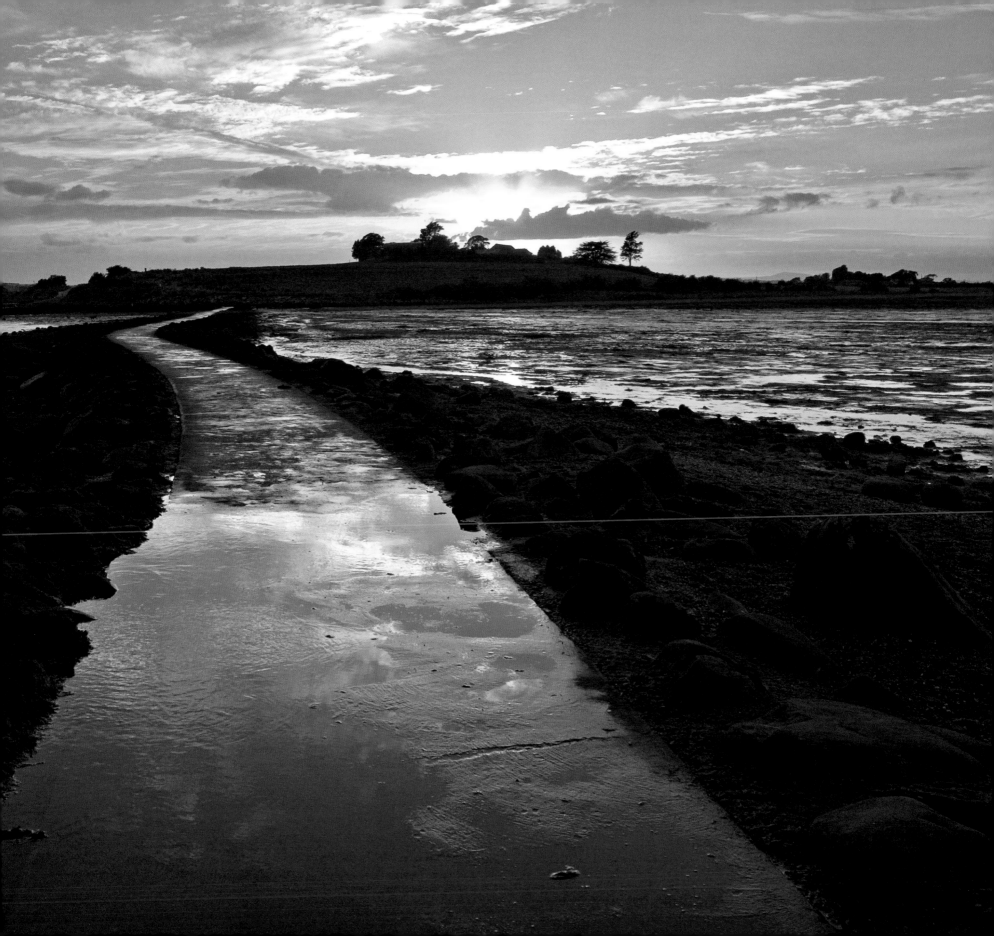

The archipelago is awash with a skein of stone jetties, piers, quays and slipways leading across fields or up loneys and laneways, each recalling past centuries of encounters between farm-cart and kelp-boat; neighbours sober or not; lovers bold, chaperoned, shy or sly; deals done with a spit on the hand and the moist slap of calloused palms.

Or maybe the landing place is immortalised in an oft-told tale of a birth or a death – a tweed-suited doctor's Gladstone bag, the black shadow of a cleric, the telegram telling of a soldier's passing on a foreign field which is now forever this lough's shore. Whatever the resonances, many such landing places, close to tidal channels, have now found new purpose serving newer pleasure craft.

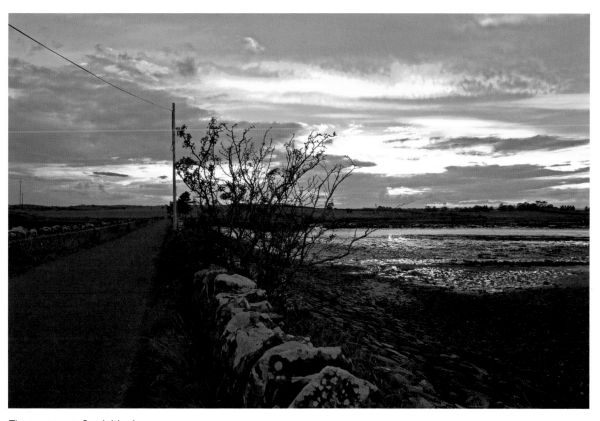

The causeway to Reagh Island

Under Watch Hill, Reagh Island, looking towards Reds Rock

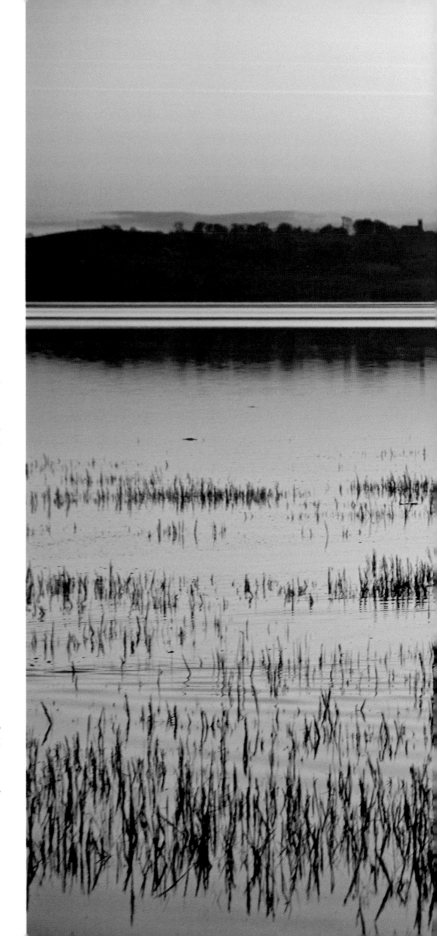

Who would not be stirred by the suggestion of a ship's timbers slumbering under the mud? Off Ringneill Quay there are the slight remains of the *Fanny Crossfield*, once a three-masted schooner of 119 tons, built in Carrickfergus in 1880 for the suitably named Thomas Ashburner of Barrow, a collier licensed to trade coals to the Isle of Man. Grounded in the lough in the 1930s, her owner was then Captain Billy Black, a shipmaster who bore, with pride it seems, the soubriquet of 'adventurer'.

Dismantled after the Second World War, the *Fanny Crossfield*'s salvors and subsequent scavengers left behind many of her structural frames, pins and treenails.

And the conundrum of the lough's stately white swans – how to tell them apart? Migrating Whooper swans arrive in the autumn, though, by the spring, all but a very few have left these shores for Iceland and northern Europe. Their beaks bear a large yellow triangle. The mute swan, which stays with us all year, has an orange beak and a black knob on its forehead. Whoopers go 'whoop-ah' in flight, trumpeting when harassed, and make a fuss when they arrive in October, 'whoop-ahing', wing-flapping, neck-pumping. Mutes don't stay mute, but hiss, snort and arch their wings when feeling threatened. They also upend like ducks, and their wings in flight make a signature throbbing whistle.

Mute swans, *Cygnus olor* (Ir. *eala bhalbh*), at Ringneill Bay

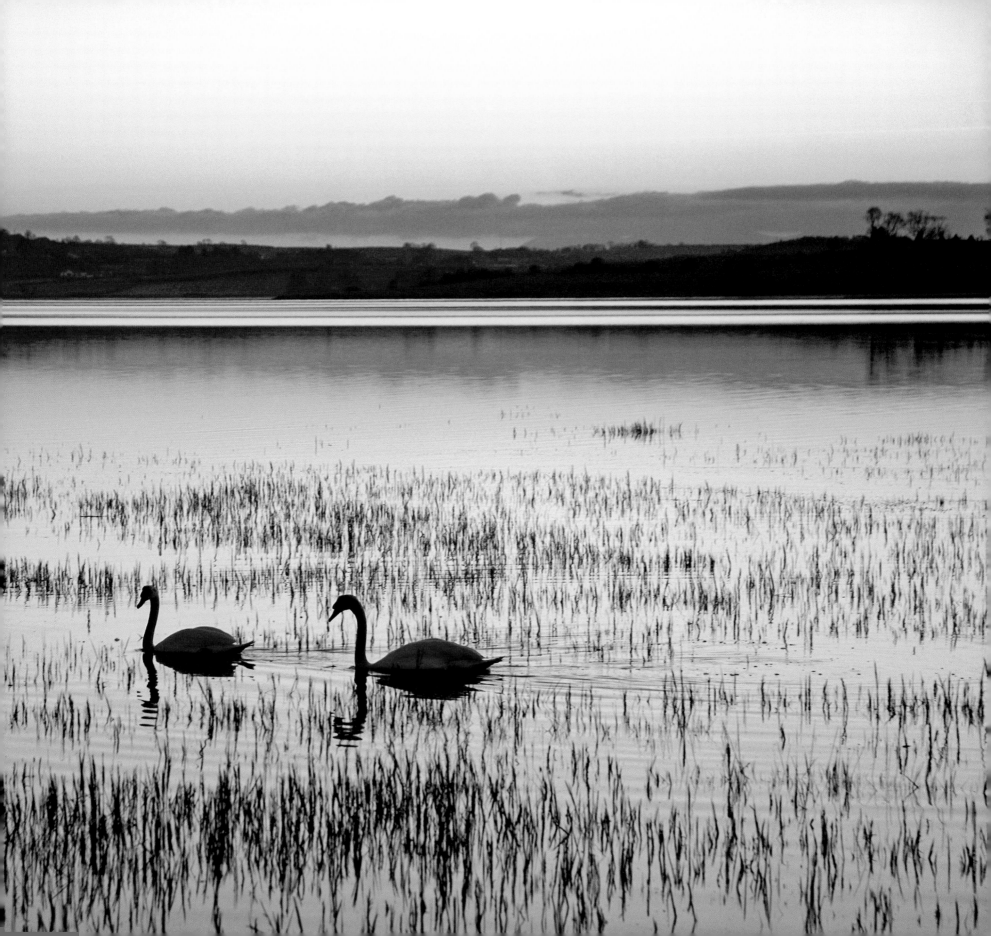

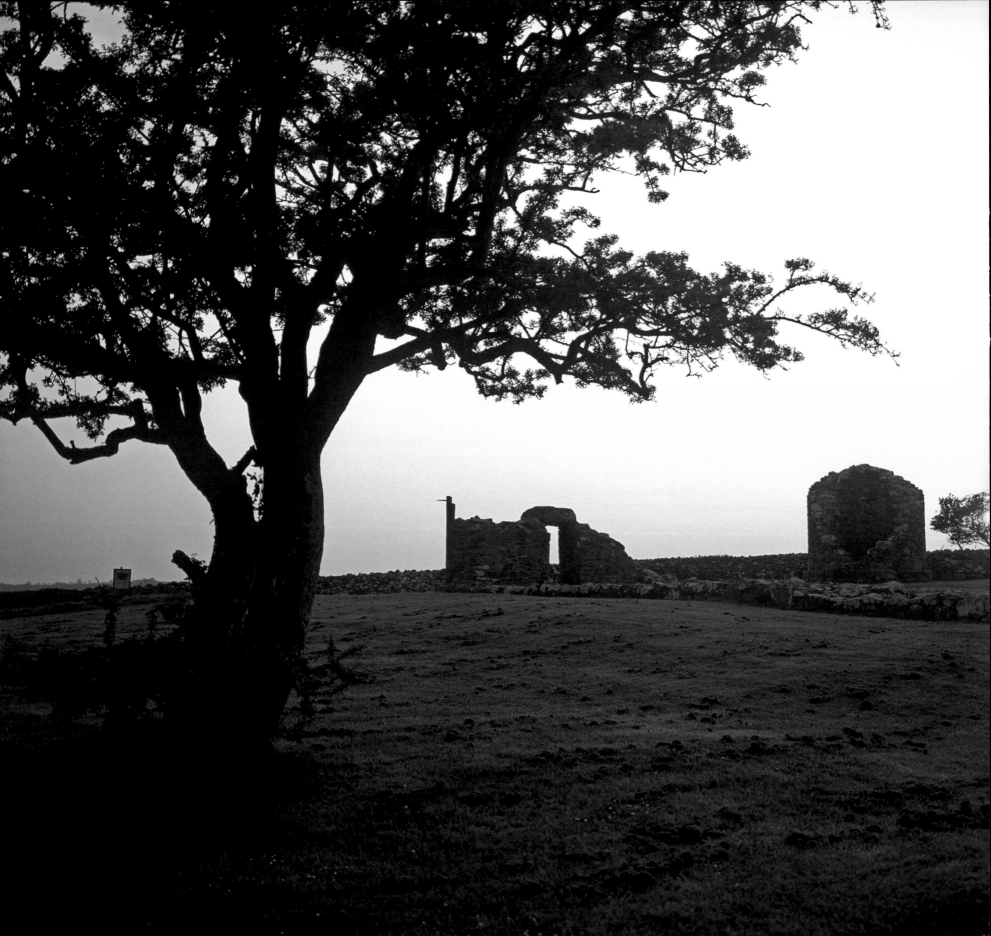

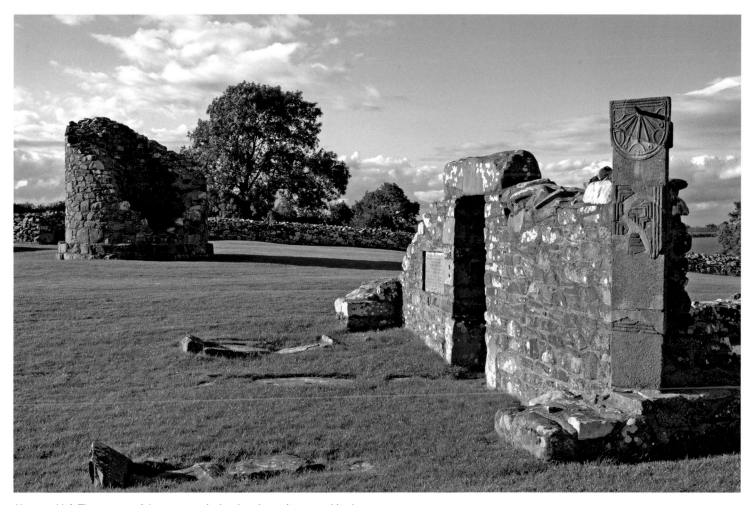

Above and left: The remains of the monastery's church and round tower at Nendrum

Whilst Mahee's castle at the head of the causeway can be dated as Captain Browne's three-storey tower-house of 1570, the origins of Nendrum, this lough's most celebrated and extensive monastic site, are lost in a historical fog as dislocating as the sea frets that creep across the water, muffling all sounds but the resonant bass boom of distant foghorns, that of South Rock Lightship every fifteen seconds, St John's Point every thirty.

Believers in St Patrick trace Nendrum's origins to his fifth-century gift of a winged crosier, long before bishops wielded crosiers, to the institution's founder, St Machaoi. Yet the earliest artefacts, of a monastery workshop, are from four centuries later. Undisputed, however, is the fact is that this was one of de Courcy's twelfth-century Benedictine houses, its church falling out of use three hundred years later. The tide mill, which was at the cutting edge of seventh-century technology, is the oldest in the whole wide world.

Boulder clay, deposited as the most recent of the ice ages retreated, blankets the bedrock shales all around the lough's shores. This creates the fertile soils which – combined with a covering of light forest and raised storm beaches at Ringneill – were well suited to the needs of the Stone Age fishers, fowlers and hunters, who left behind the worked flint scrapers found at Rough Island and Ardmillan. The well-drained drumlin slopes would surely have encouraged the cultural progression of their sucessors – the farmer-fisher folk of the new Stone Age – who left behind the wood-clearing axe-heads, arrowheads and pottery bowls found in the two great chambered tombs beside the tributaries of Graffan Burn, upstream, west of Castle Espie. Graves at Audleystown, at Castle Ward in the south, have given up the bones of goat, ox, pig and sheep, evidence of perhaps seasonal, pastoral farming. Away to the north, in the Knockiveagh Hills, impressions of wheat and barley grains – evidence of an advance in agricultural techniques – have been found on pottery, along with roasted hazel nuts, in a not dissimilar grave. The triangles and chevrons incised on Bronze Age pots found at Killinchy point to an age of craft-workers and farmers.

The early Christian period brought first un-enclosed farms; then came the vast abbey estates divided up after the dissolution of monasteries; followed by the break-up of some of the old Anglo-Norman demesnes which were then acquired by a new generation of English colonists much given to land reclamation and improvement, and the building of floodgates, watermills and windmills. The Napoleonic Wars saw the destruction of the cereal business and the spread of clusters of co-operating farm-cottages or 'clachans', many of whose fields were abandoned in the Great Hunger, their spade-dug ridges still visible today on relatively unimproved farmland. In more fertile areas, where modern methods were and are used, the footprint of a farmstead, its outbuildings and family cottages will cover more land than the clachan which preceded it.

Below Drum Hill

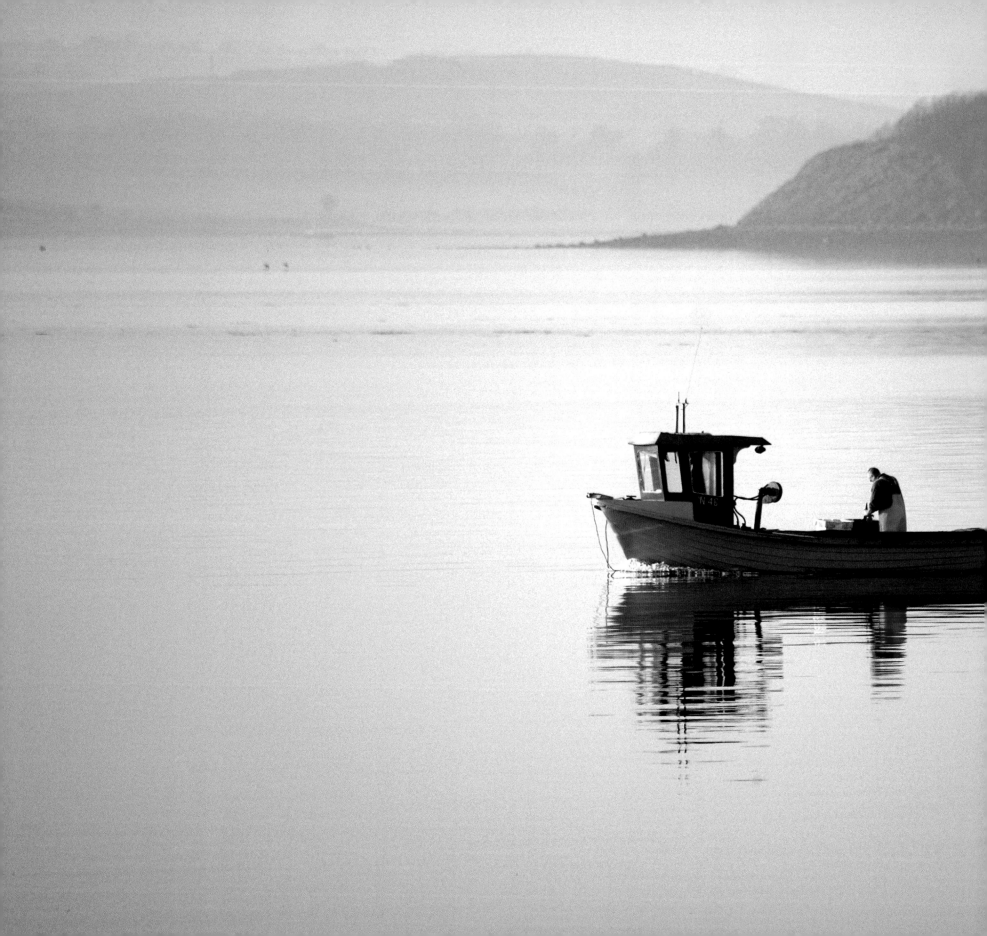

Mahee Island to Inch Abbey

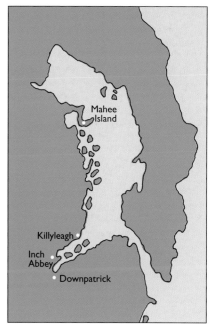

The lough's western waters – from Mahee Island south to the Quoile Barrage – sparkle in summer with the jockeys'-silks colours of spinnaker and genoa, billowing out from the craft which berth in winter at a handful of salty yacht clubs in the townlands of Portaferry, Kircubbin, Ballyewry, Whiterock, Ringhaddy, Moymore, Killyleagh, Castle Island and Castle Ward.

The boatmen's histories stretch back over the centuries. They crewed yachts for the gentry in the early twentieth century. They skippered trading schooners, fishing smacks and wherries in the nineteenth, and spied the French standing off Kilclief with guns for the insurgents in the eighteenth, while fishing in their shallow draught yawls for mythically enormous shoals of herring. Perhaps they saw off Barbary pirates in the seventeenth. Certainly Vikings broached their peace in the eleventh, centuries after their boats were skin over ash, or a log, hollowed.

The herring are gone these sixty years and with them a knowledge preserved in a skein of oral history. Who can now remember whose grandfather it was who said his grandfather had to preserve his nets with noxious tar, instead of the preferred oak tannin, when the Planter landlords declared that the wood in their plantations had to be reserved for building their boats and warehouses?

But even when a boat was nothing but a fishing engine using a hemp line baited with lugworm, fish belly, gull feather or fuchsia flower, it is hard to countenance – beyond the backbreaking haul of crabbing pot or the hand-over-hand pull for codling, haddock, gurnard or skate – that there wasn't, and isn't, a magic.

Dunnyneill Island has been a hostage-holding fort, leper colony, cholera graveyard, limestone mine and local Alcatraz over the centuries.

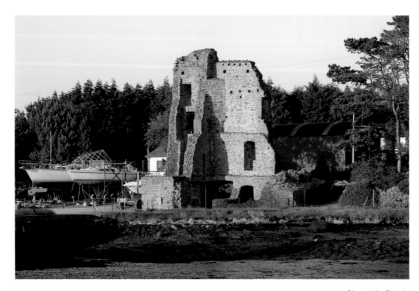

Sketrick Castle

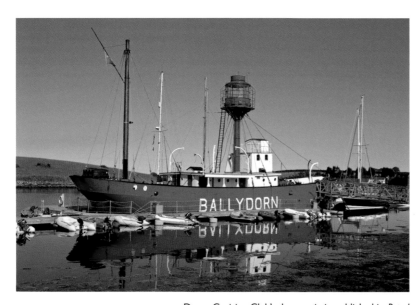

Down Cruising Club's decommissioned lightship, *Petrel*

Reduced to a skeletal ruin by a fierce storm in 1896, three-storey Sketrick Castle is one of sixteen tower-houses on the lough's shores. Modest now, it was the most important in the front line of the English defences when cited as the fort at Sgathdeirge, captured by the O'Neills in 1470 and gifted to the MacQullinans of Dufferin who'd gaelicised their Norman de Mandeville past. Re-ordnanced as the Earl of Kildare's 'Castell of Scatryke' with 'one great pottgonne of Irne' before the Geraldine Rebellion of 1534, it was captured two years later by the Constable of Carlingford only then to vanish, vanquished, from historical record.

Looking south and east from the Killinakin Road, Craigarusky

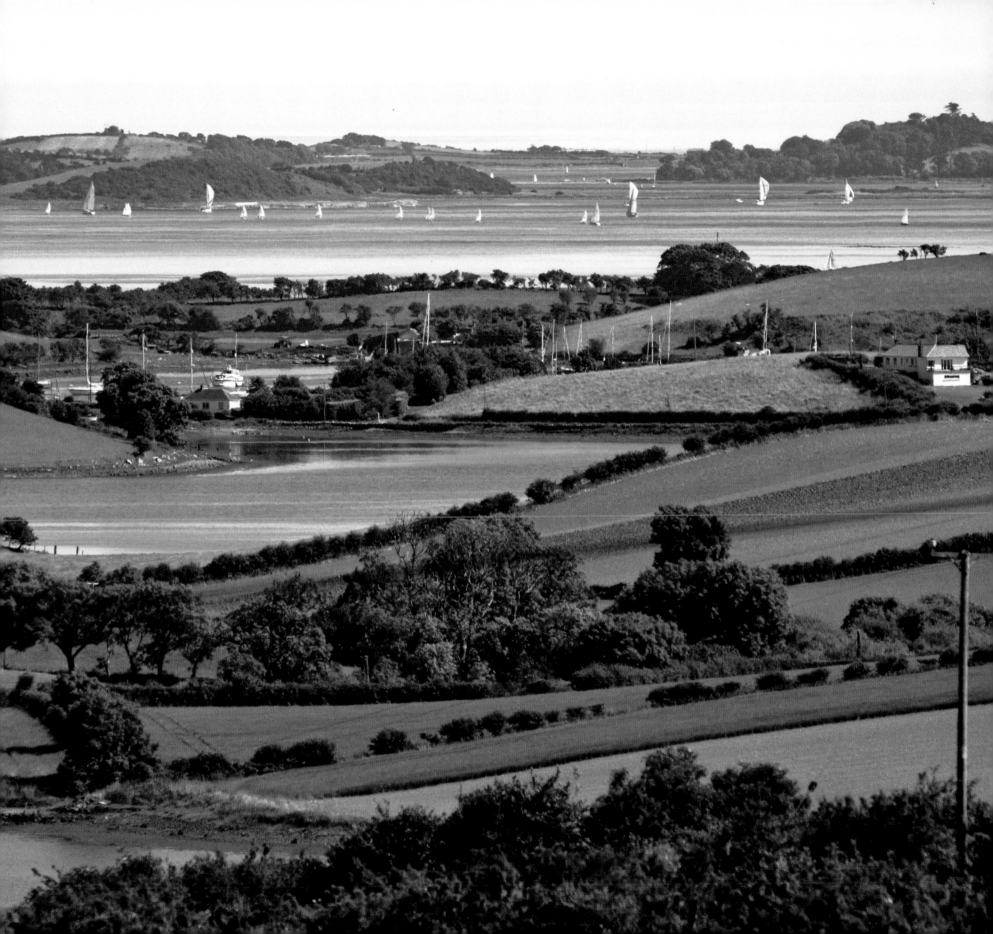

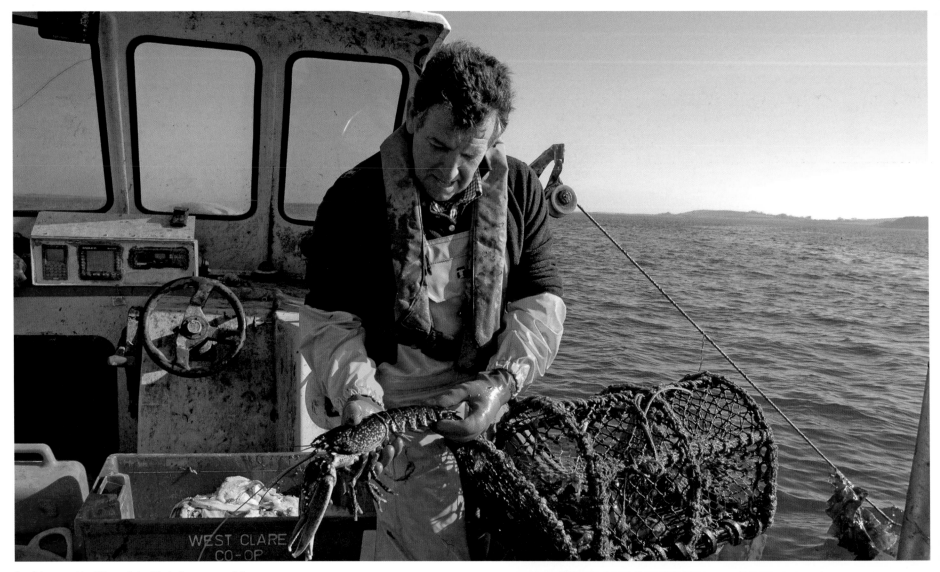

Pot-fisherman Noel Taggart's haul includes common lobster,
Homarus gammarus (Ir. *gliomach*)

Oyster middens found around Reagh Bay, dating from Mesolithic times, attest to our ancestors' taste for these delightful creatures. From the eighteenth century until their collapse at the end of the nineteenth century, the lough's natural beds of native European oysters were the basis of an industry dredging three thousand a day from the shallow waters at Ardmillan, Ballydorn, Sketrick and Whiterock. Cuan Sea Fisheries at Sketrick now farm mostly Pacific and Portuguese oysters.

It is now the common edible crab, its modest relative the swimmer crab and its posh, very distant relatives the lobster and the langoustine, that are the mainstay for pot-fishermen such as Ballyhornan's Noel Taggart who works the lough from a mooring off the Old Quay in Strangford village.

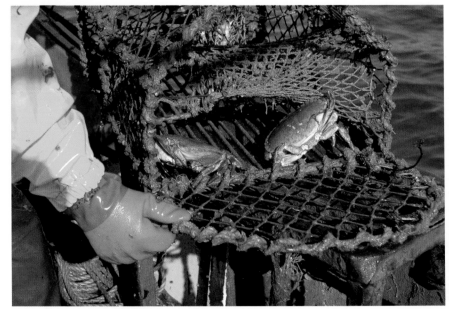

Common crab, *Cancer pagurus* (Ir. *portán*)

Left: Lesser black-backed gull, *Larus fuscus* (Ir. *droimneach beag*)

Below: Opportunist lesser black-backed gulls and herring gulls, *Larus argentus* (Ir. *faoileán scadán*), follow the fisherman home

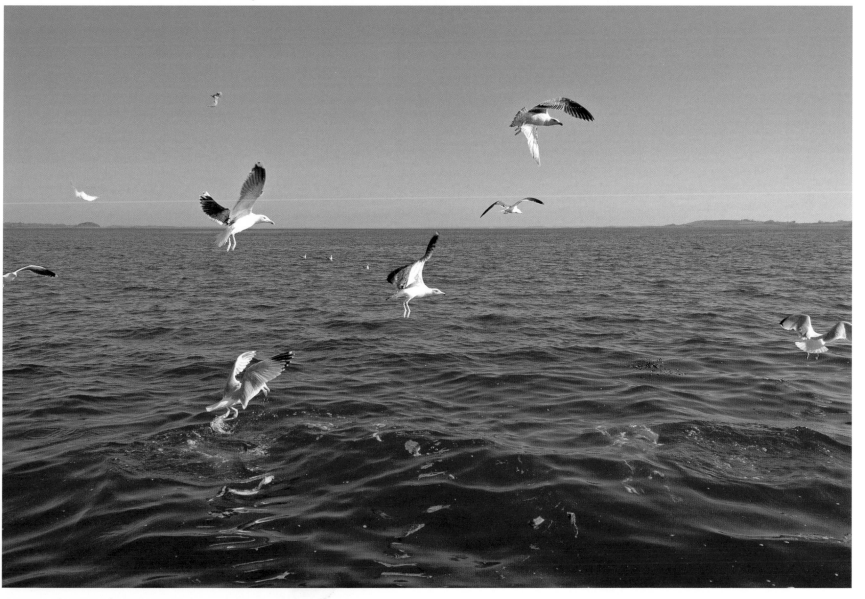

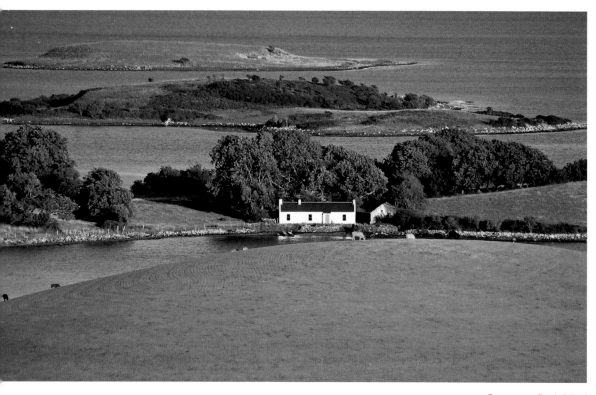

Cottage on Conly Island

King John spent the night of 30 July 1210 in 'Balimoran'. Thomas Raven's map of 1625 showing Killinchy gives the lands encircling 'BalleMaron' Bay, with 'Island Conel' at its mouth, as being as densely forested as that part of the Dufferin estate phonetically spelt 'Killincha', so that access by sea must have been preferable to any hard-wrought woodcutter's path.

The Black Death of 1350 had decimated the population, land use had fallen away and the Dufferin's regenerated forest reached near to Belfast by the end of the sixteenth century.

Maps of the nineteenth century show Conly with farms and four landing places. Two of each had disappeared by 1920 with just two of the impressive stone quays with slipways remaining. Woodland still covers half the island and there are many cleared slipways and well-built quays still in use at the ends of laneways running down to join the little streams entering Ballymorran Bay. The cleared slipway at Drumildoo Point has a boat naust, but only a visit will reveal what that is.

Low tide, Ballymorran Bay

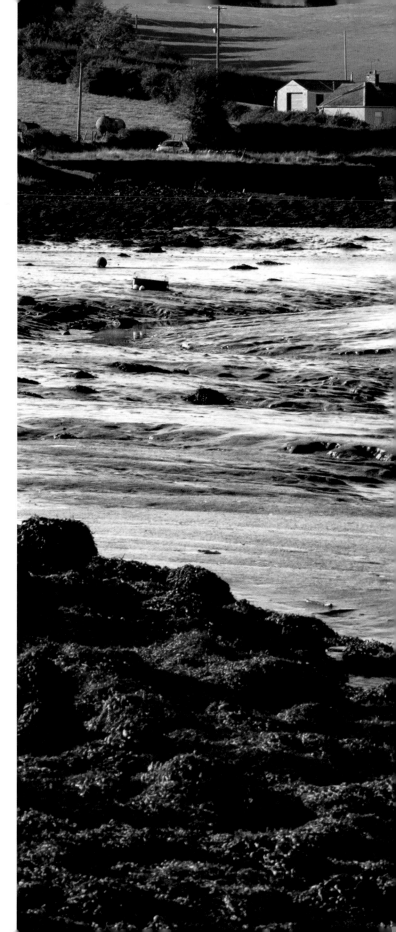

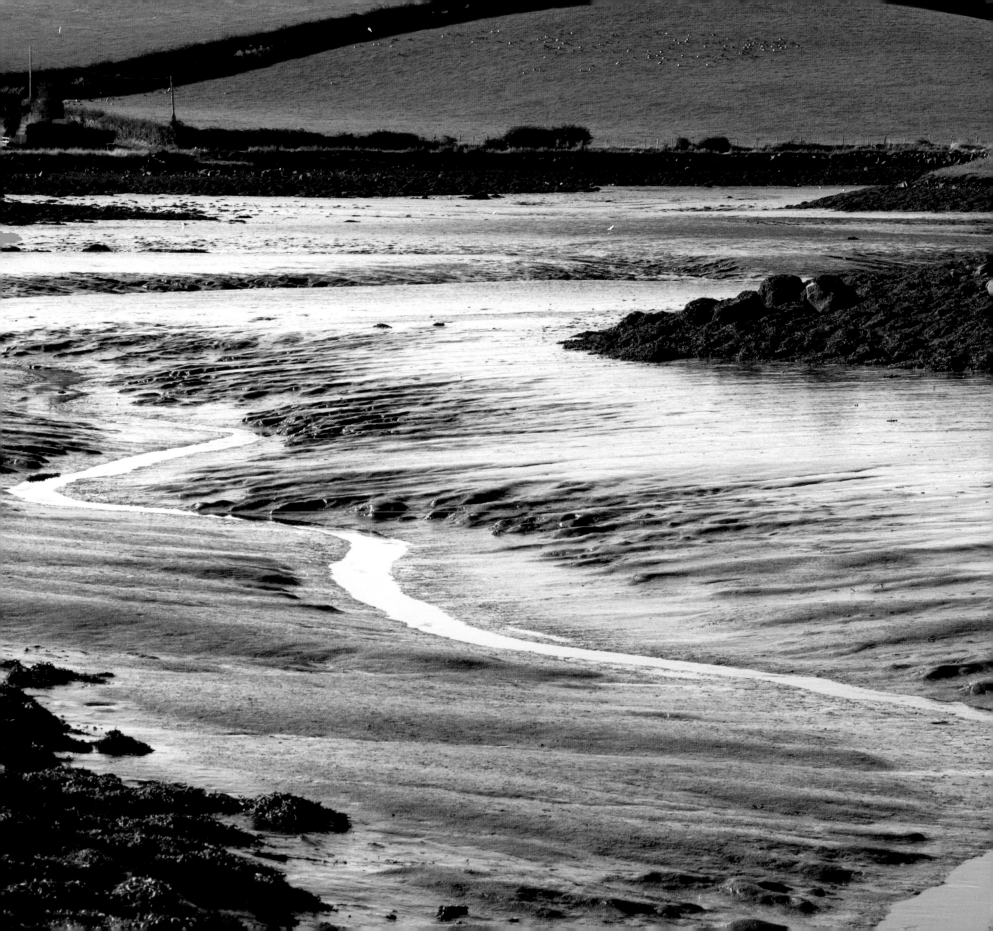

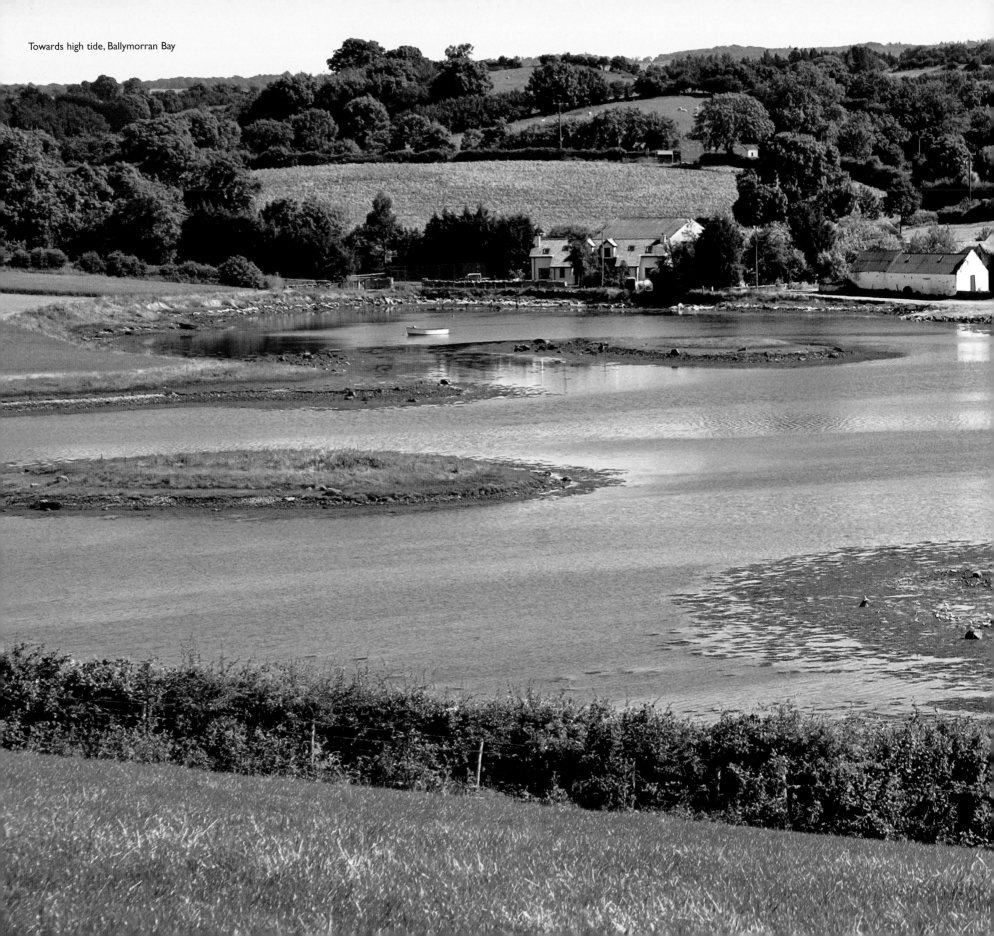

Towards high tide, Ballymorran Bay

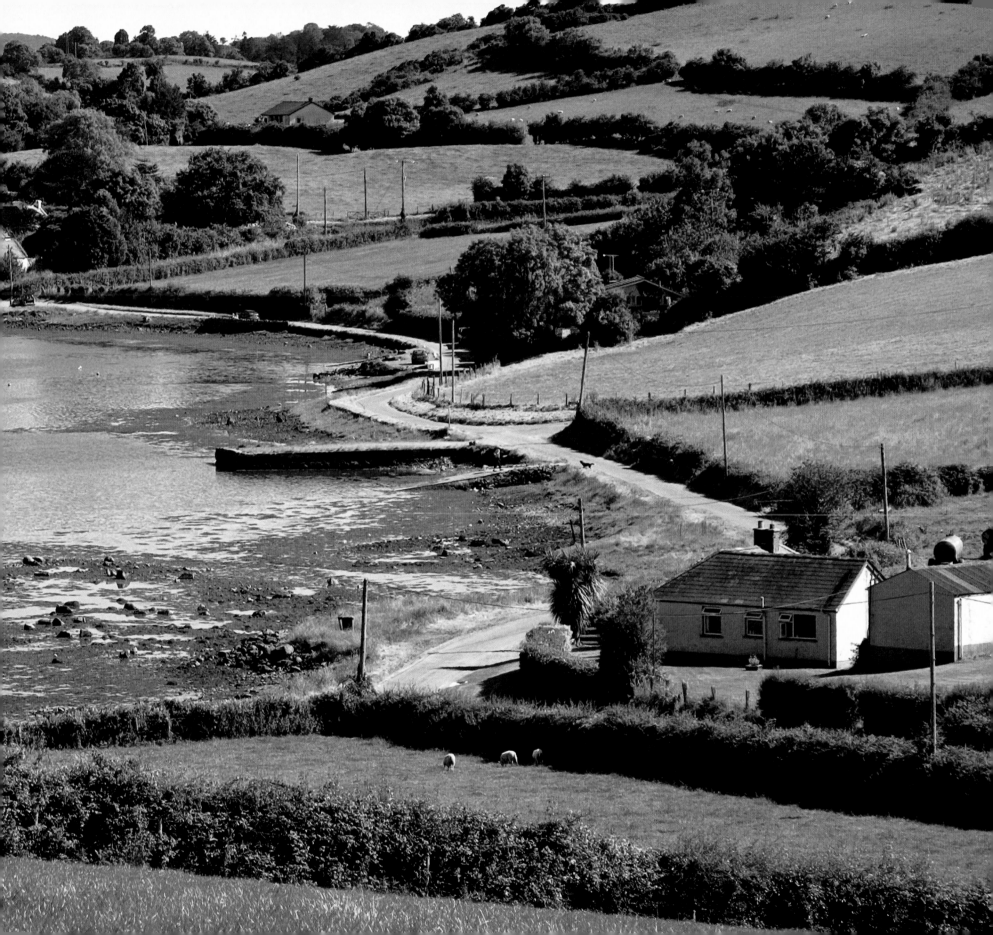

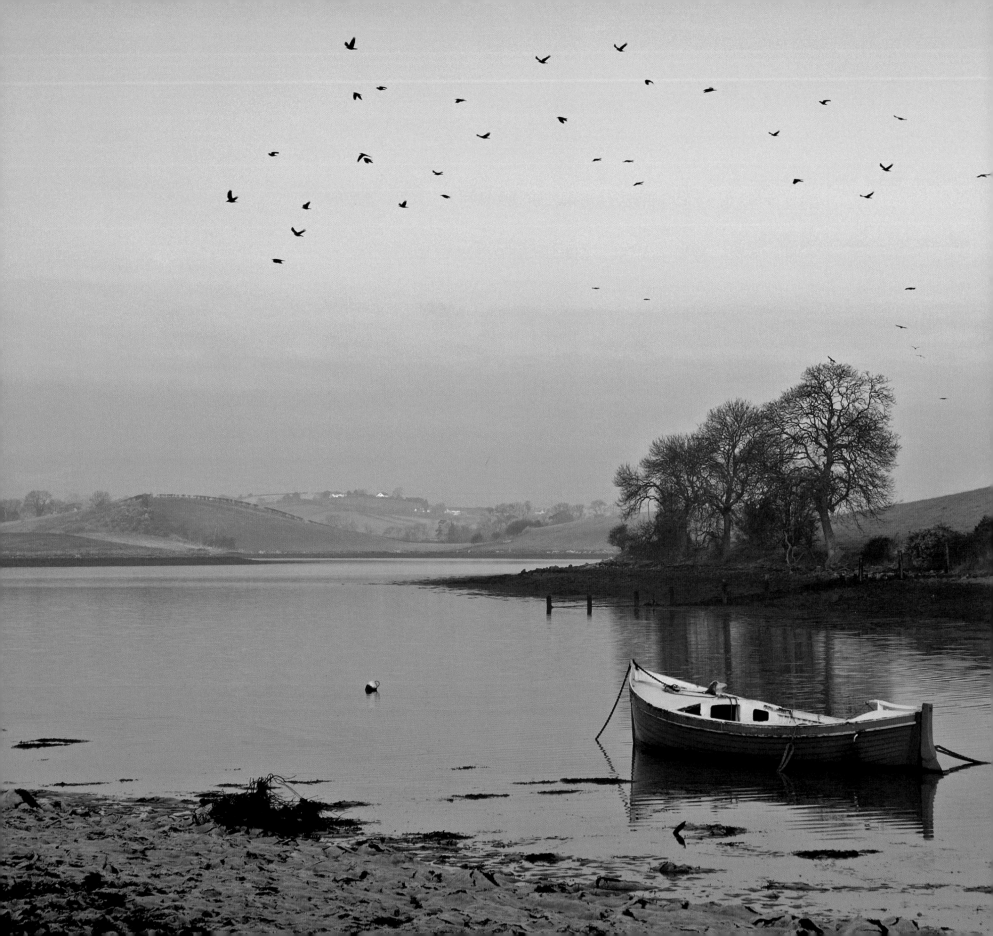

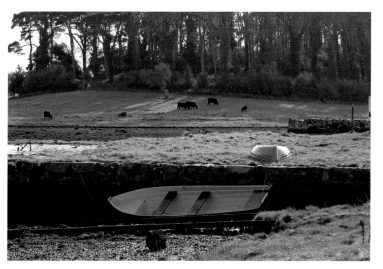

Mullagh Quay and Gibb's Island

The Corry channel – between Castle Island, with its Quoile Yacht Club, and Gibb's Island, with its stand of trees – is now blocked by the barrages at either side of Hare Island which lies south-west of Midge Island and Mullagh's broad quay. The channel takes its name from the *coragh* (fish weir), built to catch salmon for the rich man's table. For, in the seventeenth century, there were 'royal salmon within the river call'd the Narrow water and lochcoan which runneth up by Strangeforde to the Quoy so thence to Downepatrick and so too Annaghcloye'.

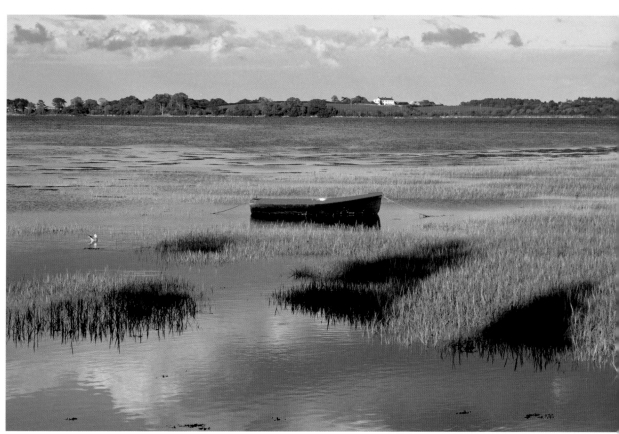

Offshore from now almost landlocked Ardmillan – whose corn, flax and threshing mills made it such an important port during the seventeenth and eighteenth centuries – at the mouth of the once salmon-rich River Blackwater, which runs towards the oyster beds of Reagh Bay

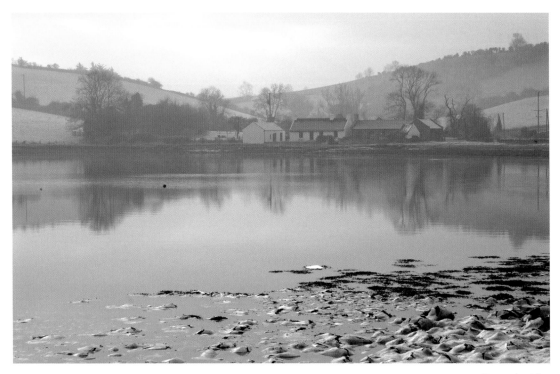

Quarterland Bay

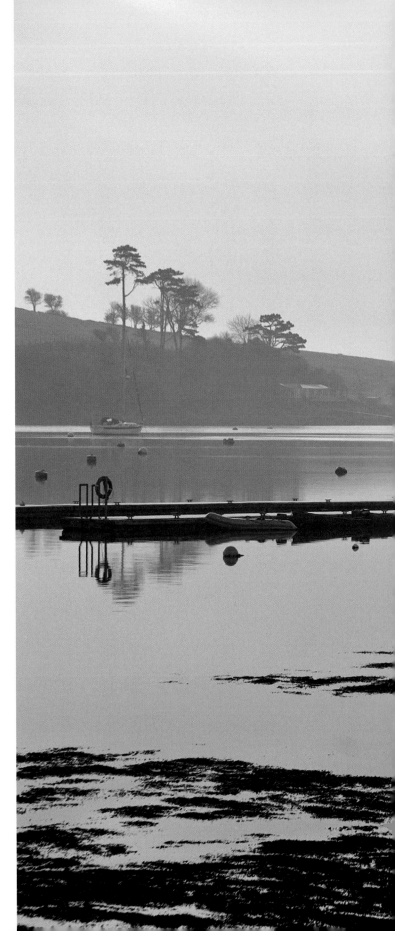

Quarterland's 'hard', a rough paving of flat slabs that runs from farm gate to the lough, had few aspirations, fashioned there to beach naught but a farmer's rowing boat. Ringhaddy Castle and Sound, given on sixteenth-century maps as 'Renagheddye', is by contrast a yacht haven. North by north-east lies Dunsy Island, taking its name from the cult of the Virgin St Duinsech of Kilwyinchi – Killinchy or *Cill Ince* in Irish, meaning the island church – whose saint's day is 24 December. East is Islandmore, or Big Island, immortalised in *The Blue Cabin* by Michael Faulkner, the son of Brian Faulkner, Northern Ireland's sixth and last Prime Minister.

Ringhaddy Cruising Club

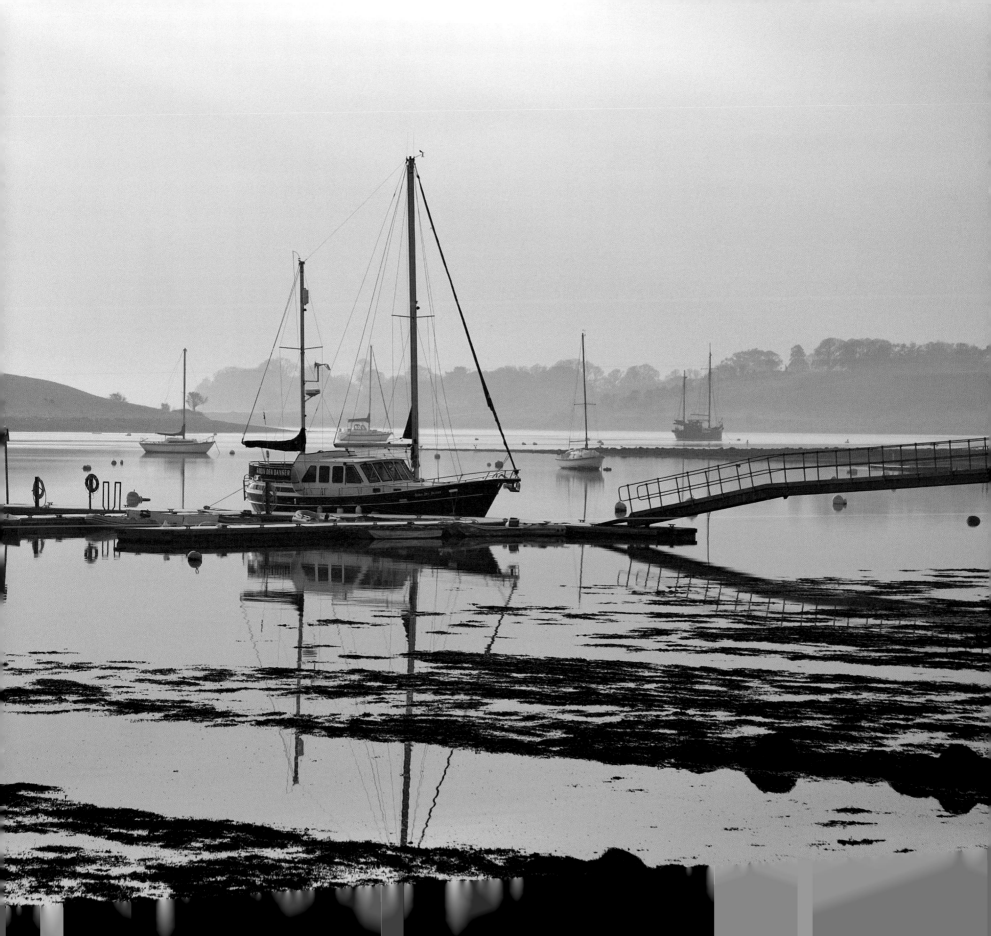

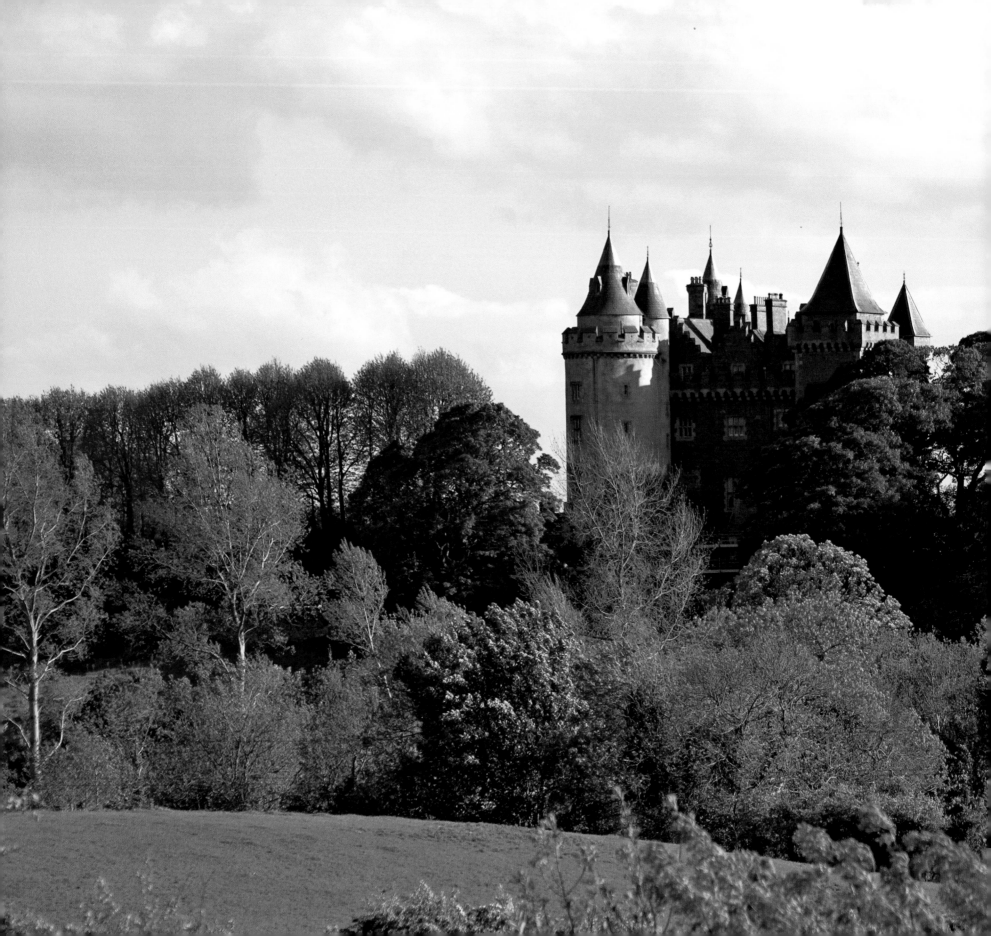

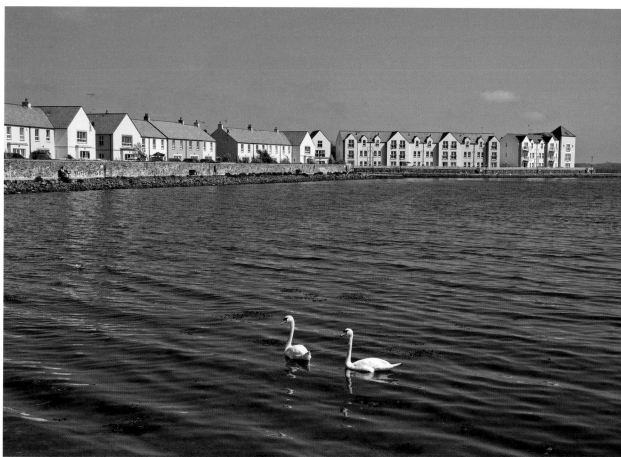

Killyleagh's Hans Sloane Square

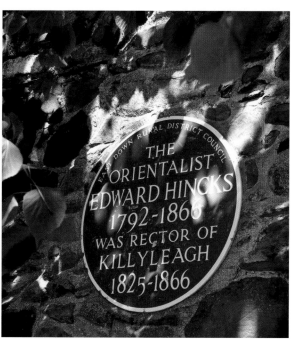

Edward Hincks, an innovator in the deciphering of Assyrian and Babylonian cuneiform texts, isn't Killyleagh's only hero. That honour is shared with pedagogue, naturalist, earl, admiral, lady lyricist, singer-songwriter, baron and soccer star. The seventeenth-century schoolmaster was the Reverend James McAlpin who taught philosophy but not divinity. The naturalist was Hans Sloane, educated in the library of the second Earl of Clanbrassil's fairytale castle in the town. Sloane's collections founded Kew Gardens and the British Museum, and his name is preserved in London's Sloane Square. The Earl was not so fortunate: becoming impotent he was poisoned by his wife. Sir Henry Blackwood, Vice-Admiral of the Blue, witnessed, at the Battle of Trafalgar, Nelson's will favouring Lady Hamilton. The lyricist was Lady Dufferin who wrote 'The Emigrant's Lament'. Bluesman Van Morrison, whose 'Coney Island' cites nearby Shrigley, plays concerts within the castle's walls. By marriage, Baron Killyleagh is England's Prince Andrew. David Healy, Northern Ireland's striker, scores when his country needs.

Killyleagh Castle, dating from 1610

Looking towards Quoile Yacht Club from
the National Trust's Gibb's Island

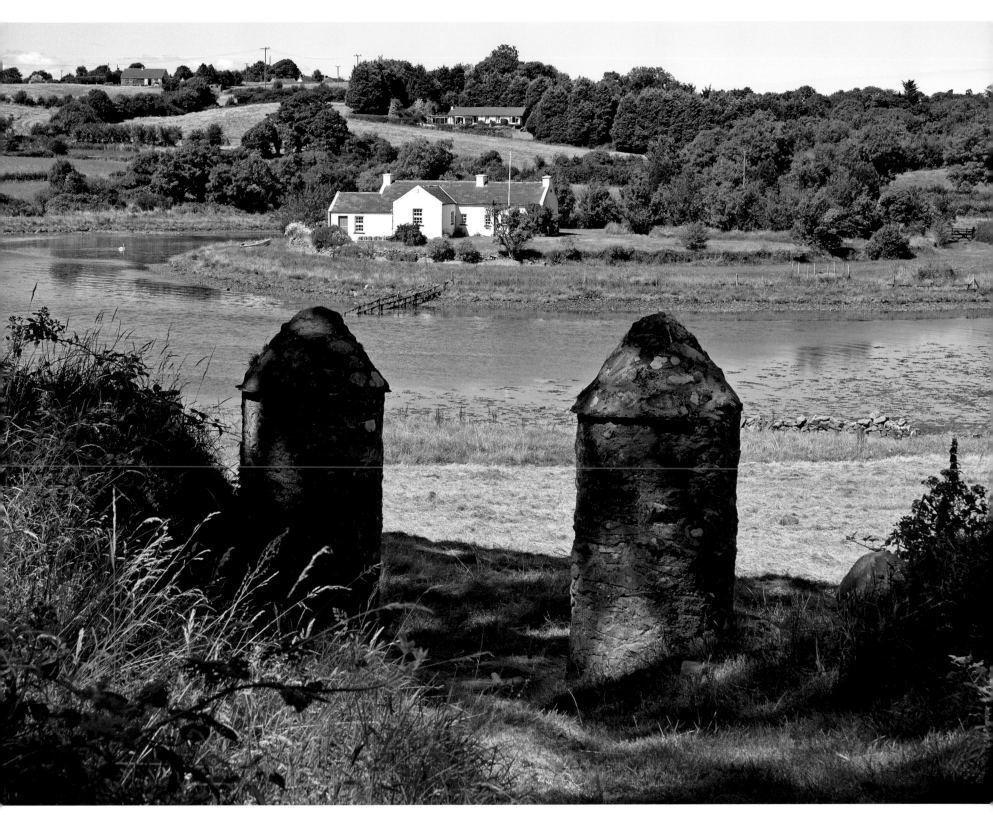

From Gibb's Island, north-west to its mainland access via the Island Road to Mullagh Quay:
the ominously named Midge Island lies within Mullagh Bay

The Gordons, an eighteenth-century mercantile family – whose more stylish architectural heritage is concentrated amongst the lovely old stone bridges at Kilmood, east of Killinchy – bought the estate at Delamont, just outside Killyleagh, from the Delahayes. So named because of an ancestor's affection for flora, the Gordons' Florida manor house at Kilmood is just one of the village's listed and eclectic buildings which also include the steward's house, farm buildings, gate lodge, stables, church, church hall, vicarage and manor courthouse, this last having housed award-winning chef Nick Price's first restaurant.

As is customary on the lough's shores, the original seventeenth-century Delamont stood by an early Christian rath, itself a successor to prehistoric habitation. Indeed over the centuries the house took many fancies, Tudor Revivalist being but one, American Gothic another, whilst Neo-Georgian – a style much in favour for twenty-first-century 'gentlemen's residences' – was added after a mid-twentieth-century fire.

Operated by Down District Council as a country park, and accessible on foot from Gibb's Island, Mullagh Quay and Island Road, the two-hundred-acre demesne boasts drumlin walks, a walled garden, a heronry and Ireland's longest miniature railway ride.

Gibb's Island from the shore

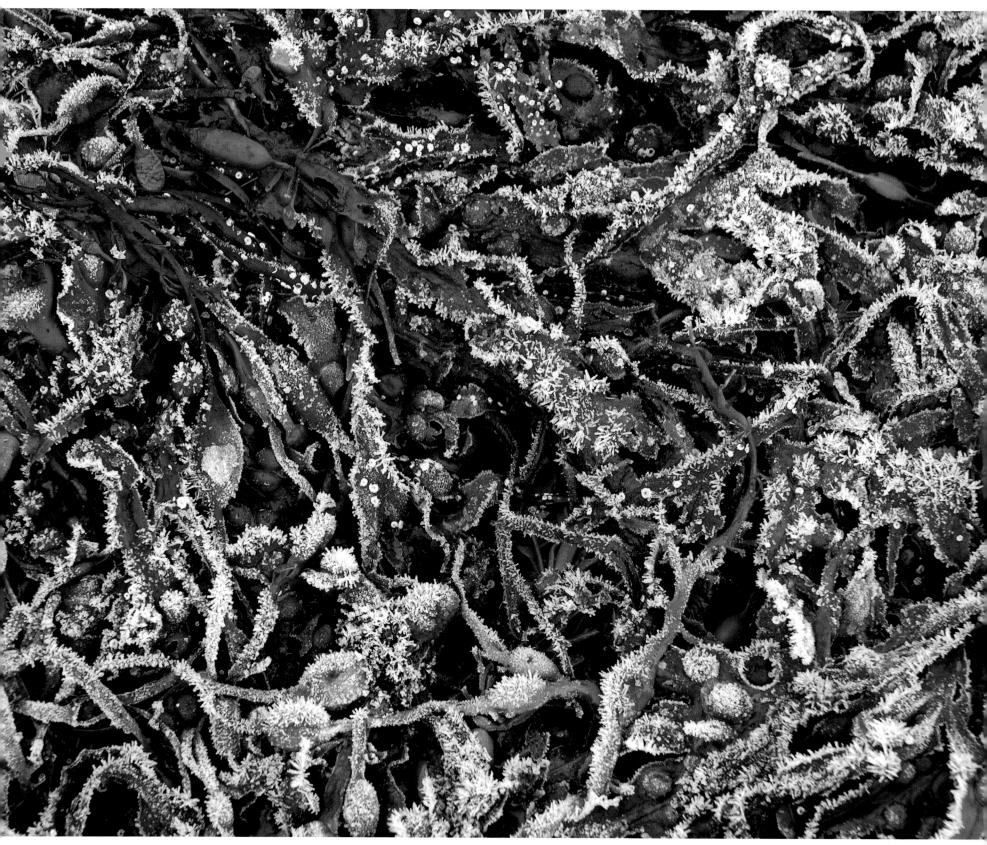

Bladder-wrack, *Fucus vesiculosus*(Ir. *feamainn bhoilgineach*), in winter

Left: Elder, *Sambucus niger* (Ir. *trom*), in berry

Below: Spindle-tree, *Euonymus europeaus* (Ir. *feoras*), in berry

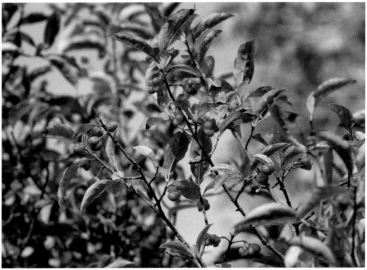

Above: Hawthorn, *Crategus monogyna* (Ir. *sceach gheal*), in blossom

Above: Blackthorn, *Prunus spinosa* (Ir. *draighean dubh*), with sloe berries

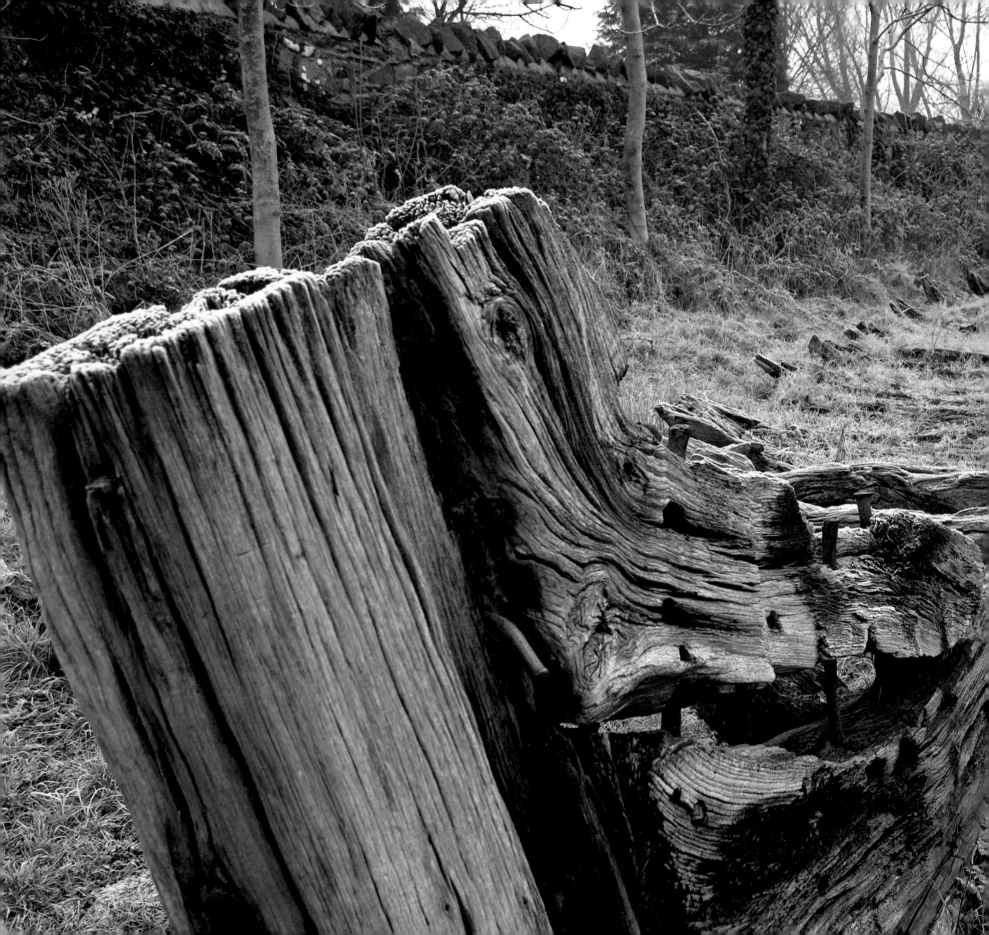

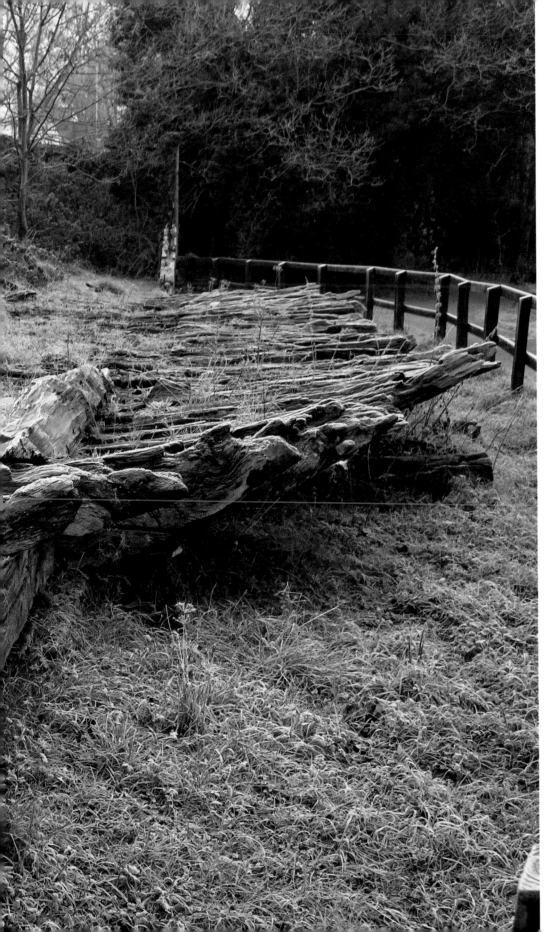

Inch Abbey to Killard Point

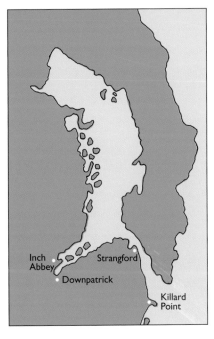

The lough has embraced vessels less commonplace than the coal-carrying schooner *Hilda Parnell* whose keel, like the backbone of some ancient cetacean, lies at the Quoile's Steamboat Quay, having caught fire in 1922. Of the 140 recorded calamities – from the *Eagle's Wing*, wrecked on Angus Rock with the loss of 76 lives in 1715 and the warship *Lichfield* sunk off Kilclief in 1743, her salvaged muskets hidden beneath the thatch of nearby cottages – many never even made it as far as the Narrows. The loss of the *Santissima Trinadada* in 1790 left Strangforders with a taste for the wines of Malaqueña, the sinking of *L'Amité* in 1798 encouraged a further fancy for guns. The ketch *Happy Return* survived the Narrows but didn't live up to her name, being stranded on Swan Island in 1881. Five years on, the smack *Nil Desperando* failed its own motto, blown ashore at Killyleagh.

The quays of working ports survive at Portaferry, Kircubbin, Castle Espie, Killyleagh, Castle Ward and Strangford. Downpatrick's two outlying quays, Quoile and Steamboat, are downstream of the Quoile Bridge and old floodgates. Yet before the first bridge of 1640, fifty-ton vessels came near to circumnavigating the town, sailing upriver as far as Inch Abbey then turning to port, discharging by what is now the St Patrick Centre, below Down Cathedral. Southwell's Quoile Quay, built in 1717 at Frankville, was first named New Kingsweston after his English estates. From here exports from the town's distillery, linen halls and corn warehouses were loaded up, while timber from Gdansk, tallow from Russia and brandy from France were unloaded.

The keel, sternpost and frames of the *Hilda Parnell*

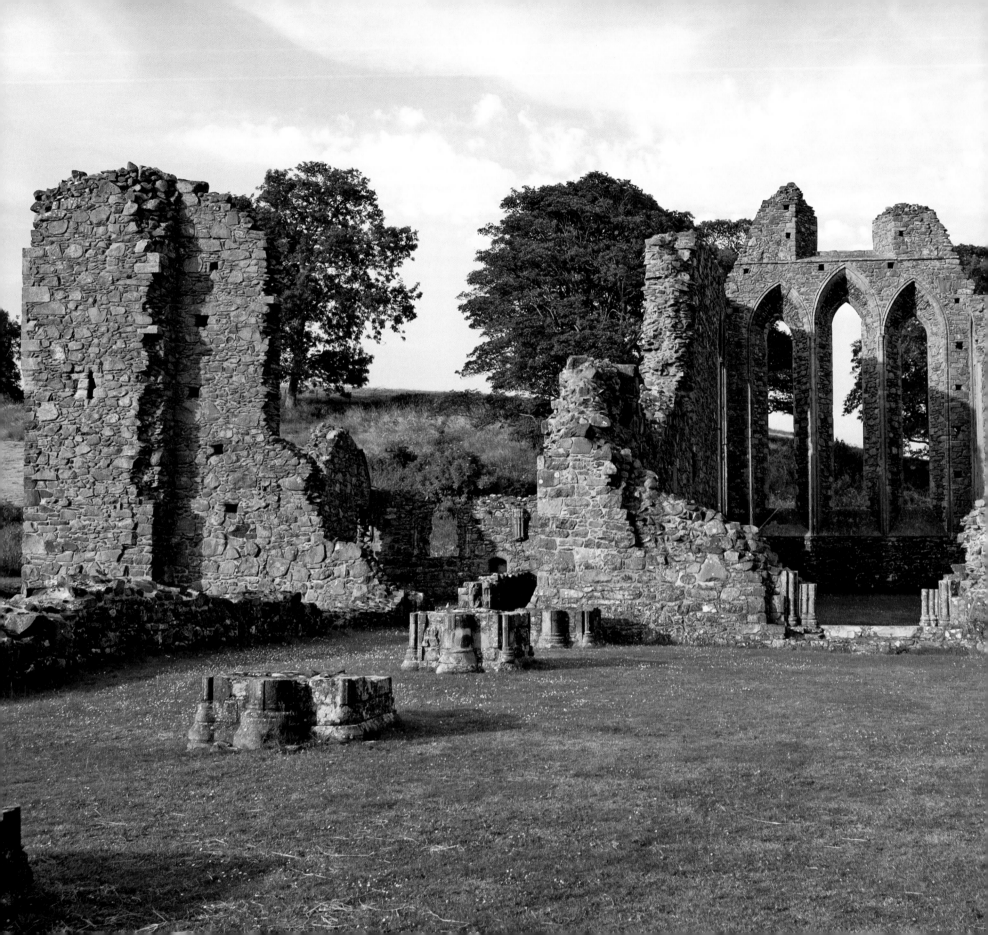

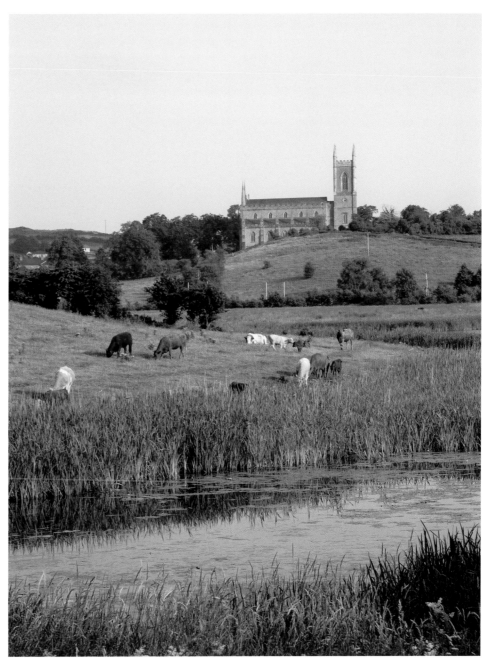

The Church of Ireland's Cathedral Church of the Holy Trinity in Downpatrick, from Inch Abbey

In 1187 John de Courcy founded Inch Abbey as penance for razing the nearby Benedictines' abbey – which had been garrisoned by the Magennis clan – during his invasion of this part of Ulster. The monks looked – as do today's picnickers freshly arrived by antique steam train from Downpatrick – from nave, cloister, infirmary and bake-house across meadowsweet, flag iris, river and reed mace to the twelfth-century Cathedral Church of the Holy Trinity. Here Ireland's patron saint, Patrick, may be buried. He received the viaticum at Saul, where, legend has it, his mission had begun, and then his body – placed on a cart drawn by unbroken Finnebrogue oxen – was drawn, under an angel's instructions, to Downpatrick where his corpse was interred.

Inch Abbey

Above and right: Quoile Pondage Nature Reserve

Upstream of Steamboat Quay and Goulbourn's Hole, silence rules Quoile Castle and Quoile Quay. The only hibernal sounds are the clunk of a car door, a leashed collie's haugh, the muted tic-tic-tic of power-walkers' heels or the clup of a pike-fisherman's plug breaking the mirrored waters. Gadwall, goldeneye, mallard, merganser, scaup, pochard, shoveler, teal, tufted duck, wigeon, and rarer overwintering ducks can swim easy, the toll of punt guns over Shooter's Island naught but a grandfather's tale, although the sighting of a buzzard would undoubtedly cause a flutter of worried wings. The return of the red kite, a *glede* in Ulster-Scots, is, as yet, an ecologist's dream.

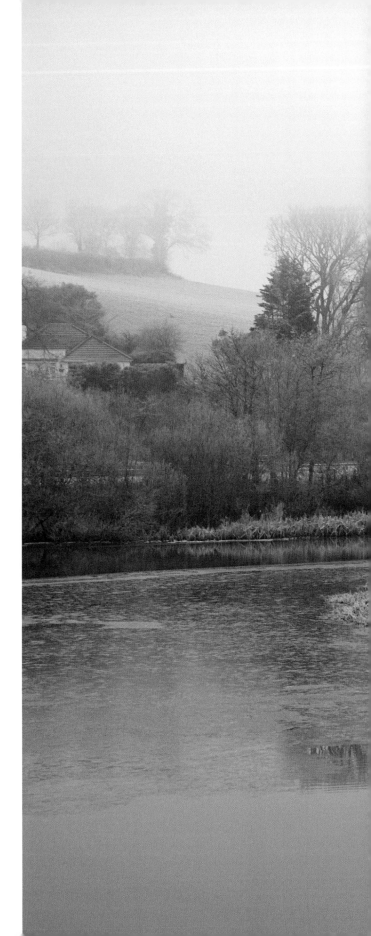

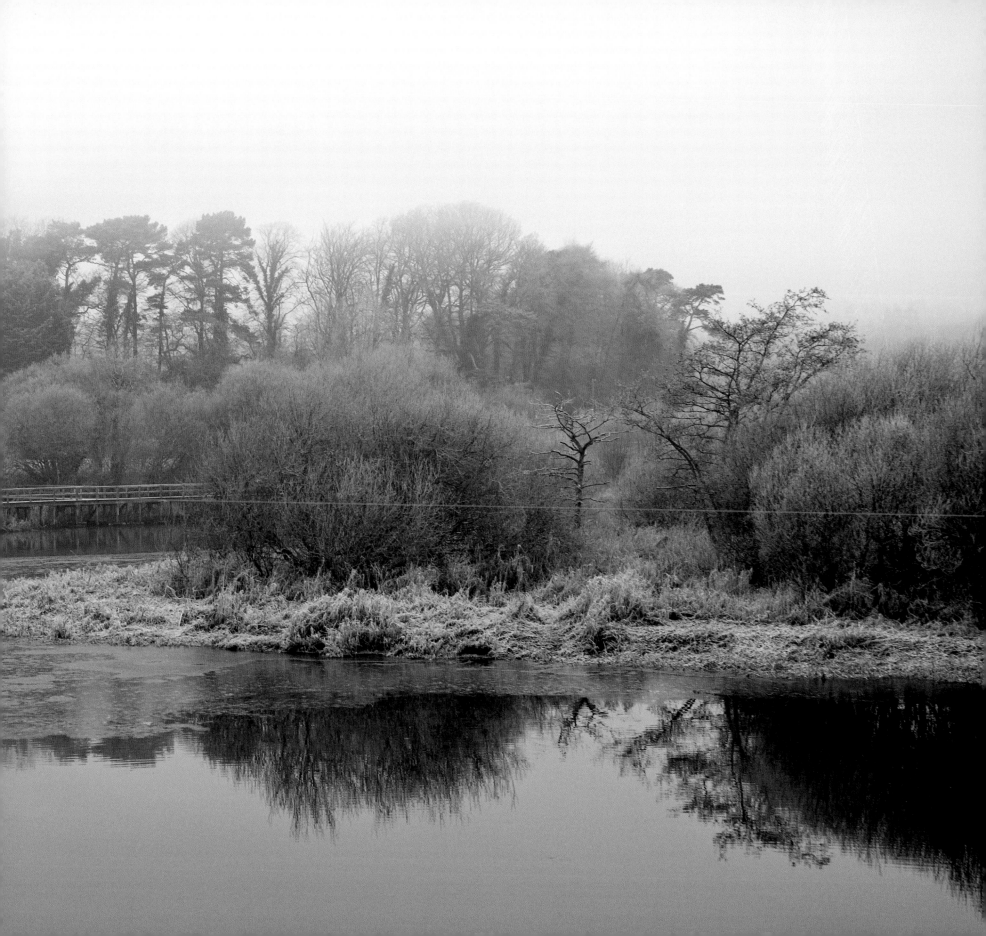

Shoveler ducks, *Spatula clypeata* (Ir. *spadalach*)

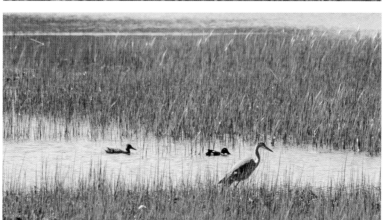

Heron, *Ardea cinerea* (Ir. *corr ghlas*), foreground, with shoveler ducks

Male mallard, *Anas platyrhynchos* (Ir. *mallard*)

Below Loop Hill, upstream of Shooter's Island

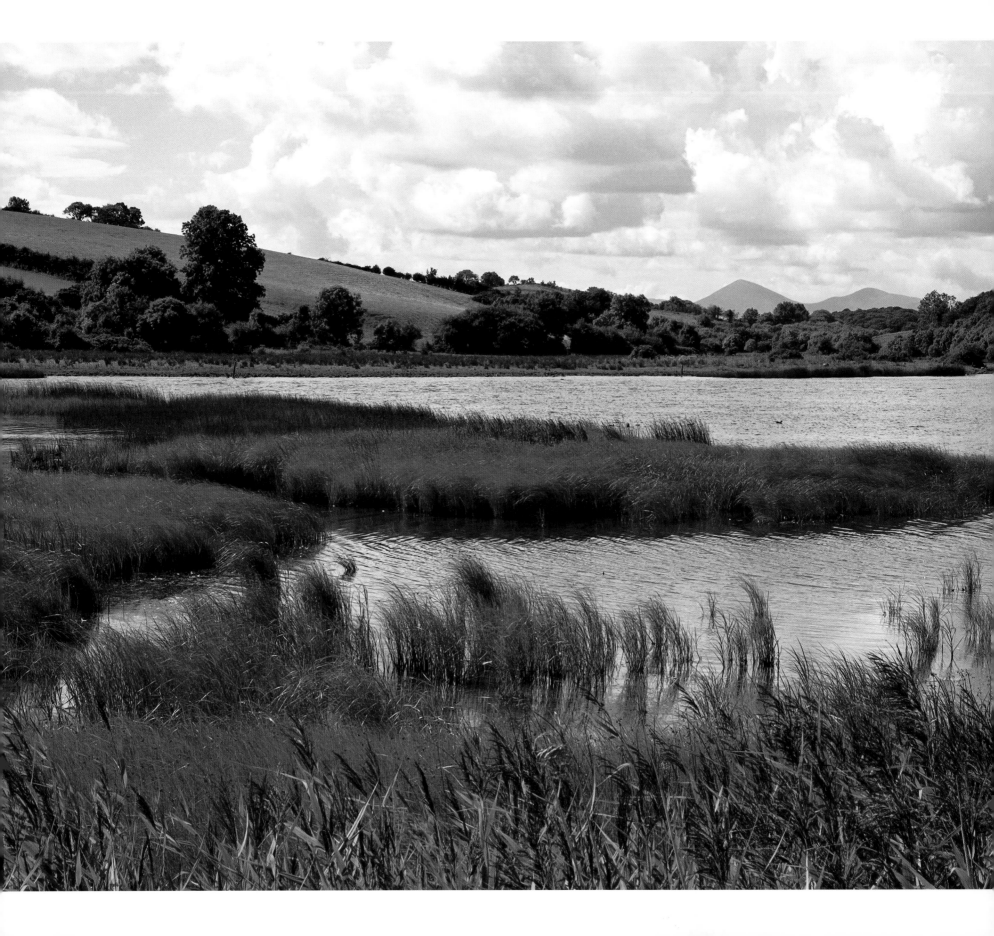

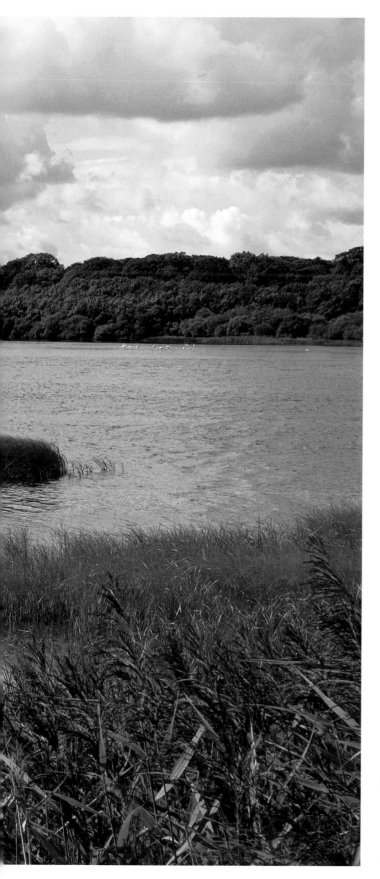

There were those who once evoked the old gods, and there may be others who still make their rituals – ancient and modern – by this, Loughmoney's megalithic chambered grave. Or maybe they prefer to go to either of its two companions – the dolmens at Slievenagriddle and Ballyalton – across this charmed and tiny lough at a moon's phase, at Lughnasa, or at some other solstice, to find significance in the relationships of the planets, the sparkling of the stars, or in the perceived mystical alignment of the all but lost line of six standing stones which once marched over the hills from Audleystown in the north-east past Carrownacaw's Long Stone, south-west to a peak in the Mournes. Or, pan-celtically, in a line beginning in the Shetland Islands, Brittany or Galicia?

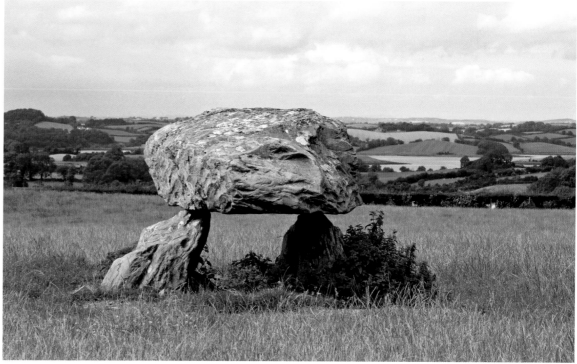

Loughmoney dolmen

The Mountains of Mourne, from Castle Island

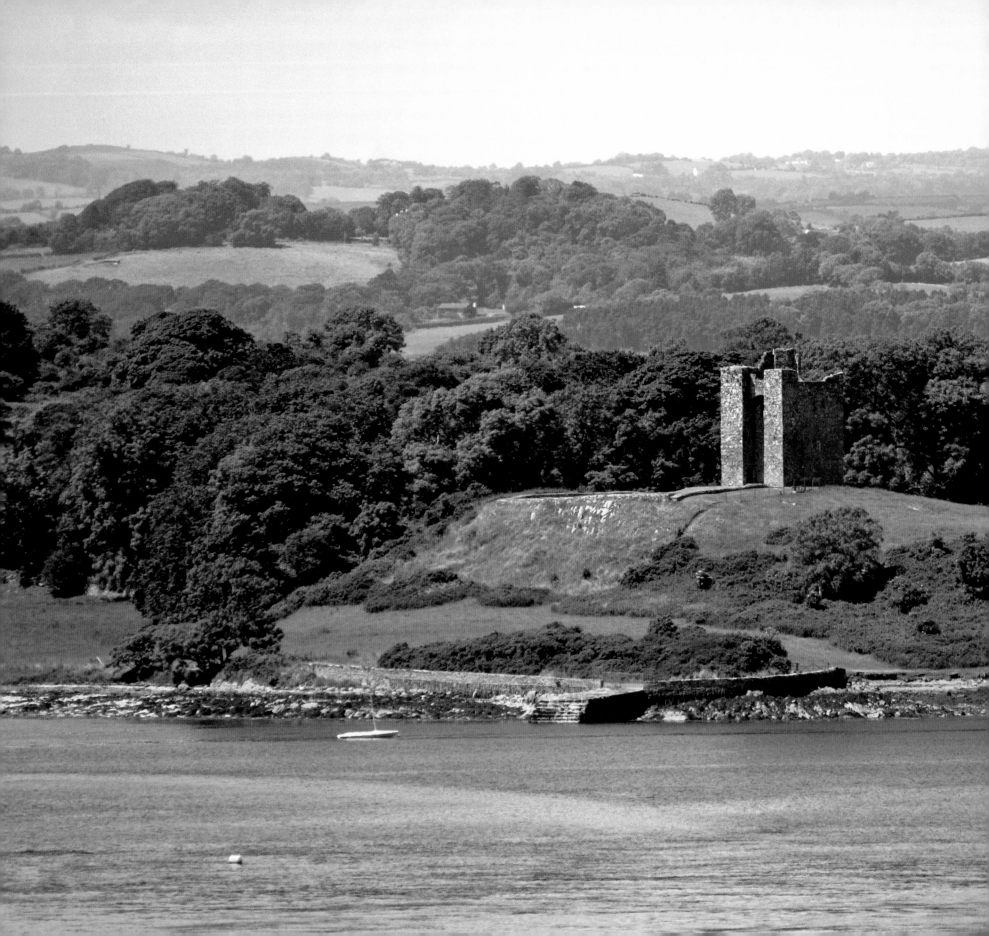

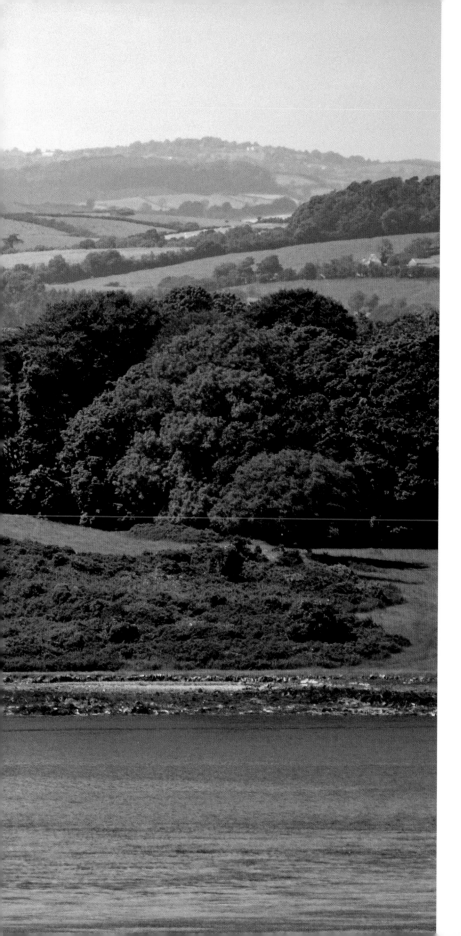

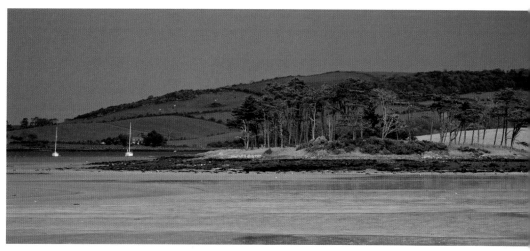

Crane Point, Castleward Bay, from Black Causeway

The lough's waters below Audley's Castle – named Audley's Roads at a time when the seas proffered more profitable access than their wooded shores – would have harboured a Spanish armada had the Gaelic earls' plan to repulse Elizabeth I of England's invasion come to fruition. A French ship, *Petite Onglette*, unloaded arms, but the Iberians landed instead in Kinsale in 1601 to suffer, jointly with the Irish under Hugh O'Neill, the crushing defeat that led to the less than glorious flight of the earls to penury in Europe.

The Audleys, privileged in Anglo-Norman society under the earldom of Ulster, built their castle – complete with murder hole, pistol loop and latrine – in the mid-fifteenth century. It formed part of a defensive stone necklace of tower-houses which came to encircle the lough from Portaferry – via Ardquin, Ardkeen, Rosemount, Newtownards, Mount Alexander, Castle Espie, Nendrum, Sketrick, Rathgorman, Ringdufferin, Ringhaddy, Killyleagh, Quoile, Castle Island, Saul, Walshestown, Audleystown, Castle Ward, Strangford – to Kilclief and Bishops Court. For the lough and its lands, rich in fish and corn for the table, plus timber for boat and warehouse, was a prize which, once won, had to be held.

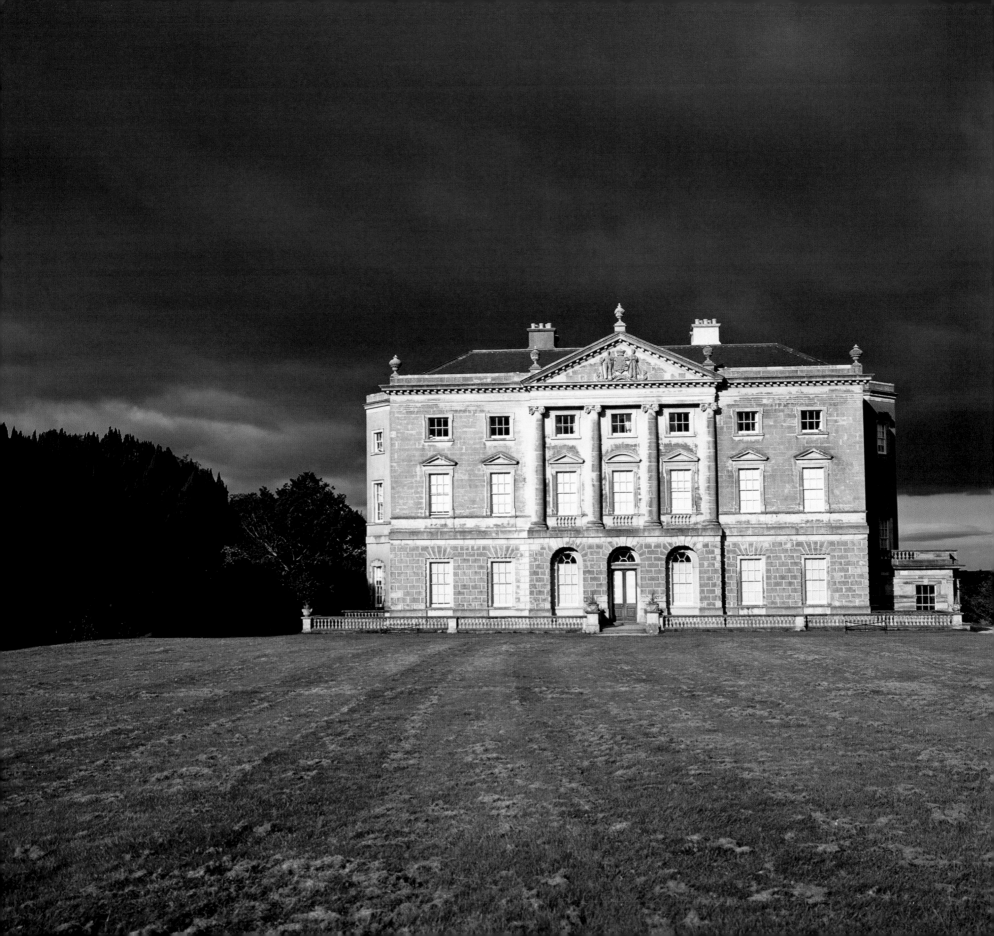

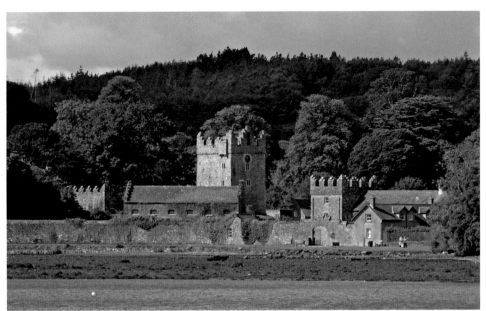

Sixteenth-century Castle Ward tower-house

While the male Stewarts of Mount Stewart bedded and sometimes wedded beauty, wealth, coal and title, Castle Ward's Wards were a less aspirant lot. They commissioned first a workman-like sixteenth-century stronghold, then this charming eighteenth-century mansion midst their two-hundred rolling drumlin acres, whilst tumbling the occasional maidservant; dismissing a cleric who frowned on such behaviour; deporting villagers; razing the village of Audleystown because it spoiled the view; developing a port; erecting a folly; excavating a lake; and funding almshouses, churches and cross-denominational schools. In time, though, just like the Stewarts, they had to witness their demesne enveloped sympathetically in cultural aspic by the National Trust.

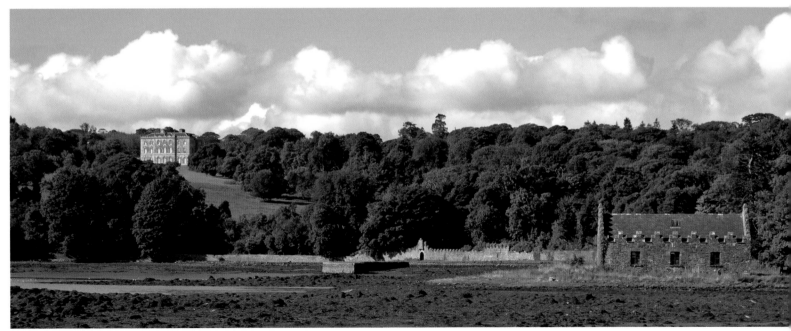

Above: Eighteenth-century Castle Ward House, quay and Dickson's Island boathouse

Left: The classical south-west façade of Castle Ward House, a contrast to the neo-Gothic of its north-eastern elevation; the styles reflecting the tastes, respectively, of Lord and Lady Bangor

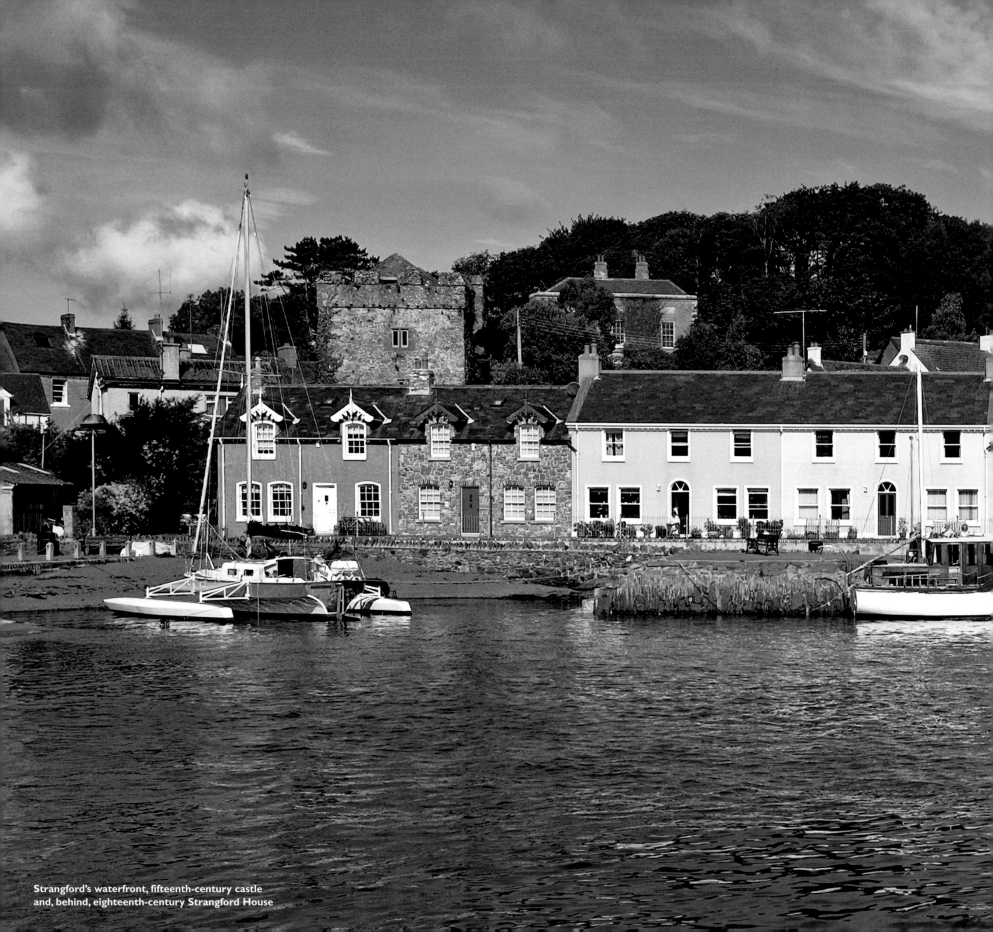

Strangford's waterfront, fifteenth-century castle
and, behind, eighteenth-century Strangford House

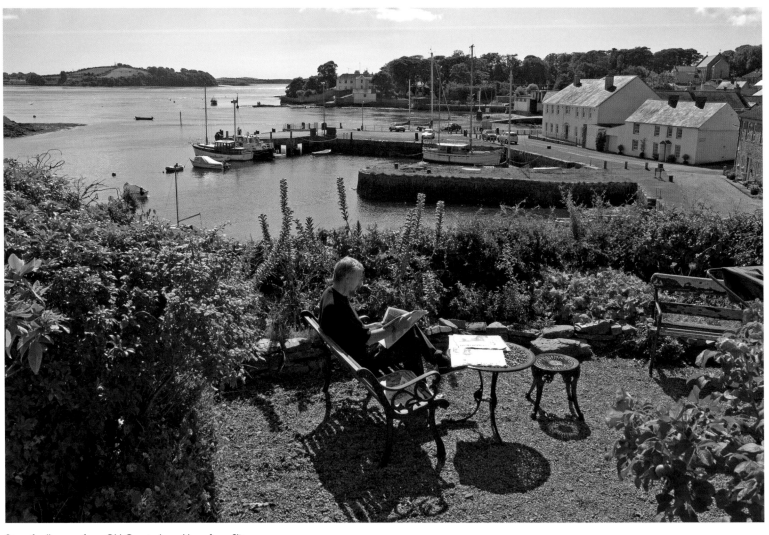

Strangford's quays from Old Court, above Horseferry Slip

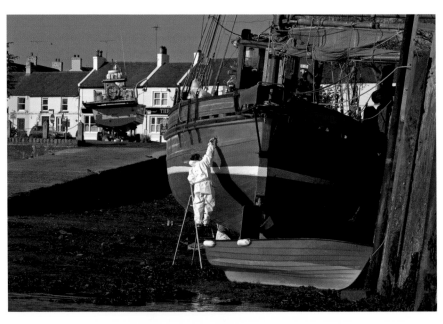

Nineteenth-century working quay and slipway, Strangford Lower

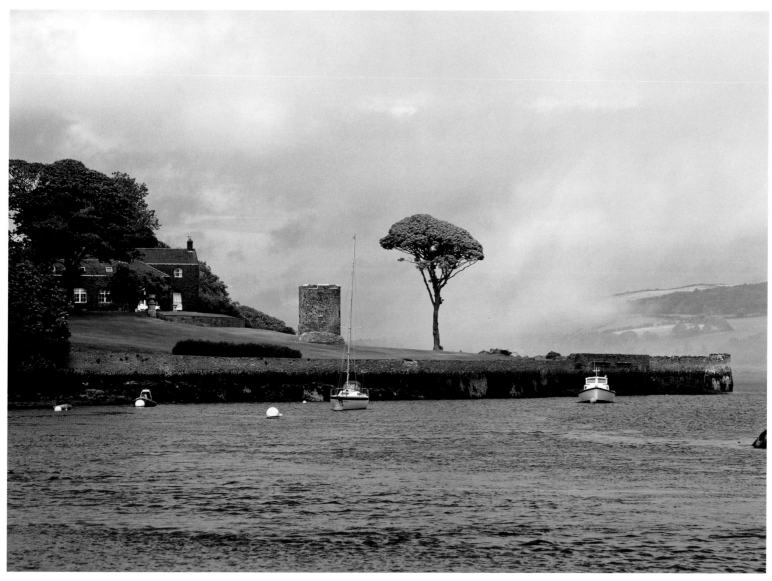

Strangford Tower and Katharine Quay, Old Court

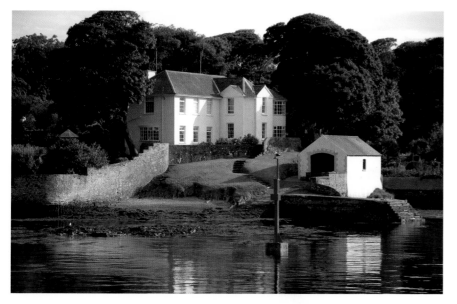

Medieval Strangford, a major port, witnessed the repulse of the Scots in 1400. It went on to flourish under the Earls of Kildare when in 1629 their agent Valentine Payne built Horseferry Slip and Old Quay – 'that the biggest shippe the King hathe may lay her side beside it'. Now its working ferry port charms are preserved by the conservation area status of its Georgian, Regency and Victorian architecture, its village greens and, in particular, its framing inheritance of plantations of mature trees at Old Court, Compass Hill, Strangford House, Strangford Square, Old Rectory, Ferry Quarter and Watch House.

Watch House, Ferry Quarter, Strangford

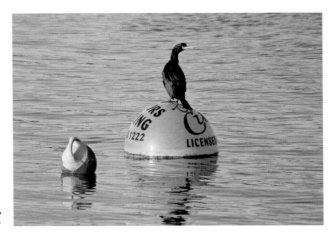

Shag, *Phalacrocorax aristotelis* (Ir. *seaga*), on the Cuan Bar's buoy

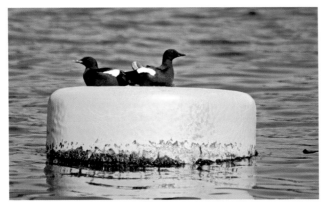

Black guillemot, *Cepphus grylle* (Ir. *foracha dhubh*)

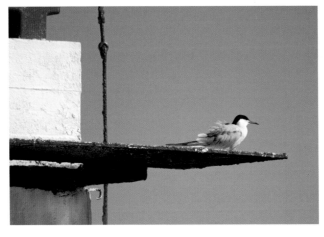

Common tern, *Sterna hirundo* (Ir. *geabhróg*)

Its open throat as red as its legs, the sooty black guillemot comes and goes, whistling while it works. It speeds low over the water, ploughing the sea-bottom for food, nesting in boxes on Katharine Quay. Terns lay on Swan Island, calling harshly, plunge-diving for fish. Swallows nest under the eaves, cormorant on Bird Island, shag and kittiwake on Guns Island, lapwing at Killard, fulmar in Benderg Bay, heron at Delamont, Gibb's Island, Strangford's Compass Hill and Isle O'Valla House, with buzzard in the woods at Ballyhenry, across the Narrows. The ferries, come rain come shine, depart every day except Christmas Day.

Portaferry bound

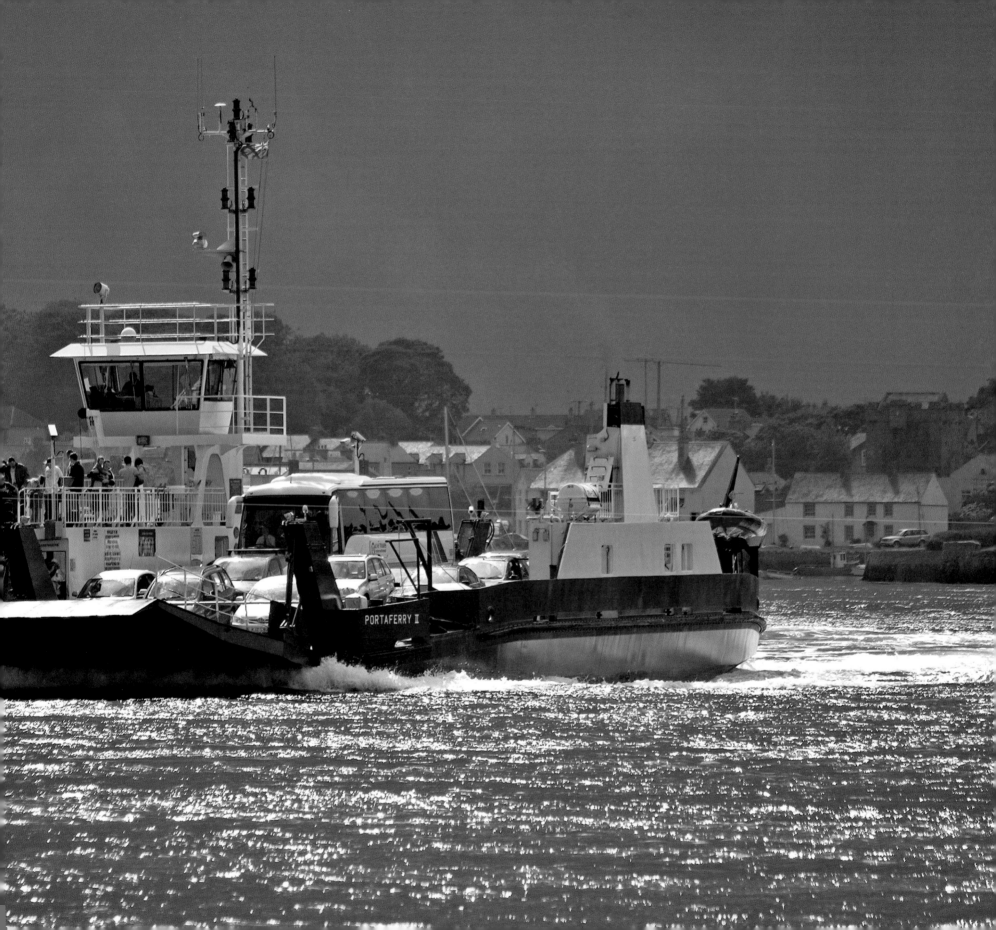

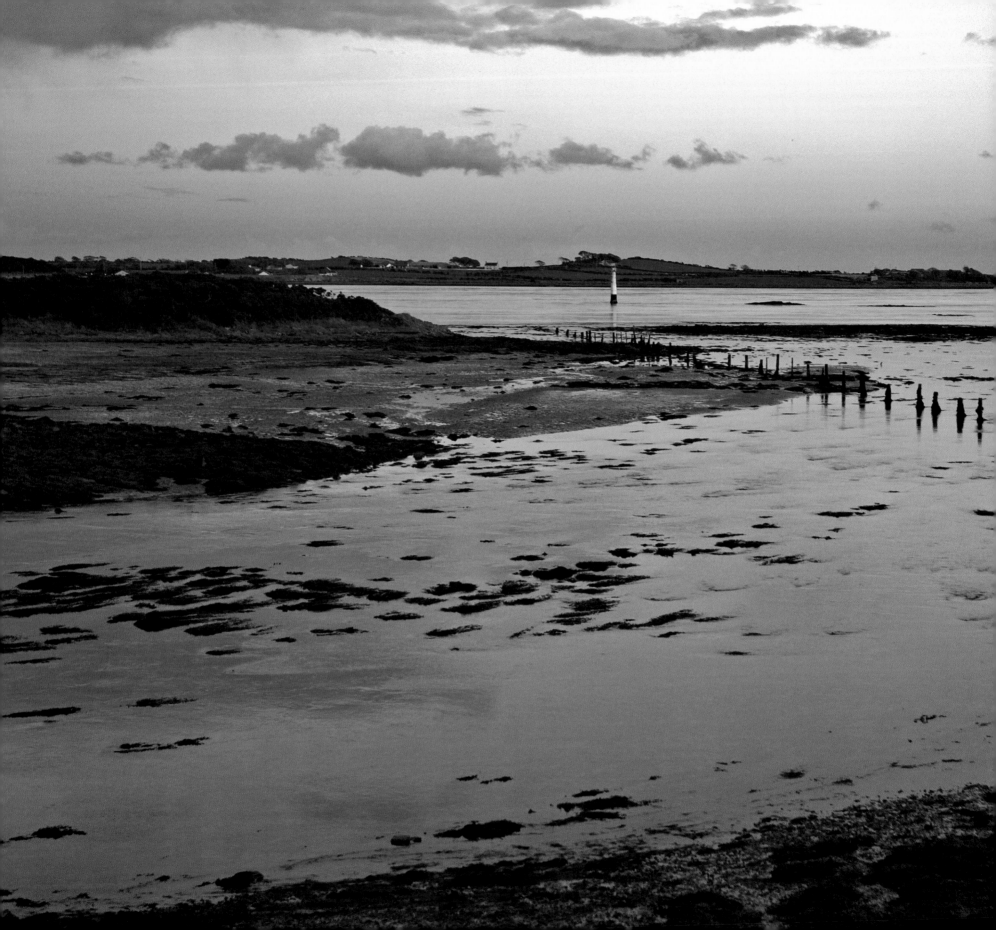

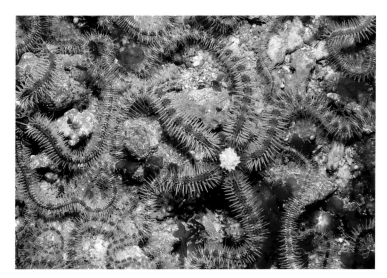

Common brittle-star, *Ophiothrix fragilis* (Ir. *crosóg bhriosc*)

While Angus Rock and St Patrick's Rock bore navigation markers from 1580 onwards, Salt Rock, pictured left, wasn't marked with a perch until it featured on Portaferry pilot George Johnston's excellent chart of 'Strangford River', published in 1775. The Rock has borne a beacon since 1852.

Natural and built features, headlands and spires, on the land also play their part in guiding the helmsman's course, as does a knowledge of the position of the stars, the significance of the movements of birds and fish, the shapes of clouds.

But wrecks enough – of brigantine, ketch, schooner, warship and yawl – remain to provide diversion for the diver seeking exhilaration in civilisation's, as well as nature's, underwater world.

Velvet crab, *Macropipus puber* (Ir. *luaineachán*)

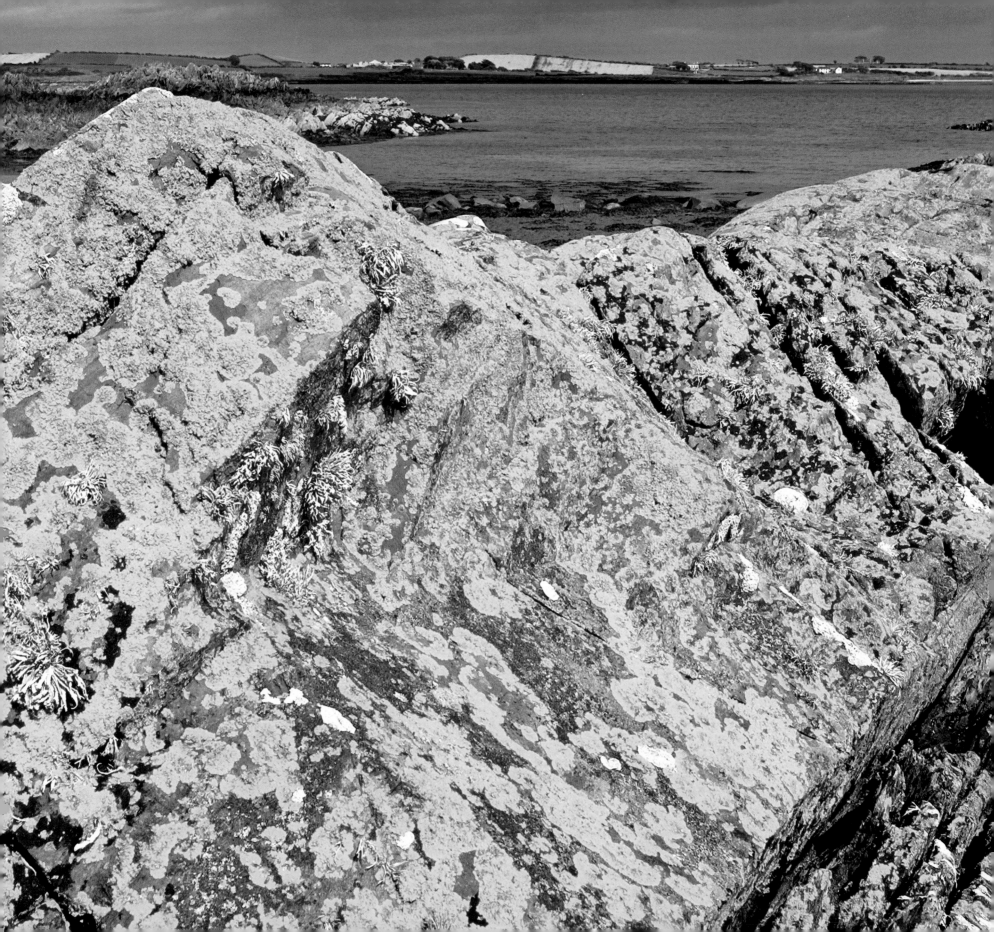

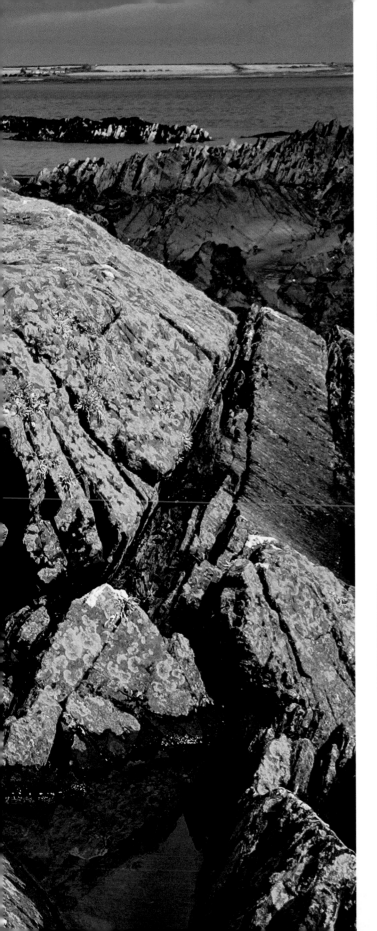

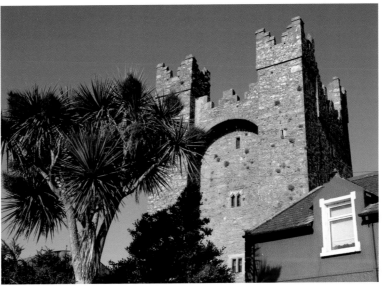

Fifteenth-century Kilclief Castle

In 1441 Bishop of Down John Sely was, in a precursor to the late-twentieth-century carnal peccadilloes of the Irish Roman Catholic church, deprived of his manorial residence – this four-storey 'castro de Kylcleth' – for consorting with Laeticia Thomas, a married woman.

Open in summer in state care, a study of the history of this tower-house – which comes complete with such diverting martial accessories as gun-slits double-splayed to increase the field of defensive fire – may distract from sandy sandwiches and offer an affirmative answer to all of the following. Was that V of rocks across the stream an episcopal fish trap? Is the mound to the north a defensive Anglo-Norman earthwork? Did the Vikings plunder a Patrician monastery, predecessor to the spare little church south, in 935? Had Kilclief a borough seal in the fifteenth century? Were those common seals at Cloghy?

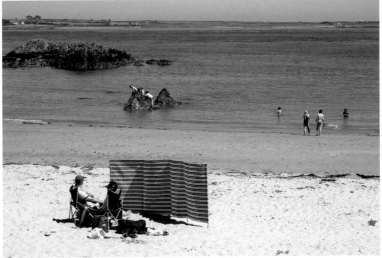

Kilclief beach

Sea ivory, *Ramalina siliquosa* (Ir. *Eabhar mara*), amidst yellow scales lichen, *Xanthoria parietina* (Ir. *Léicean duilleach flannbhuí*)

137

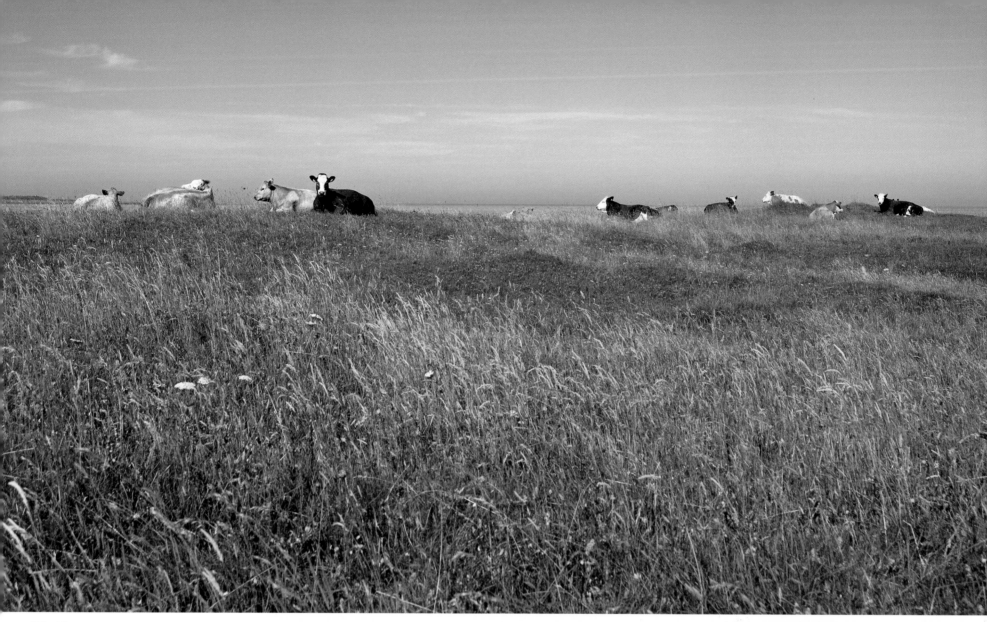

Killard Point

Killard is a Nature Reserve and an Area of Special Scientific Interest (ASSI) on the Lecale Coast Area of Outstanding Natural Beauty. Named for an untraced church on the hill, it is a lime-rich wild flower dune meadow of magical status. Yes, bring guide-books to flowers, seashells, birds, butterflies and moths; but leave them aside. Lie prone. Listen: skylarks at noon, shearwaters at midnight.

Right: Vernal squill, *Scilla verna* (Ir. *sciolla earraigh*)

Far right: Early marsh orchid, *Dactylorhiza incarnata* (Ir. *magairlín mór*)

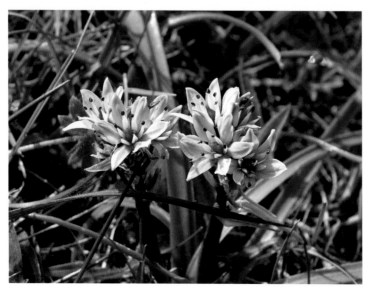

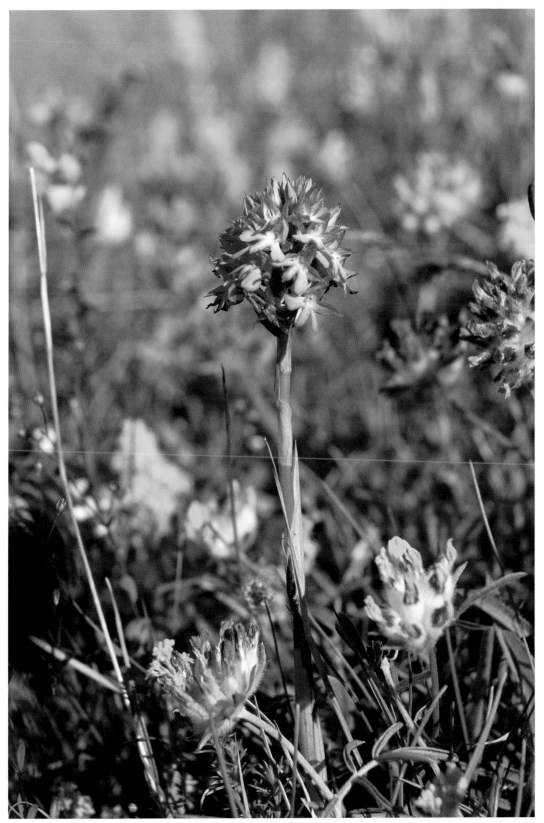

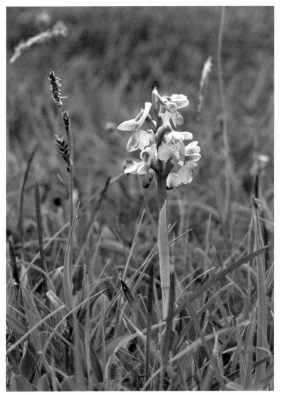

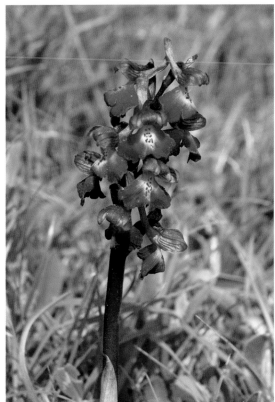

Pink and purple forms of the Green-winged orchid, *Orchis morio* (Ir. *magairlín féitheach*), at its only Northern Irish location

Pyramidal orchid, *Anacamptis pyramidilis* (Ir. *magairlín na stuaice*), amongst kidney vetch, *Anthyllis vulneraria* (Ir. *méara muire*)

Killard from Ballyquintin

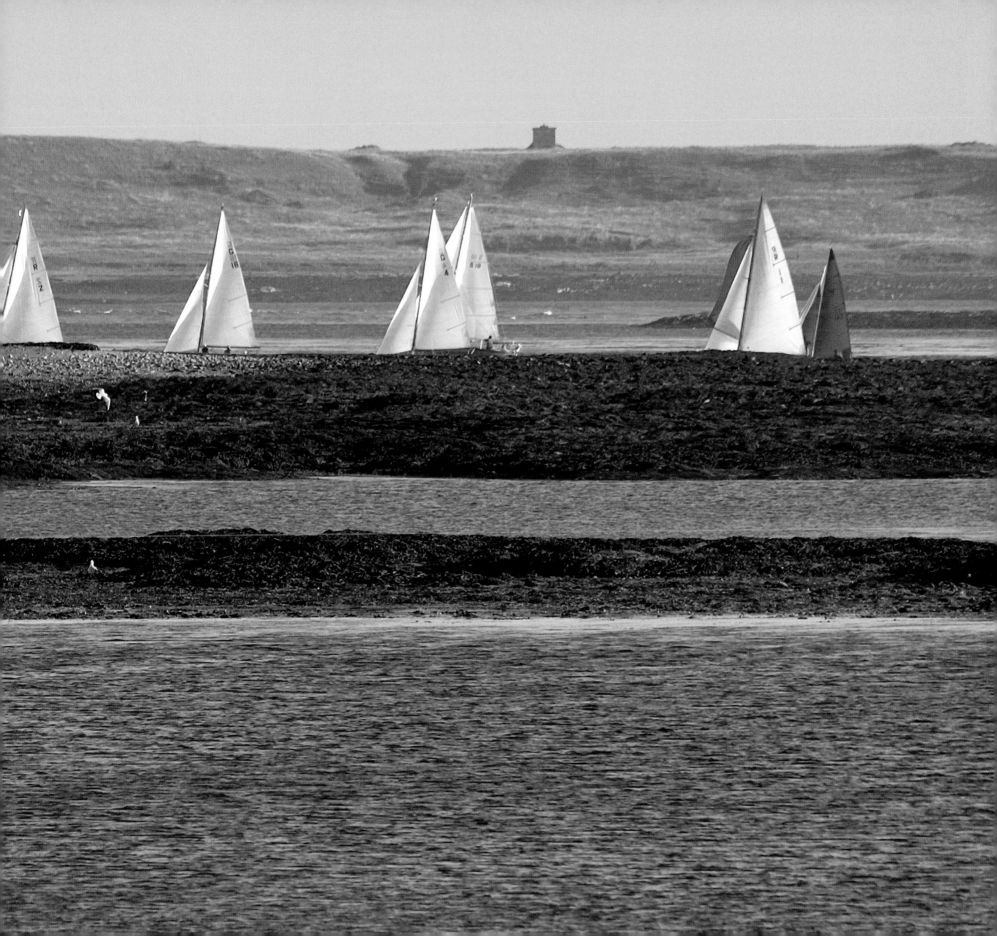

Faced in white glazed brick, the modernist design of the beacon on the Pladdy Lug reflects the 1926 date of its construction.

Bibliography

Archaeology Data Service (2007) http://ads.ahds.ac.uk

A Planning Strategy for Rural Northern Ireland (1993). Belfast (Planning Service)

Ards and Down Area Plan 2015 (2002 draft). Belfast (Planning Service)

BARDON, J. (1992) A History of Ulster. Belfast (Blackstaff Press)

BASSETT, G.H. (1988) County Down 100 Years Ago: A Guide and Directory 1886. Reprint. Belfast (Friar's Bush Press)

BELL, G.P., BRETT, C.E.B. and MATTHEW, R. (1969) Portaferry and Strangford. Belfast (Ulster Architectural Heritage Society)

BELL, S.H. (1974) December Bride. 2nd edition. Belfast (Blackstaff Press)

BERESFORD ELLIS, P. (1992) Dictionary of Celtic Mythology. London (Constable)

BRETT, C.E.B. (2002) Buildings of North County Down. Belfast (Ulster Architectural Heritage Society)

BRETT, D. (1999) The Reformation, Culture and the Crisis in Protestant Identity. Belfast (Black Square Books)

BROWN, A. and CROSBIE, J.E. (1996) Strangford's Shores. Donaghadee (Cottage Publications)

BUCHANAN, R.H. (1997) 'The Lecale Peninsula, County Down', Atlas of the Irish Rural Landscape. Cork (Cork University Press)

BUCHANAN, R.H. and WILSON, A. (1997) 'Downpatrick', Irish Historic Towns Atlas 8. Dublin (Royal Irish Academy)

CHESNEY, H.C.G. (1997) 'Enlightenment and Education', Nature In Ireland: A Scientific and Cultural History. Dublin (Lilliput Press)

CRAIG. P. (ed.) (2006) The Ulster Anthology. Belfast (Blackstaff Press)

CURL, J.S. (2006) A Dictionary of Architecture and Landscape Architecture. 2nd edition. Oxford (Oxford University Press)

DAVIDSON, A. (1979) North Atlantic Seafood. London (Macmillan)

DAY, A. (ed.) (1991) Letters from Georgian Ireland: The Correspondence of Mary Delany, 1731–68. Belfast (Friar's Bush Press)

DAY, A. and McWILLIAMS, P. (eds) (1992) Ordnance Survey Memoirs of Ireland, 17, Parishes of County Down IV 1833–1837, East Down and Lecale. Belfast (Institute of Irish Studies, Queen's University Belfast)

DE COURCY, A. (1992) Circe: The Life of Edith, Marchioness of Londonderry. London (Sinclair-Stevenson)

DEAN, J.A.K. (1994) The Gatelodges of Ulster: A Gazetteer. Belfast (Ulster Archaeological Heritage Society)

DEMPSEY, E. and O'CLERY, M. (2002) The Complete Guide to Ireland's Birds. 2nd edition. Dublin (Gill & Macmillan)

Dictionary of Irish Terms/Focloír Téarmaíochta (2007) www.focal.ie

Discoverer Map Series. Sheet 21, Strangford Lough. Belfast (Ordnance Survey of Northern Ireland)

DOYLE, L. (1946) Ballygullion. Harmondsworth (Penguin)

EVANS, E.E. (1957) Irish Folk Ways. London (Routledge & Kegan Paul)

EVANS, R. (1981) The Visitor's Guide to Northern Ireland. Ashbourne (Moorland Publishing Co.)

FENTON, J. (2006) The Hamely Tongue. Belfast (Ullans Press)

FLANAGAN, D. and FLANAGAN, L. (1994) Irish Place Names. Dublin (Gill & Macmillan)

GALLOWAY, P. (1992) The Cathedrals of Ireland. Belfast (Institute of Irish Studies, Queen's University Belfast)

GERARD, A., LECOUAIL, M. and PRIEUR, D. (1979) La Pêche à Pied. Rennes (Ouest France)

GREEN, E.R.R. (1963) The Industrial Archaeology of County Down. Belfast (HMSO)

HARRY, O.G. (1984) 'The Hon. Mrs Ward (1827–1869): Artist, Naturalist, Astronomer and Ireland's First Lady of the Microscope', Irish Naturalist's Journal 21

HILL, I. (1992) The Fish of Ireland. Belfast (Appletree Press)

JOPE, H.M. (ed.) (1966) An Archaeological Survey of County Down. Belfast (HMSO)

KENNEDY, W.E. (1980) The Bangors and Ballyculter: An Historical Sketch of the Parish of Ballyculter (Strangford). Ballyculter (Kennedy)

KILLEN, J. (ed.) (1997) The Decade of the United Irishmen: Contemporary Accounts 1791–1801. Belfast (Blackstaff Press)

KING, M. (2006) Treasures of Down. Belfast (The Stationery Office)

LEWIS, S. (1837) County Down: A Topographical Dictionary of the Parishes, Villages and Towns of County Down in the 1830s. 2nd edition 2003. Belfast (Friar's Bush Press)

Listed Buildings (2007) www.ehsni.gov.uk/built/listing Belfast (Environment and Heritage Service)

LYLE, P. (2003) Classic Geology in Europe, 5: The North of Ireland. Harpenden (Terra Publishing)

MACAFEE, C.I. (ed.) (1996) A Concise Ulster Dictionary. Oxford (Oxford University Press)

Maritime Heritage (2007) www.ehsni.gov.uk/built/maritime Belfast (Environment and Heritage Service)

McCUTCHEON, W.A. (1980) The Industrial Archaeology of Northern Ireland. Belfast (HMSO)

McDONNELL, H. (2007) St Patrick: His Life and Legend. Glastonbury (Wooden Books)

McERLEAN, T., McCONKEY, R. and FORSYTHE, W. (2002) Strangford Lough: An Archaeological Survey of the Maritime Cultural Landscape. Belfast (Blackstaff Press and Environment and Heritage Service)

MAGUIRE, W.A. (ed.) (1998) Up in Arms: The 1798 Rebellion in Ireland. Belfast (Ulster Museum)

MALLORY, J.P. and McNEILL, T.E. (1991) The Archaeology of Ulster: From Colonization to Plantation. Belfast (Institute of Irish Studies, Queen's University Belfast)

MONTGOMERY HYDE, H. (1959) The Strange Death of Lord Castlereagh. London (Heinemann)

Monuments (2007) www.ehsni.gov.uk/built/mbr Belfast (Environment and Heritage Service)

Mount Stewart Garden Guide (1998). Saintfield (The National Trust)

MULVIHILL, M. (2002) Ingenious Ireland: A County-by-County Exploration of Irish Mysteries and Marvels. Dublin (Town House)

NELSON, E.C. and WALSH, W.F. (1993) Trees of Ireland. Dublin (Lilliput Press)

O CINNEIDIE, T. (1978) Ainmneacha Plandaí agus Ainmhithe/Flora and Fauna Nomenclature. Dublin (An Roinn Oideachais, Oifig an tSoláthair)

PITCHER, J. and HALL, V. (2001) Flora Hibernica: The Wild Flowers, Plants and Trees of Ireland. Cork (The Collins Press)

PRAEGER, R.L. (1939) The Way That I Went: An Irishman in Ireland. Dublin (Hodges, Figgis & Co.)

—— (1972) Natural History of Ireland. 2nd edition. Wakefield (EP Publishing)

SANDFORD, E. (1976) Discover Northern Ireland. Belfast (Northern Ireland Tourist Board)

ST JOHN GOGARTY, O. (1938) I Follow St Patrick. New York (Reynal & Hitchcock)

STERRY, P. (2004) Complete Irish Wildlife. London (HarperCollins)

STEVENSON, J. (1990) Two Centuries of Life in Down 1600–1800. 2nd edition. Belfast (White Row Press)

STEWART, A.T.Q. (1995) The Summer Soldiers: The 1798 Rebellion in Antrim and Down. Belfast (Blackstaff Press)

THOMPSON, R. and NELSON, B. (2006) The Butterflies and Moths of Northern Ireland. Belfast (National Museums Northern Ireland)

VILLOCH, J. (1991) Guía de los Mariscos. 2nd Edition. La Coruña (Casa de las Ciencias)

—— (1991) Guía de los Pesces. 2nd Edition. La Coruña (Casa de las Ciencias)

WILSON, P.W. (ed.) (1927) The Greville Diary, Volume 1. London (Heinemann)

WILLIAMS, J. (1994) A Companion Guide to Architecture in Ireland 1837–1921. Dublin (Irish Academic Press)

ZAMOYSKI, A. (2007) Rites of Peace: The Fall of Napoleon and the Congress of Vienna. London (HarperPress)

Index

Page numbers in italics refer to illustrations.

The red navigation light on the tower on Angus Rock pulses every five seconds, fifteen metres above high water springs.